UNSEENAMERICA

UNSEEN

photos and stories by workers

AMERICA

EDITED BY ESTHER COHEN

ReganBooks

An Imprint of HarperCollinsPublishers

unseenamerica is a registered trademark of Bread and Roses 1199SEIU.

Copyright for the photographs here is held by the individual photographers.

UNSEENAMERICA. Copyright © 2006 by Bread and Roses Cultural Project, Inc. All rights reserved. Printed in Singapore. No part of this book may be used or reproduced in any manner whatsoever without written permission except in the case of brief quotations embodied in critical articles and reviews. For information, address HarperCollins Publishers Inc., 10 East 53rd Street, New York, NY 10022.

HarperCollins books may be purchased for educational, business, or sales promotional use. For information please write: Special Markets Department, HarperCollins Publishers Inc., 10 East 53rd Street, New York, NY 10022.

FIRST EDITION

Designed by Michelle Ishay and Kris Tobiassen

Printed on acid-free paper

Library of Congress Cataloging-in-Publication Data has been applied for.

ISBN 0-06-059406-3

06 07 08 09 10 IM 10 9 8 7 6 5 4 3 2 1

This country's built by so many unexpected and unseen people who make up the fabric of our lives. This book is dedicated to adding their visions to the dream of democracy.

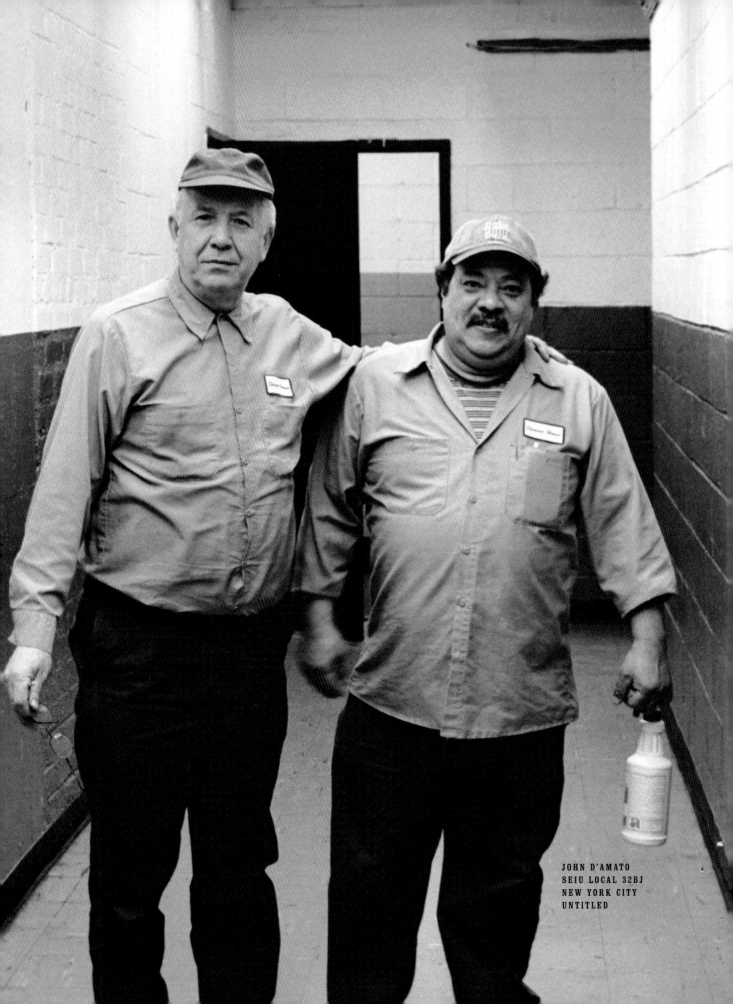

JOHN D'AMATO
SEIU LOCAL 32BJ
NEW YORK CITY
UNTITLED

"How wonderful it would be if we could see the world through one another's eyes."

—THOREAU

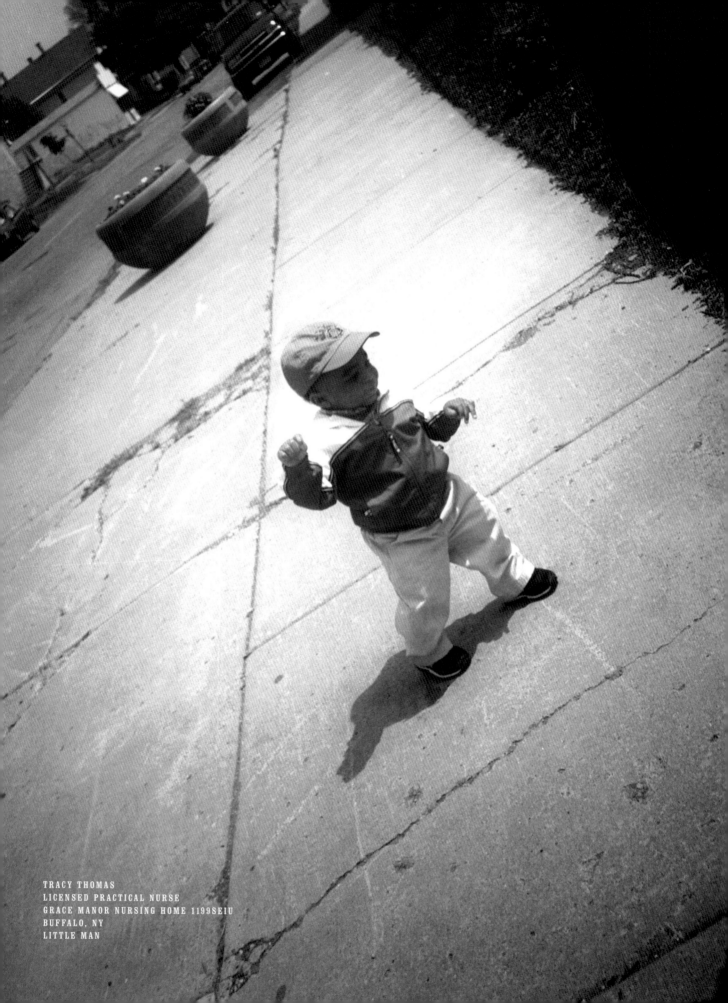

TRACY THOMAS
LICENSED PRACTICAL NURSE
GRACE MANOR NURSING HOME 1199SEIU
BUFFALO, NY
LITTLE MAN

THANKS

TO SO many with vision and persistence who have helped us along.

To all the people who shared their time, their talent, and their unexpected stories, especially to the first groups willing to take a chance: day laborers from The Workplace Project; 1199's health care workers; nannies from the Filipino Workers Center; building maintenance employees with SEIU Local 32BJ; Chinese garment workers from 23-25 UNITE HERE.

To our teachers, especially Matthew Septimus, gifted friend, to Teddy Fung of gentle grace, and Linda Markstein for her elegant sentences. To Naomi Woronow, who agreed to help. To Nathalis Wamba and Carolyn Curran for their nonevaluation, and their enthusiasm. To Michael Zweig at SUNY Stonybrook, our first partner and provider of invaluable advice. To Abby Robinson, who answered every question, and to all the many photographers who joined us to teach and to guide. To Eleanor Tilson, our godmother, and to Mitra Behroozi for her humor and loyalty. To Ossie Davis, who still helps us from the heavens, and to Ruby Dee, who've both been there from the beginning.

To visionary union leader Dennis Rivera and all of 1199, for understanding how much we all need roses. For Andy Stern and Anna Burger of the Service Employees International Union, whose ideals and struggles extend far beyond their own large parameters of 1.8 million workers; for Nina Shapiro-Perl, cultural partner and lifetime friend; for Wyatt Closs, supporter par excellence; for Michelle Miller and Zoeann Murphy, our future lights.

To Anne Newman Bacal, a gift to us all, who received one hundred donated cameras from Wolf Camera. To Dave Willard at Olympus and to Fuji for more cameras.

To the funny, original staff of Bread & Roses: Judith McCabe, curious and patient, and to Shaila George of unsurpassed grace. To Bonita Savage, Terry Sullivan, William Johnson, and Rytva Soni, a strong and effective team. To 1199 News: JJ Johnson, Belinda Gallegos, Jim Tynan, and Patty Kenney, for being there with us. To Mike Myerson, Jay Sackman, Bruce Richard, Louise Bayer, Jim Crampton, and Richard Levy, for helping us sort out the present and the future. To Kay Anderson for making everything work.

To the late Moe Foner, who brought roses to so many tables alongside the bread. To the other Foners who continue to help us: Anne, Henry, Peggy, Nancy, and Eric.

To Mark Solomon of Philmark, and Laura Tolkow of Flushleft Designs, who added incomparable beauty along the way. To Ed Murphy of the Workforce Development Institute whose plan was large and real. To Charles Ensley and Linda Schleicher, and May Chen and Sherry Kane, for helping bring our workers stories to light.

To Joe Bacal, who has more good ideas than anybody else. To Deni Robey for her generous plans. To Charles Traub for support. To Alfredo Quiles and Time Life who made our first year possible.

To Peter and Noah.

To Writers House, especially Amy Berkower and Michele Rubin, for representing us through so many crises. To David Lerner and Shonna Carter of Riptide Communications, who figured out ways for these pictures to be seen. To Judith Regan, Cal Morgan, Cassie Jones, Daniel Nayeri, and everyone else at ReganBooks who helped make this book real.

The project would not have happened without funding. We are especially grateful to The Nathan Cummings Foundation, Lance Lindblom, Claudine Brown, and Karen Garrett for their generosity, and for joining us. To Rachel Cowan for connecting the dots. To the Ford Foundation and David Chiel for support, enthusiasm, and ideas. To our friends Richard Schwartz, Chairman of the New York State Council on the Arts, and Len Detlor of the New York City Department of Cultural Affairs, thank you for coming to so many exhibits, and for helping us so often. Thank you to the many other funders: The 21st Century Fund, The Shelley and Donald Rubin Foundation, Con Ed, The Puffin Foundation, and to so many anonymous donors. Thank you from the bottom of so many hearts.

CONTENTS

Introduction by Esther Cohen xiii

WORK
1

LEISURE
51

COMMUNITY
91

FAMILY
153

Appendix 195

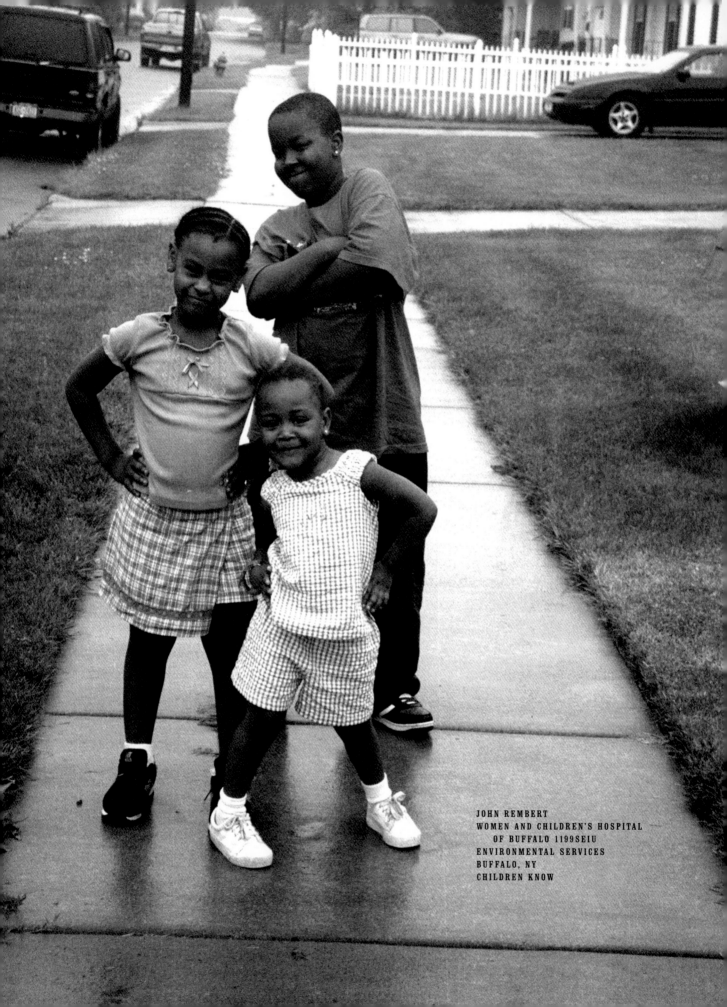

JOHN REMBERT
WOMEN AND CHILDREN'S HOSPITAL
OF BUFFALO 1199SEIU
ENVIRONMENTAL SERVICES
BUFFALO, NY
CHILDREN KNOW

INTRODUCTION

At the start of every unseenamerica class, we talk about what seeing means. Students always ask me to begin.

I saw so much as a child, but the world I lived in told me that what I was seeing wasn't really there. My family lived in Ansonia, a small factory town in Connecticut precariously abutting the Naugatuck River, a river that didn't meander the way some do in novels. Like our town, it hobbled along. Lives were mostly hard, and I never once had the thought that I was going to leave for college and come back to make life better there. I just wanted to leave, to live in a place that was more interesting, more fair.

People didn't see one another much in Ansonia. An Irish Italian African-American Polish place, communities were tribal and self-contained. My family was Jewish. My father and his brother owned a store on Main Street called Oscar Cohen's. Men's clothing and family shoes. Our social world was centered around the Beth Israel Synagogue Center in Derby, the next town over, where a few hundred Jewish families shared their lives. Bas Mitzvahs, anniversaries, funerals. We Jews grew up together. We were more alike. The kids all went to college, as did some of our parents.

I sometimes wonder if they'd all seen too much, or heard too much, because of the Depression and World War II, because of anti-Semitism and the difficult lives their families had.

Neither of my parents was prone to logic. My father, a Talmudic man of myriad contradictions, was the son of Eastern European immigrants. He studied premed at Cornell, and intended to go to Yale medical school, a few towns away from Ansonia. He was told at his interview that the Jewish quota was full. This sentence marked him. He refused to go anywhere else. He moved to New York and worked for Merrill Lynch until his father got sick and he returned to Ansonia to run the family store. He never liked it, and he never left, either.

My mother, a glamorous, chain-smoking dancer, bridge player, and one-time date of Clark Gable (all she said was that his teeth were capped) was born in Grand Forks, North Dakota, of Roumanian parents who snuck across the Canadian border through Winnipeg. She and her mother moved to New Haven when her younger sister went to Yale to study biochemistry. My parents met through a

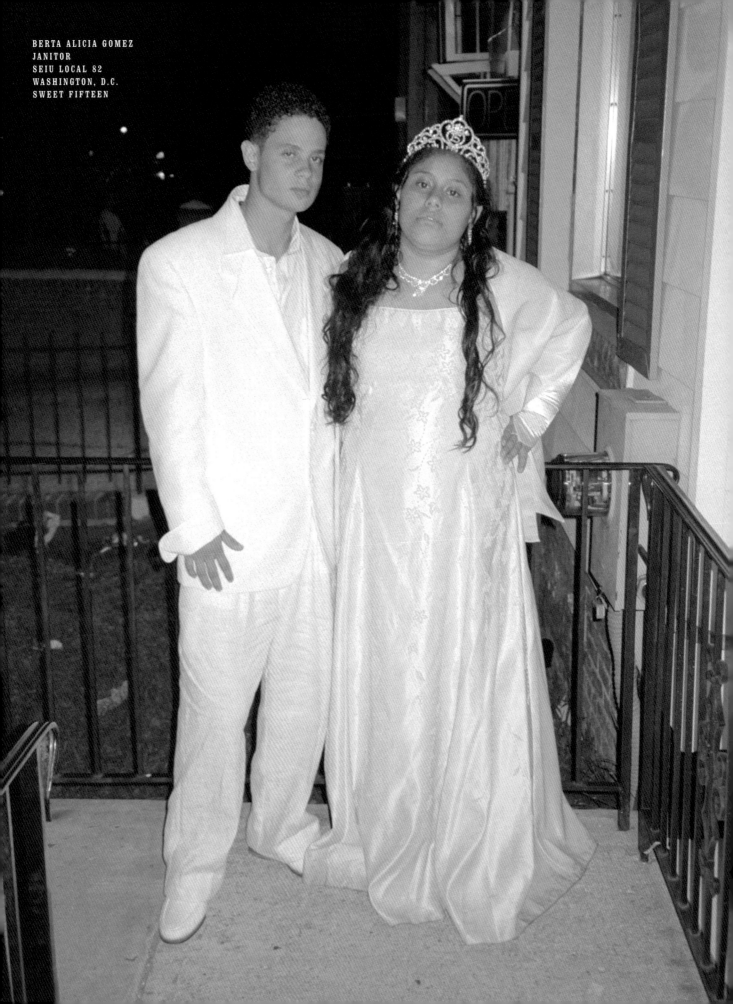

BERTA ALICIA GOMEZ
JANITOR
SEIU LOCAL 82
WASHINGTON, D.C.
SWEET FIFTEEN

friend of my father's who sold scrap metal. (They were an unlikely pair, and happy enough.) Bridge players, they led a careful, quiet life.

I don't know why, but as a child I was drawn to the unknown. Let's invite someone over who we don't know anything about: Italians, or African Americans, a Catholic priest, a factory worker, an Irish immigrant, the Polish family down the block. The answer was always no—the peculiar reason I was given was always more or less the same: *they don't like us*. While it was true I had not been invited to birthday parties of most of my classmates because I was Jewish—one girl said Jews were even worse than Italians—it did not seem to me like a very good reason for us to do the same.

My own world felt far too small. I knew I had to leave Ansonia to make it bigger, so I went to George Washington University in Washington DC, because it was in a city and because the school had a large population of foreign students.

Life in college was mostly social, with art, politics, and music. For the first time in our lives, my friends and I could spend days and weeks and months together telling stories and making each other laugh. Music—the James Brown beat—emphasized our own frantic energy and excitement. None of us thought too much about careers, or the paths our lives would take. All we knew was that we were not our parents, listening to Perry Como and "Autumn Leaves." It was the late sixties. Life was extreme. We went to rallies, demonstrations, lectures by impressive visionaries who talked about better worlds.

After college, I joined a volunteer group that traveled to Israel to work for a year. I didn't know much about Israel. We had relatives there we never saw. I knew about the wars, about Ben Gurion and Golda Meir, about the blooming desert and victories one after another.

Our group of ninety volunteers settled in modern apartments on top of the ancient holy city of Nazareth. Below were winding streets with camels, donkeys, and a lavish church in the center. I took the bus to Lower Nazareth on the very first day and stayed there for three months. It's a mysterious place, intensely alive and dynamic in a way I'd never seen. I encountered gentle Palestinians who had lived there forever. But I knew so little about them: who they were, how they lived, what they wanted, what they wrote about in their poems. Palestinians were as fascinating as Jews, or Druze, an ancient people who would pass down their stories to one another, or the Armenians in their immaculate, walled off Jerusalem quarter, or the Copts, or the many others I saw for the first time.

In so many ways, those months helped shape my life and added to my belief that there's so much in the world around us we just never see. I became conscious of what I hadn't seen and what I didn't know.

The seventies floated by in a kind of orange haze. It was an odd time in America, when many of us who were young and middle class were given the peculiar chance to continue our youth for a while. I worked, but not in a career. I tried to earn my living in a way that connected me to what I believed. My apartment was cheap, and I could afford to work where I wanted. Through a friend, I got a job as an editor in a small publishing house, The Pilgrim Press. My boss, Paul Sherry, a Protestant minister who had studied with Reinhold Niebuhr, asked me what I wanted to publish. I said I wanted to publish books by and about people who didn't have a voice. So that's what we did: books about homeless women, death row inmates, teenagers from Lombard, Illinois. We exposed the world to people who didn't get many chances to tell their stories.

Paul introduced me to scores of people. One of the most impressive was Moe Foner, a labor leader. Moe worked for a union called 1199 that represented people who work in hospitals. At the time I knew very little about unions. Of course, Moe saw that as an intolerable error that he immediately corrected. We worked together on three books about working people when I was at Pilgrim Press. He had a famous Rolodex of people he had met: celebrities, politicians, journalists, artists of all

kinds, friends, children of acquaintances, labor leaders, foreign dignitaries, funders, disciples. He called them all, and often, to say hello, to ask for advice, to hear a story or tell one, to ask for money. For many of us, he became a telephone fixture, a guiding light.

Moe ran a cultural program for the union called Bread & Roses, named for a strike in Lawrence, Massachusetts, in 1912 where picketers carried signs that said "We want bread, and roses too." Moe brought well-known activists and artists like Martin Luther King Jr., and Ossie Davis and Ruby Dee into the union world, to speak to workers, join protests, and to perform.

About ten years ago I started working for Moe at Bread & Roses. For the second time in my life, I felt I was suddenly seeing people I hadn't truly seen before: low-wage workers, mostly women of color, who performed a range of jobs in hospitals and nursing homes. People who helped others through many of the most difficult periods of life and death. They worked with their hearts though they were often paid very little.

I started teaching a free, union-sponsored creative writing class called Workers Write, in which members told their stories through poetry and prose, and read novels, essays, stories, and poems. Many of them had several jobs and would travel on subways and buses for over an hour each way just to spend time in our classroom.

The students were full of life stories. Tanvir was from Pakistan. When she was fifteen, her family arranged for her to marry a wealthy older man. She did not see him until her wedding day. Her husband was condescending and abusive. He kept her largely sequestered, unable to work or to learn. She had three children, one right after another. She learned English from a book her driver had loaned her, and with his help and the help of a few female friends, she borrowed money, grabbed the children, and flew to New York where she started her life all over again. Living on her own in Queens, she got a job in a hospital, joined the union, and took part in their free educational program. She went to college and became a social worker. Her children studied too, eventually becoming a doctor, a lawyer, and a computer programmer.

Dorothy was a woman in her sixties born in the Caribbean. Although she worked two jobs during the week, cared for an elderly man on weekends, and raised her children on her own, she still traveled two hours each week to get to class. Dorothy wrote children's stories about bees based on people she knew. Her bees could sing and make love. Their honey had a flavor that she described for pages.

It didn't seem enough that I alone hear their stories. I began to consider how it might be possible to have more voices heard. And how we could link these stories and these lives to the millions of others in our society who have unknown lives to share.

A volunteer in our office, Anne Newman Bacal, walked into a new camera store in her neighborhood and asked the clerk to donate cameras to workers. He did. Anne brought one hundred cameras into our office and it seemed like the answer to a question we hadn't yet asked. No matter where you come from, or what your literacy level, you can learn to take a picture. Given these cameras, and classes taught by volunteer photographers and writers, people could learn to describe their lives through pictures and words.

We decided we would give twelve-week classes to some sample groups, to see how it all went. We made a long list of groups we wanted to know more about. Some were in unions, some weren't: day laborers on Long Island, garment workers in Chinatown, Filipino nannies, building workers, and hospital workers of all kinds. The process is not the usual bug-in-the-jar approach, with experts arriving to unfamiliar territory: photographers, anthropologists, sociologists, economists, professional writers looking around, interpreting what they see. (I don't like words such as "empowered." It sounds too

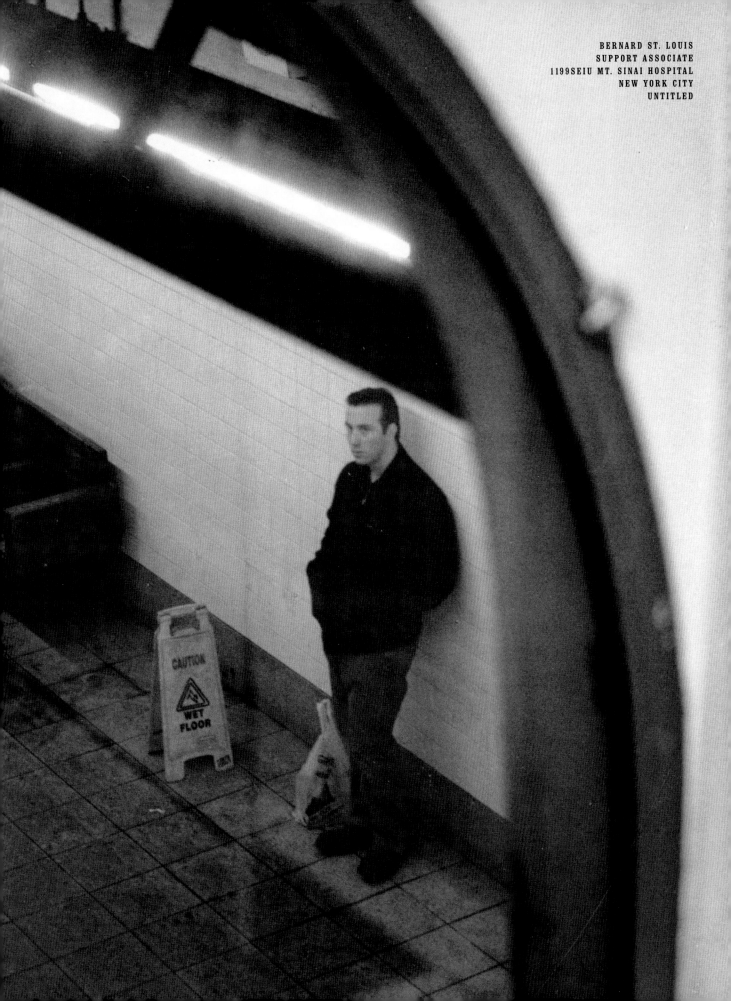

BERNARD ST. LOUIS
SUPPORT ASSOCIATE
1199SEIU MT. SINAI HOSPITAL
NEW YORK CITY
UNTITLED

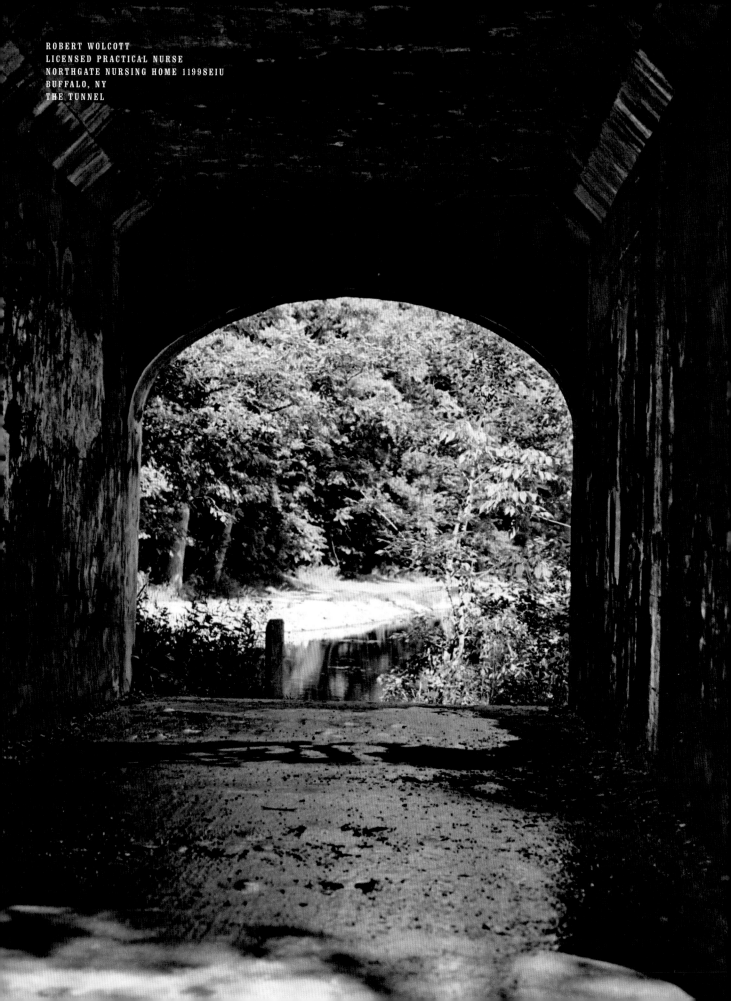

ROBERT WOLCOTT
LICENSED PRACTICAL NURSE
NORTHGATE NURSING HOME 1199SEIU
BUFFALO, NY
THE TUNNEL

much as though a battery's being recharged. But it's the right word for this program, which gives many the voice in society they deserve, and we all deserve to hear.)

The photographers represented here are people who make up the very fabric of our lives: taking care of the sick, working in restaurants, picking fruit, building roads, maintaining buildings, sewing clothes, working in offices, helping children, washing dishes. Like the Federal Writers Project, a program of Franklin Roosevelt's Works Progress Administration that set out to "write down America," *unseenamerica* shows the strength of this country in its diversity. A strong national culture holds countless different visions—voices of all pitches from the myriad of jobs, experiences, and perspectives that make up our society. Pictures, spontaneous and accessible, capture those visions in unexpected ways. They are not cynical or ironic. They do not manipulate or trick. They are not self-conscious or self-righteous. They do not exclude, or imply, by the way they're shot, or by the way they're hung, that these images are only for a well-informed few, for people who believe they know how to see. They are not selling a product or advocating anything except their own humanity.

For the first meeting of each class, I'd show up with stacks of popular magazines and ask the students to try to find themselves in the stories and pictures. I'd do the same exercise with other forms of popular culture, such as television and movies. Hospital workers often mentioned that they were missing from all the doctor shows on TV. Other workers also had difficulty finding themselves.

The culture of the students played a major role in each class. Chinese students, for instance, explained how they had been raised to photograph only happy moments: birthday parties, weddings. Without these occasions, they said, there was nothing to capture. After some weeks, this changed. A retired garment worker, a former presser, took a picture of a bus in the snow filled with workers who had traveled from Philadelphia to New York to join a demonstration. He explained that he had tried to capture a cold day and the warm hearts inside the bus. He told us he now understood that happiness takes many forms.

The images and captions were often unexpected, offering brief, startling glimpses into lives we rarely see and, sadly, know so little about. A mother photographed her twenty-one-year-old son's haircut because she'd held two jobs and never had the chance to get a picture of his first one. An innocent looking photograph of a Central Park horse and buggy had the explanation "I feel just like the horse."

In the three years since we started, many people have joined us: steel workers, social workers, Head Start employees, autistic adults and children, Lakota Sioux, Oaxaca fruit pickers, immigrant workers from all over the country, public employees, janitors, retired Jews on the Lower East Side, blind teenagers in Nashville, Afghan women in Queens.

Our first exhibition of *unseenamerica* opened at the Bread & Roses gallery, a small, imperfect room on the first floor of the union's headquarters, near Times Square. (A gallery, like a poem, can be anything and anywhere. Our space, though inelegant, with rough walls and spotty lighting, is transformed eight times a year. Without art, it's just a small lobby room.)

We've had over three hundred classes and exhibits so far—large and small—in libraries, restaurants, high schools, colleges, community centers, city halls, and museums. The U.S. Department of Labor hosted an exhibit in Washington DC, and U.S. embassies around the world have also asked to show these photos.

There are infinite stories to show and tell: poultry workers, Laotian meat packers in Omaha, Uzbekistani immigrants in Queens, Haitians in Florida, California farm workers, Iraqi students, Korean manicurists, Arab gas station workers, Israeli limo drivers, Bosnians in Utica, Cambodians in Maine. . . .

We're all just beginning to see.

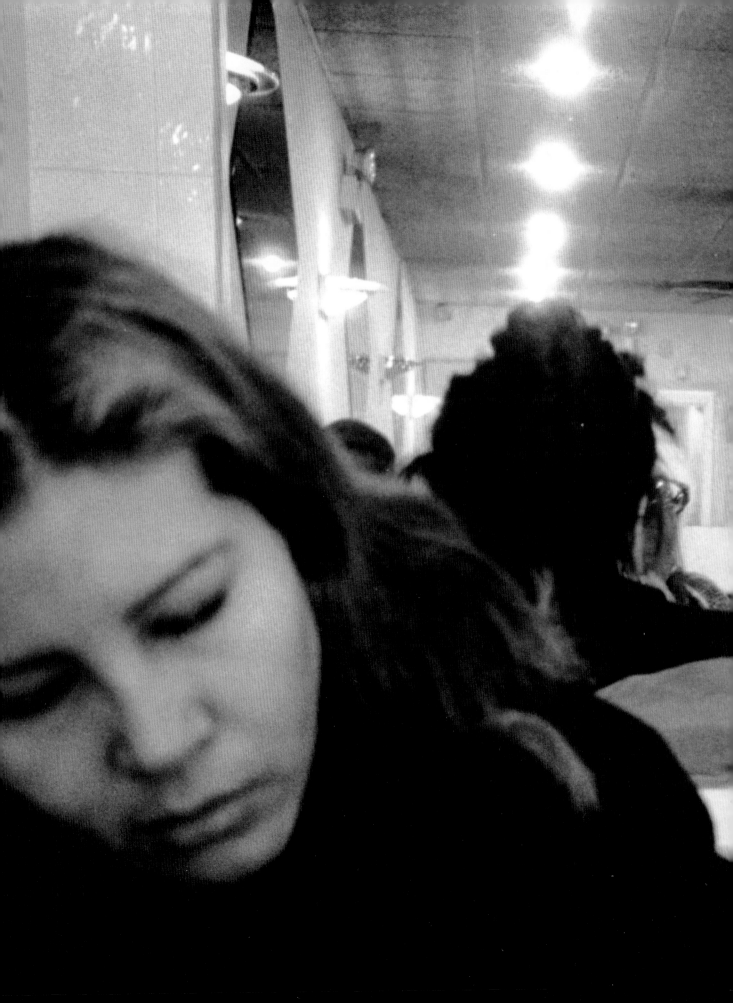

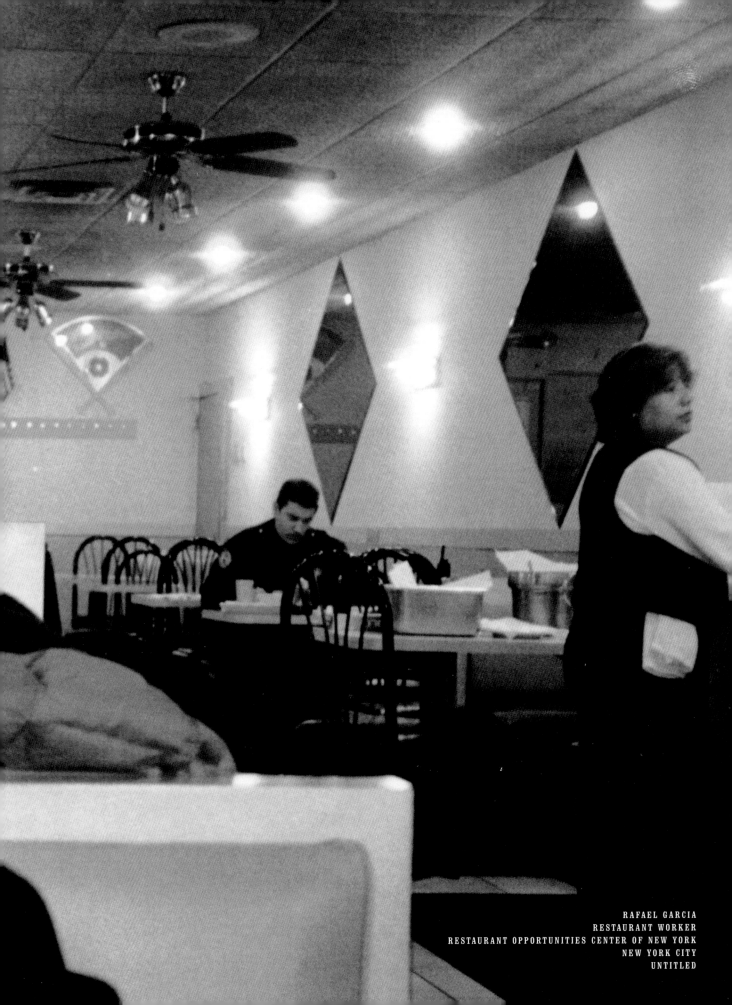

RAFAEL GARCIA
RESTAURANT WORKER
RESTAURANT OPPORTUNITIES CENTER OF NEW YORK
NEW YORK CITY
UNTITLED

WORK

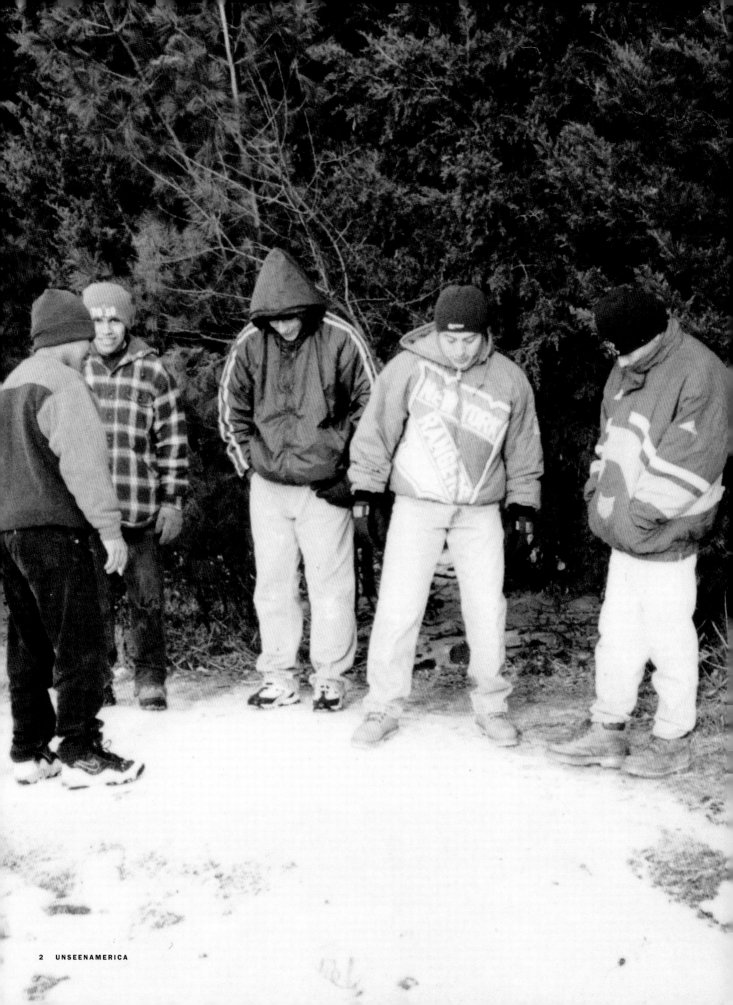

ANONYMOUS
DAY LABORER
WORKPLACE PROJECT
LONG ISLAND, NY

WAITING FOR WORK

We have built so many houses and fixed
so many streets throughout Long Island
and throughout this country that we
deserve to be treated as human beings.

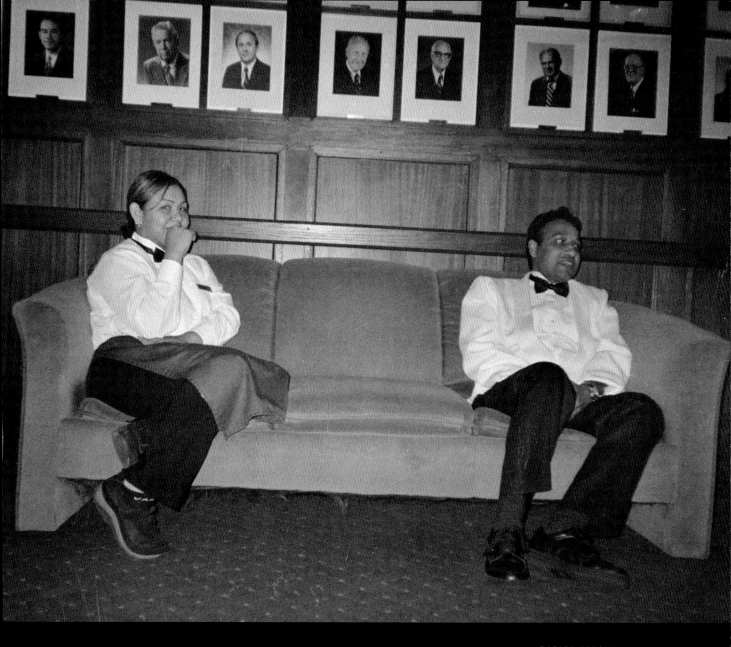

RAFAEL GARCIA
RESTAURANT WORKER
RESTAURANT OPPORTUNITIES CENTER OF NEW YORK
NEW YORK CITY

TWO ON COUCH

After setting up the main dining room, we took a break in the "Governor's Room," where they have pictures of former presidents of the club. It was funny for us to relax surrounded by all these photographs of important people. My coworkers, Jose and Brenda, are resting on a couch usually reserved for guests.

My coworker is always checking my work to make sure everything is clean. He wants everything to be absolutely perfect on the job.

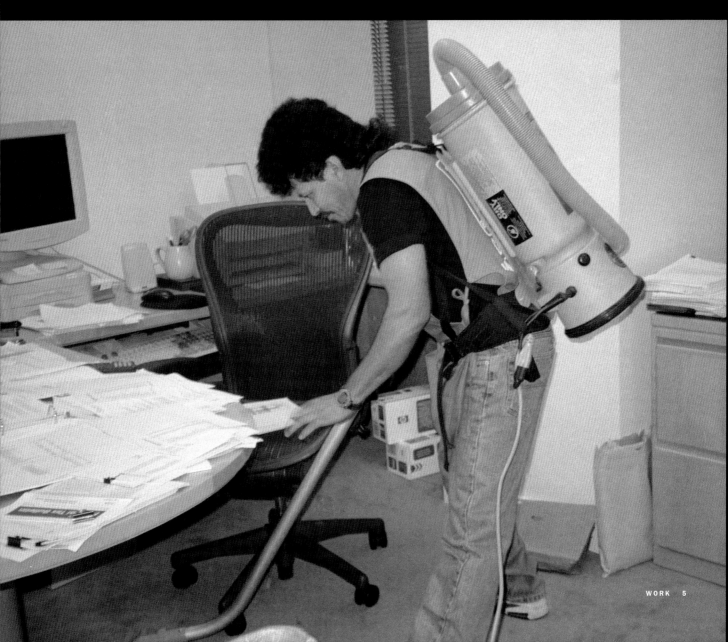

CINDY LEUNG
SEAMSTRESS
LOCAL 23-25 UNITE HERE
NEW YORK CITY

SHOEMAKER

When I first arrived from Hong Kong, I was lost
and felt like a stranger. I started working in a
garment factory in Chinatown, but I knew nothing
about sewing. I had worked in making wigs in
Hong Kong. I joined the union and now Local 23-
25 has become my second family. I have gotten
to know my friends through their many activities,
such as the English classes and the chorus.

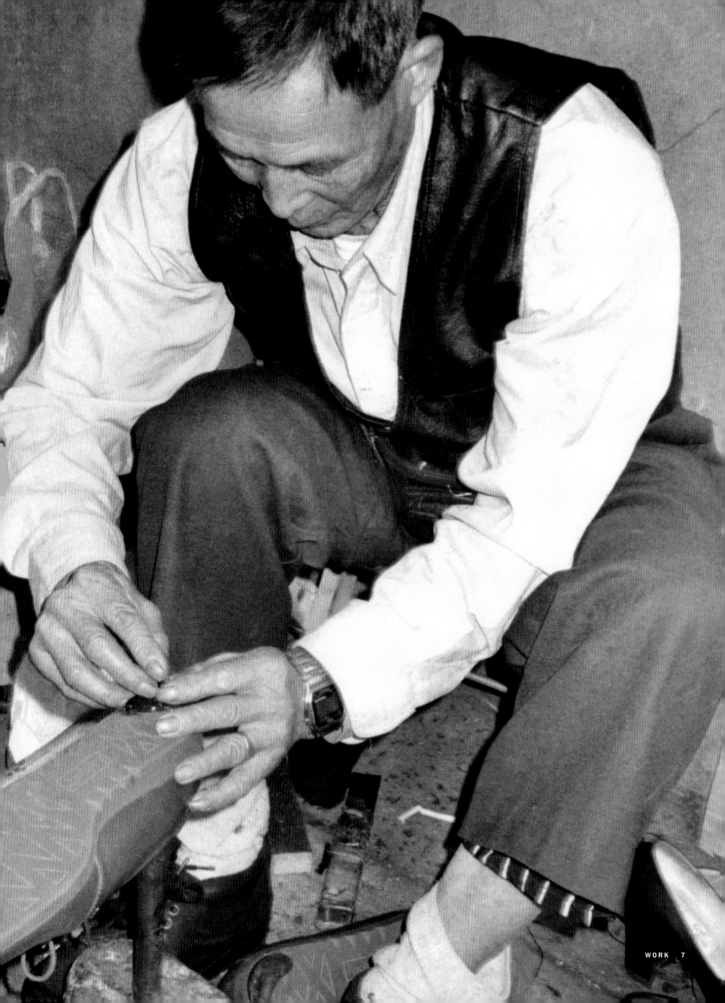

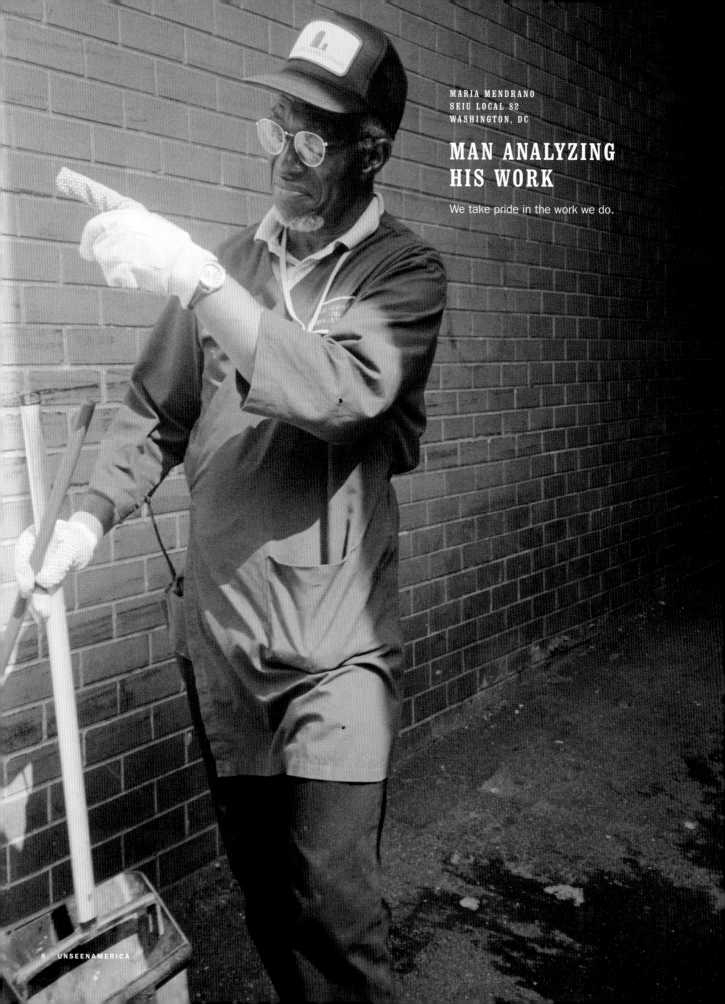

MARIA MENDRANO
SEIU LOCAL 82
WASHINGTON, DC

MAN ANALYZING HIS WORK

We take pride in the work we do.

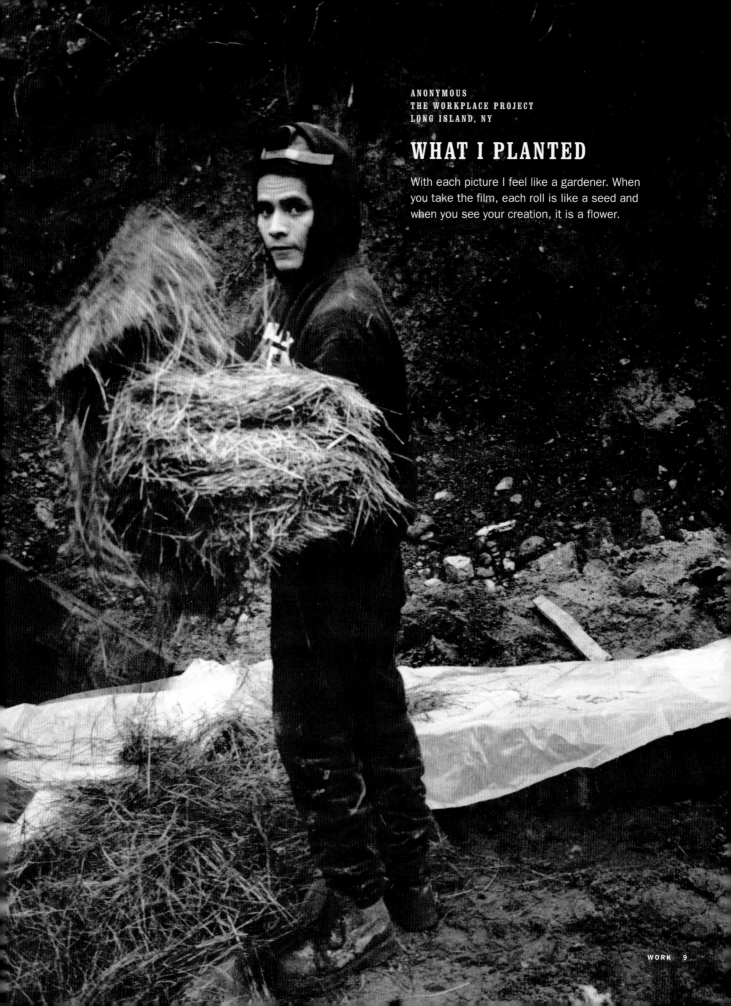

ANONYMOUS
THE WORKPLACE PROJECT
LONG ISLAND, NY

WHAT I PLANTED

With each picture I feel like a gardener. When you take the film, each roll is like a seed and when you see your creation, it is a flower.

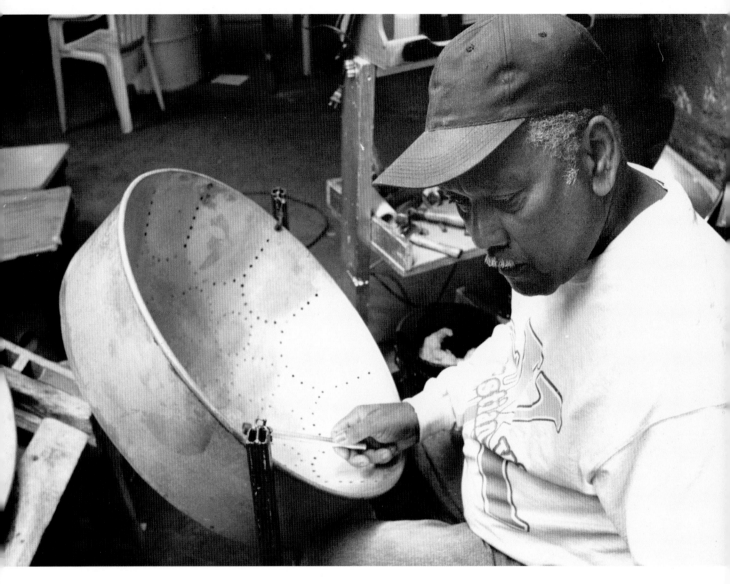

BLASÉ ALLEYNE
ENVIRONMENTAL SERVICE WORKER
1199SEIU
MARY MANNING WALSH NURSING HOME
NEW YORK CITY

STEEL DRUMS

I chose this photograph because I wanted to give my friend, Austin Wallace, something to remember him by if he retires from playing. He does magic on this musical instrument.

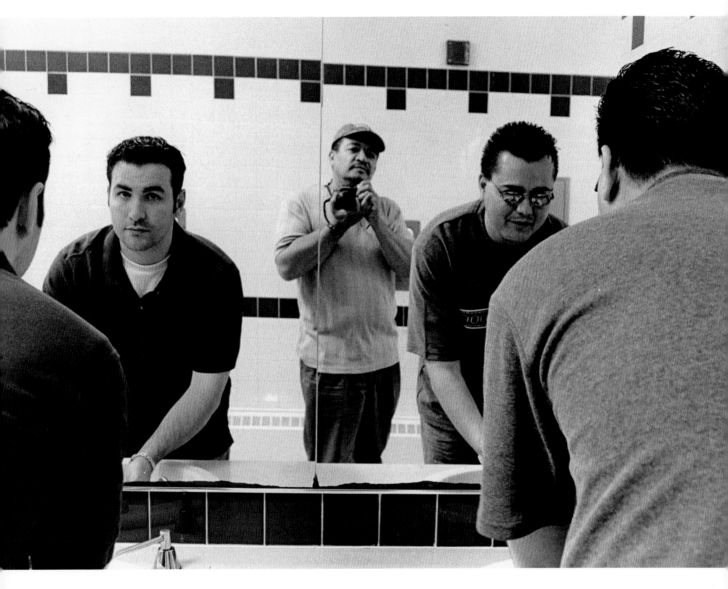

HECTOR AUSTIN
ASSOCIATE FRAUD INVESTIGATOR, ELIGIBILITY VERIFICATION AND REVIEW
SSEU LOCAL 371 AFSCME
NEW YORK CITY

THREE MEN IN RESTROOM

This was taken at a rest stop off of I-95, on the way to the New York Welfare Fraud Investigators Conference. I'm in the picture with two other investigators. I really admire these two guys. It was an impulse to get them together and get myself in the picture, too.

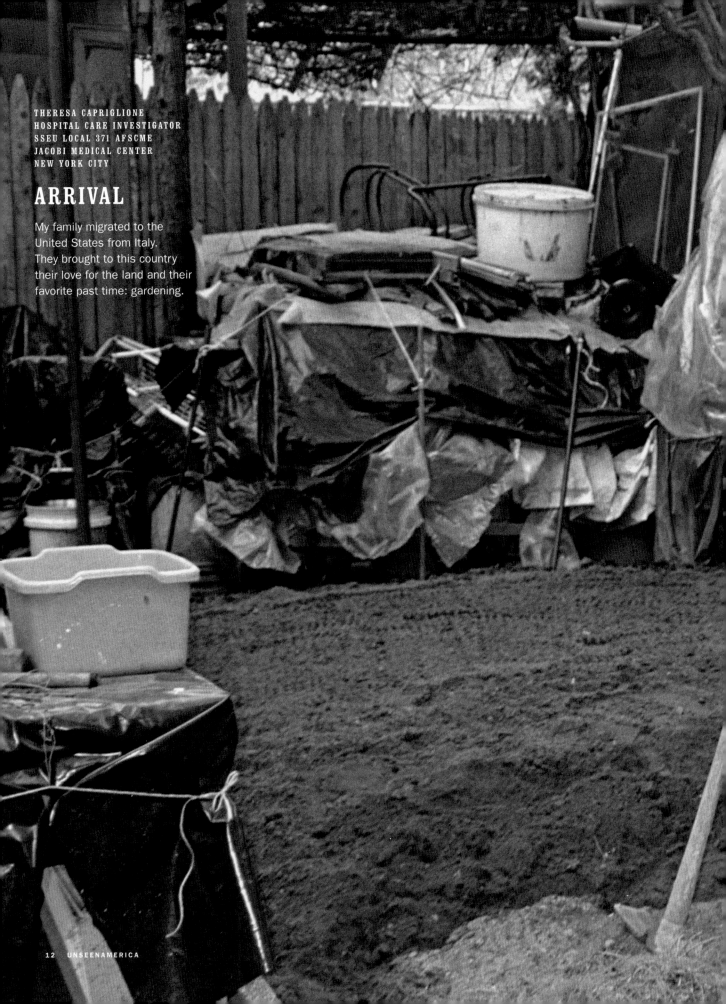

THERESA CAPRIGLIONE
HOSPITAL CARE INVESTIGATOR
SSEU LOCAL 371 AFSCME
JACOBI MEDICAL CENTER
NEW YORK CITY

ARRIVAL

My family migrated to the
United States from Italy.
They brought to this country
their love for the land and their
favorite past time: gardening.

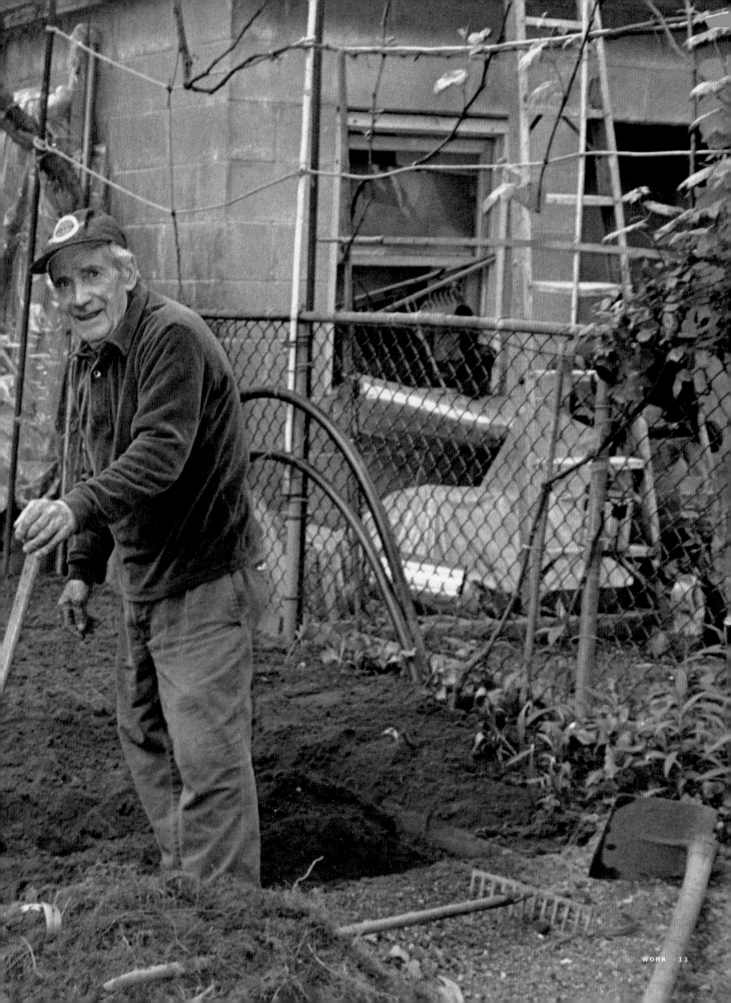

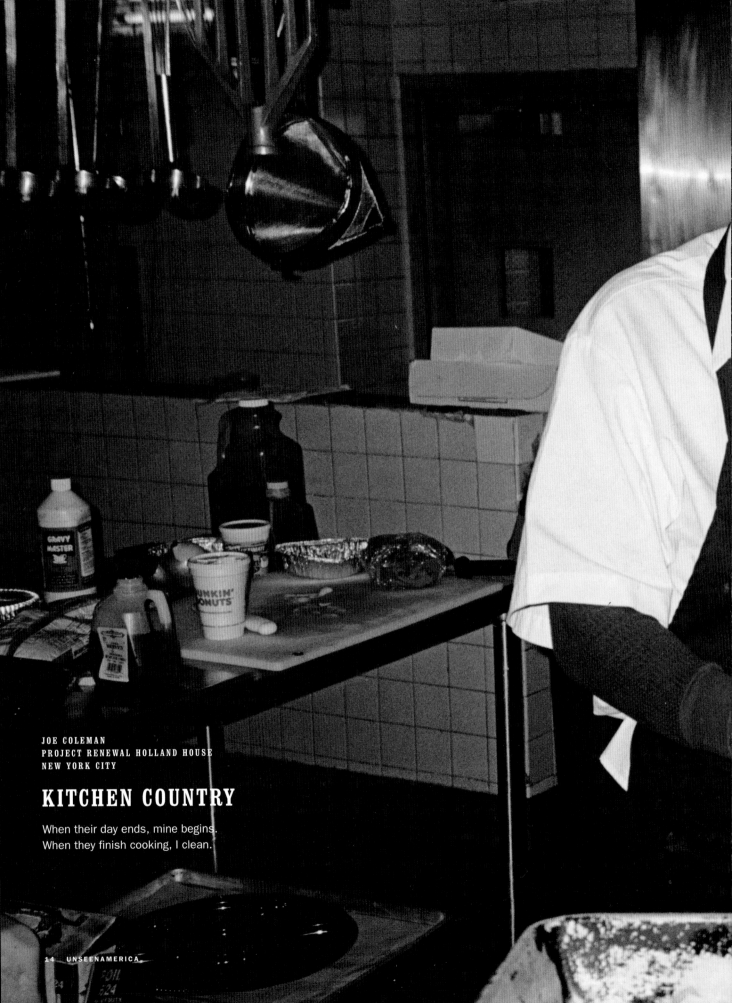

JOE COLEMAN
PROJECT RENEWAL HOLLAND HOUSE
NEW YORK CITY

KITCHEN COUNTRY

When their day ends, mine begins.
When they finish cooking, I clean.

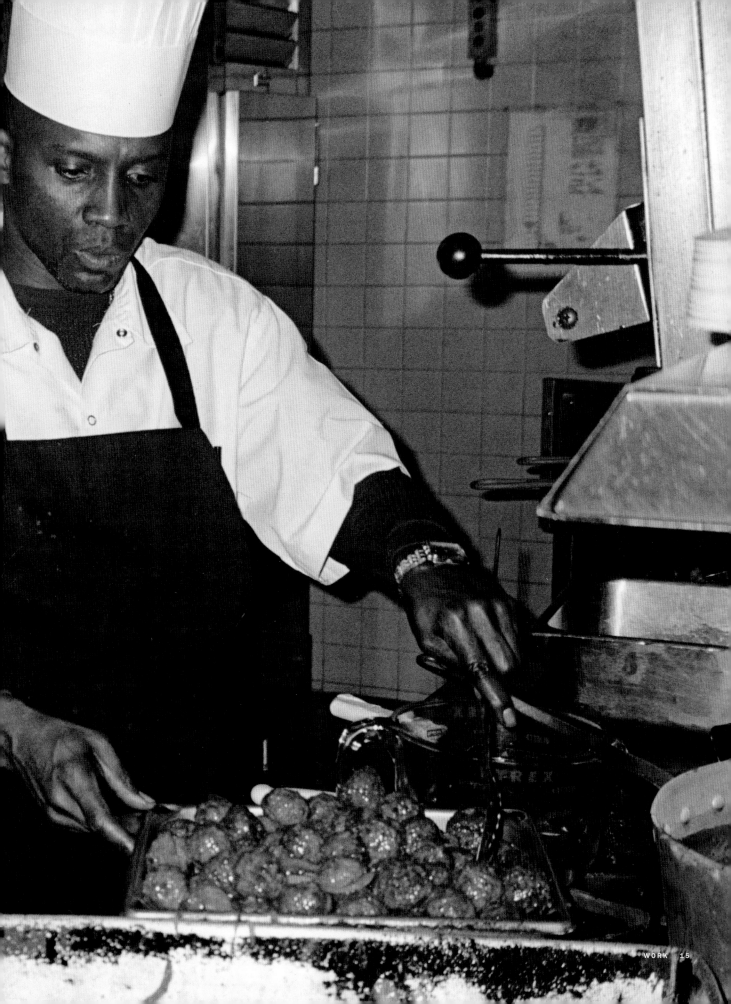

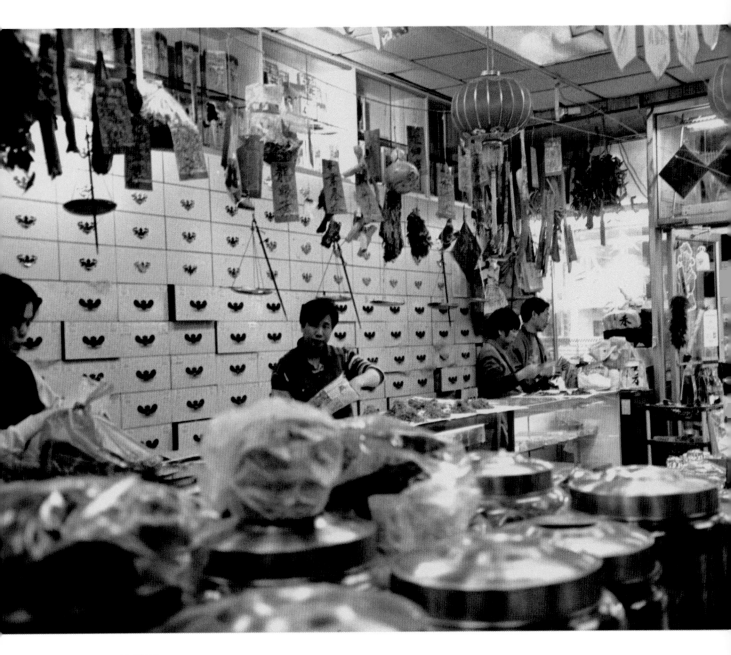

CHI LING TANG
GARMENT WORKER
LOCAL 23-25 UNITE HERE
NEW YORK CITY

CHINESE HERB STORE

Chinese herbs have been used to cure diseases, save people, and keep us healthy for thousands of
years. These plants can do many things. All of the little drawers on the wall are filled with different
Chinese herbs.

SAMUEL CONTRERAS
BUILDING MAINTENANCE WORKER
SEIU LOCAL 32BJ
NEW YORK CITY

LOBBY

There's a whole second part, a second soul to everybody here that nobody seems to know about. Unfortunately, a lot of people will assume that you are what your job is: taking out garbage or fixing plumbing. They don't realize that there's an artful soul to every one.

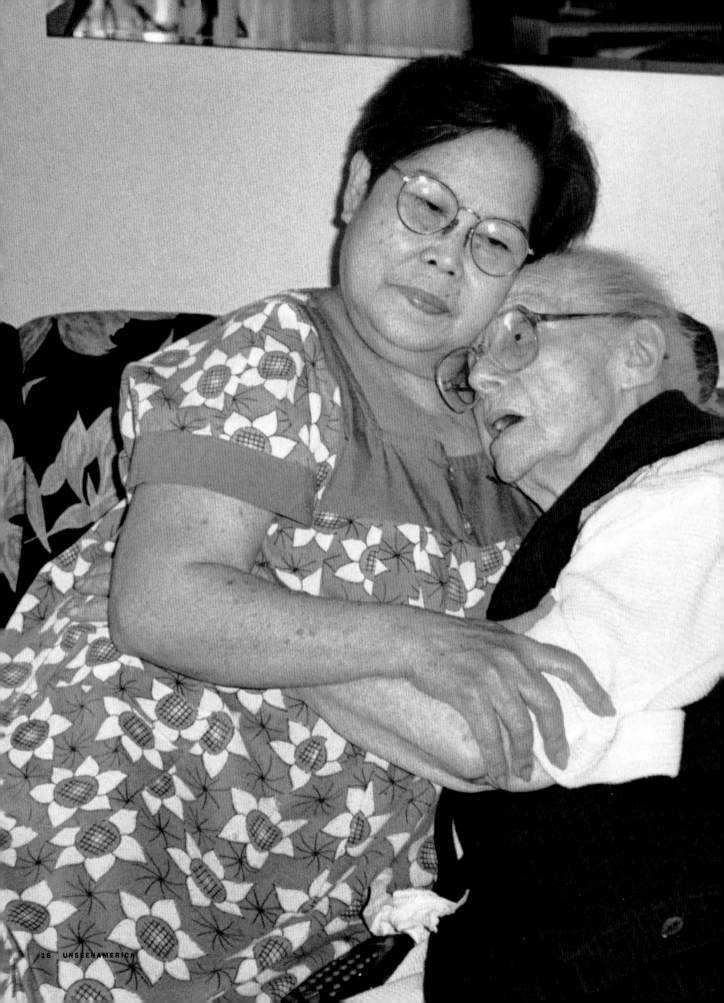

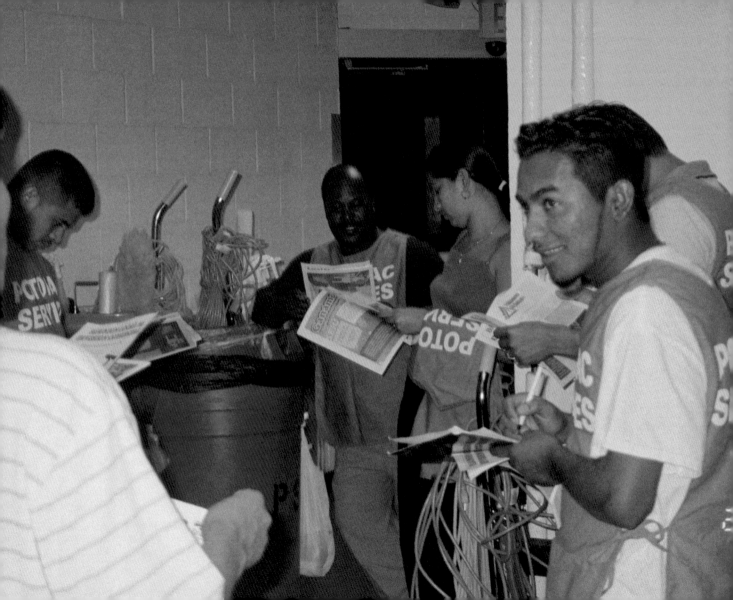

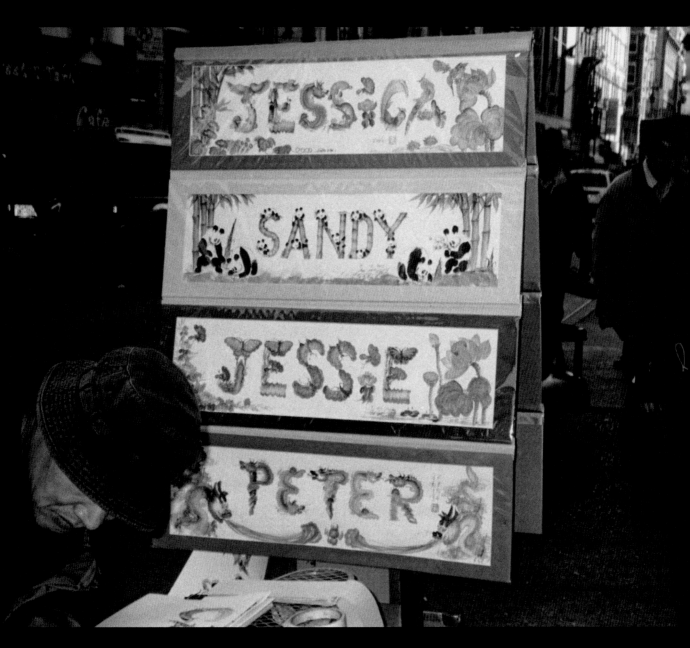

MEI YIN LEE
GARMENT WORKER
LOCAL 23-25 UNITE HERE
NEW YORK CITY

STREET ARTIST

A street artist selling his art on Mott Street. To me, this shows the ability of immigrants to use their traditional skills to survive in their new society.

SUZANNE WALTZ
PEF 202
SAFETY & HEALTH
ALBANY, NY

MOTHER AND CHILD REUNION

Ruth Post is a full-time working woman at the New York State Department of Labor. Here, she shares a moment with her daughter, Morgan, who is enrolled in the on-site day care program.

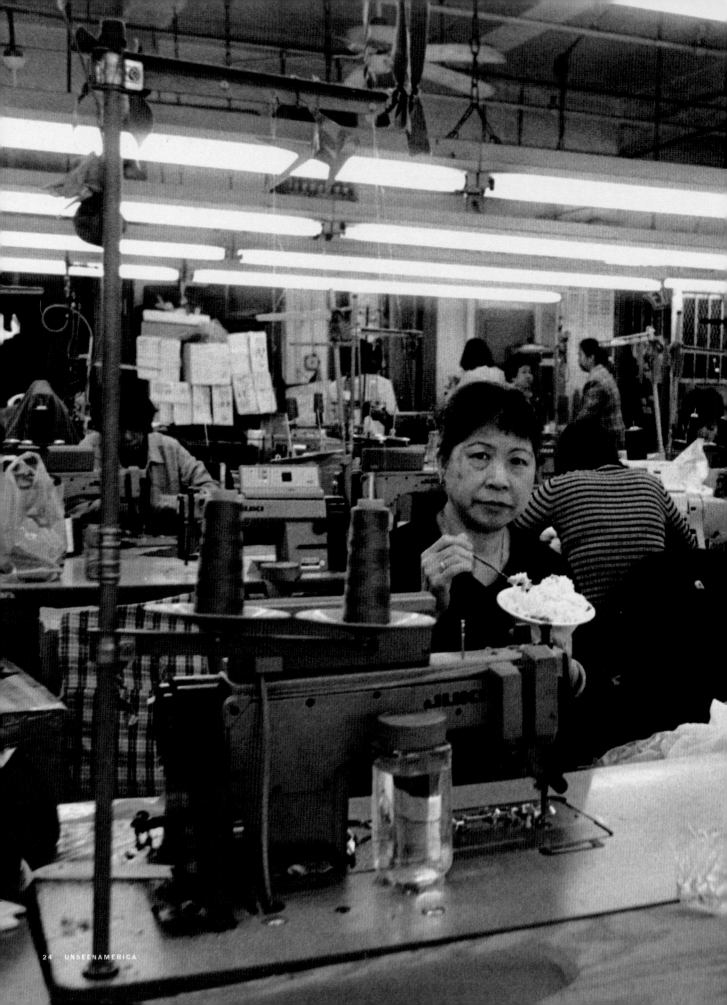

BONNY LEUNG
SEAMSTRESS
LOCAL 23-25 UNITE HERE
NEW YORK CITY

WOMAN AT SEWING MACHINE

Most of us eat our lunch at our workstations. We make skirts and pants in our factory.

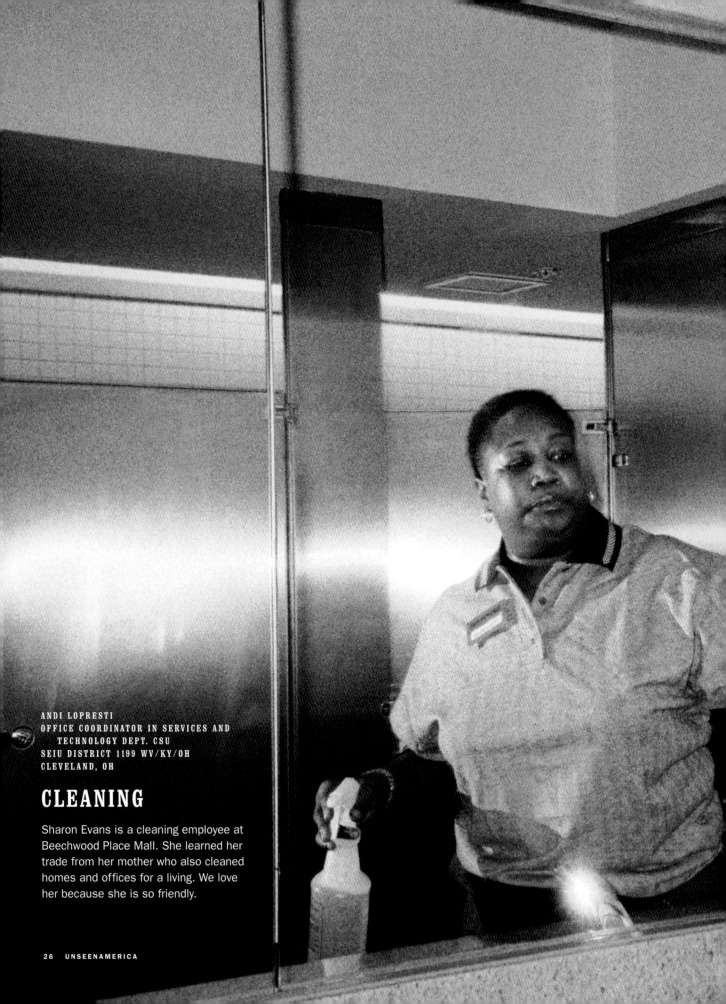

ANDI LOPRESTI
OFFICE COORDINATOR IN SERVICES AND
 TECHNOLOGY DEPT. CSU
SEIU DISTRICT 1199 WV/KY/OH
CLEVELAND, OH

CLEANING

Sharon Evans is a cleaning employee at Beechwood Place Mall. She learned her trade from her mother who also cleaned homes and offices for a living. We love her because she is so friendly.

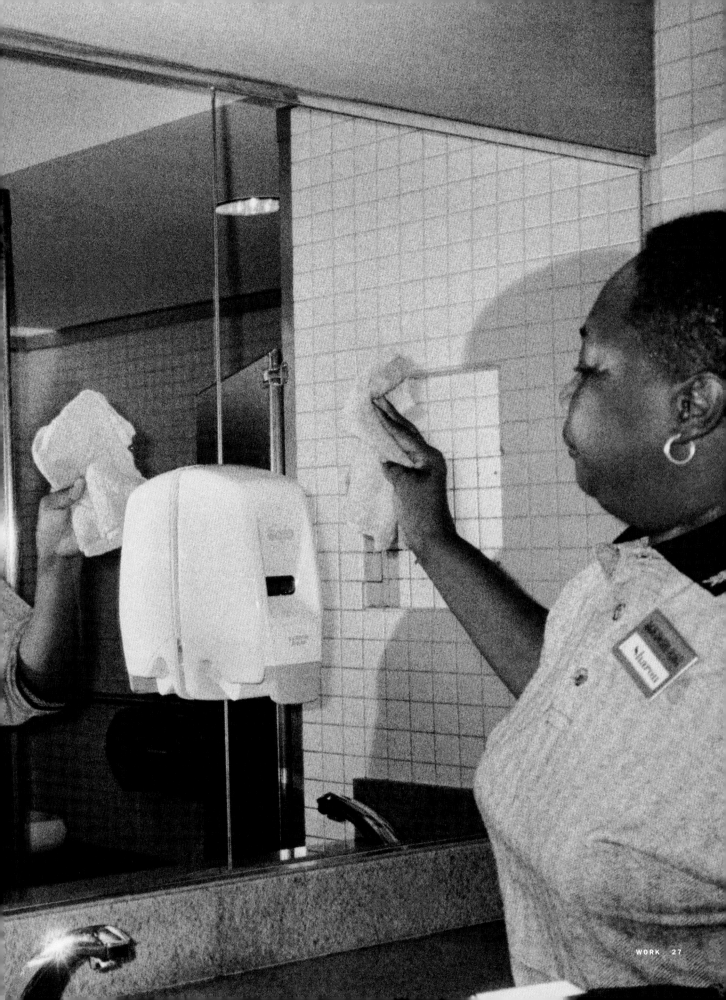

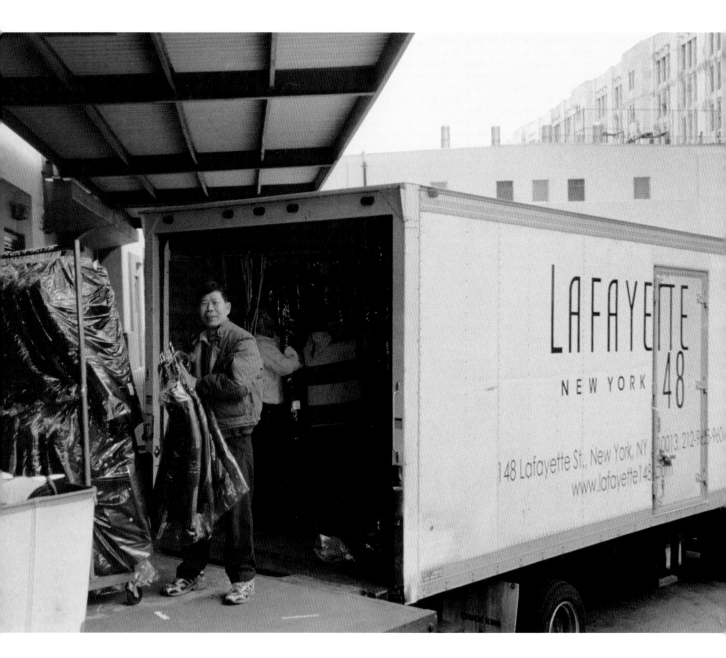

ZU RONG LI
TRUCK DRIVER
LOCAL 23-25 UNITE HERE
NEW YORK CITY

TRUCK UNIFORM

My company makes uniforms for American soldiers and we work for the government. I feel patriotic about my new country.

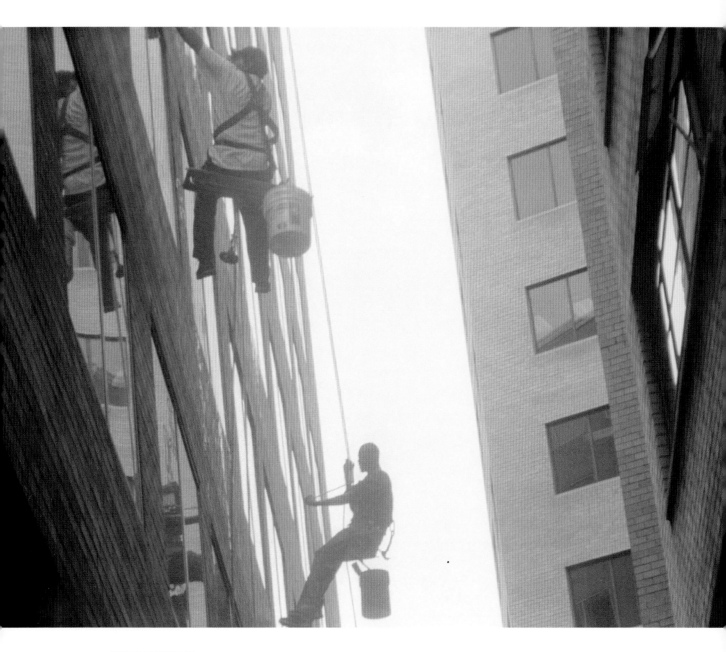

MARIA MENDRANO
BUILDING EMPLOYEE
SEIU LOCAL 82
WASHINGTON, DC

MEN WORKING

Every day they must risk their lives just to have a job. They must have faith that nothing bad will happen, that God will protect them.

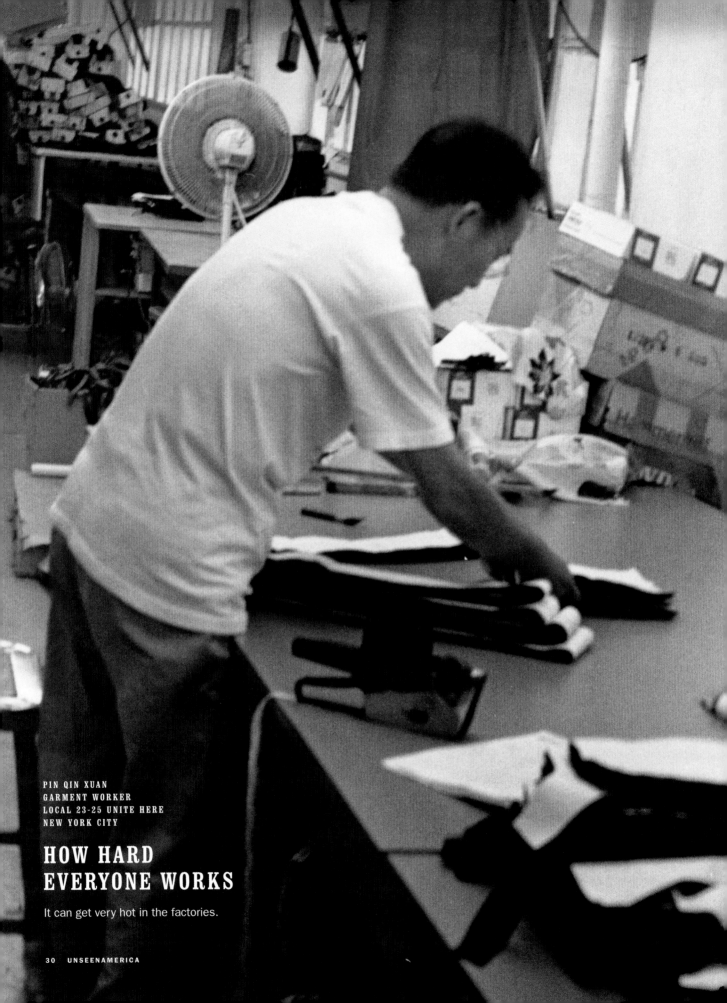

PIN QIN XUAN
GARMENT WORKER
LOCAL 23-25 UNITE HERE
NEW YORK CITY

HOW HARD
EVERYONE WORKS

It can get very hot in the factories.

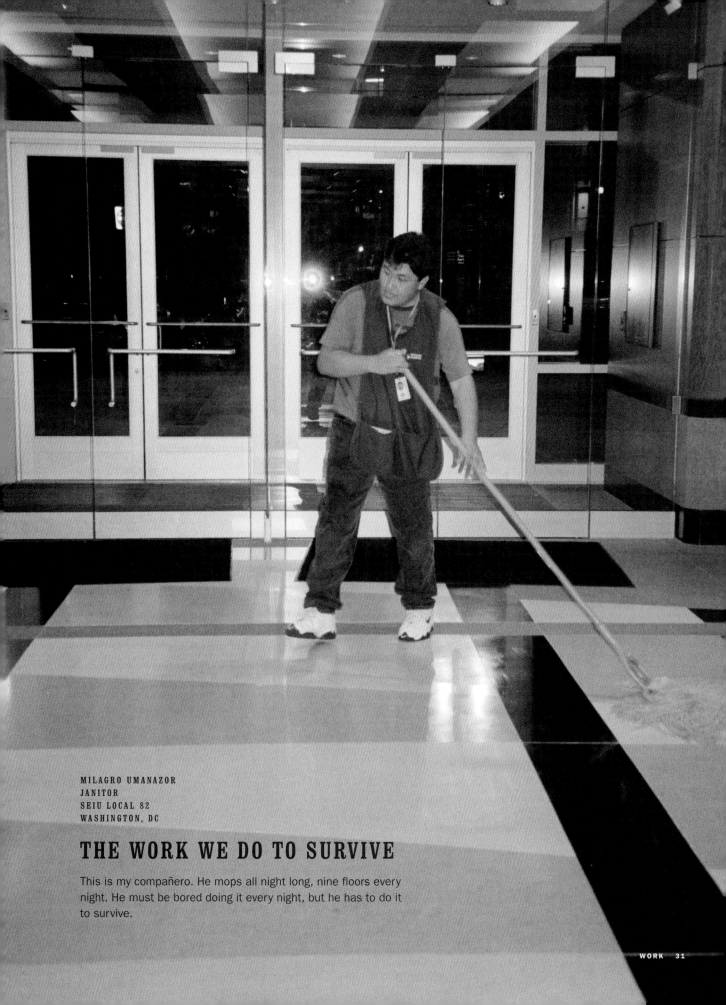

MILAGRO UMANAZOR
JANITOR
SEIU LOCAL 82
WASHINGTON, DC

THE WORK WE DO TO SURVIVE

This is my compañero. He mops all night long, nine floors every night. He must be bored doing it every night, but he has to do it to survive.

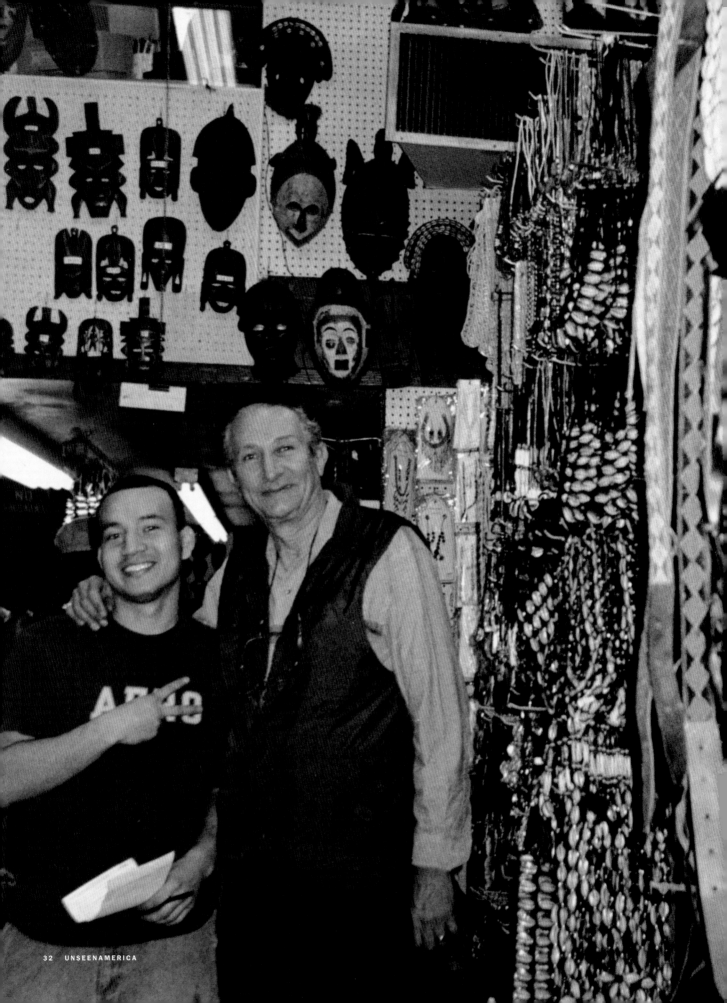

ADRIANA PAULIAN
PROJECT EZRA
NEW YORK CITY

UNTITLED

The older gentleman, Jaime, whose ancestors traveled from Syria to the jungles of Brazil and now live in New York, is world renowned. He is a famous artisan trader of many continents dealing with African, Indian, Chinese, and American works. He does not realize his contribution to the international culture exchange.

YVROSE SALOMON
MEDICAL TECHNOLOGIST
1199SEIU
NEW YORK PRESBYTERIAN HOSPITAL
NEW YORK CITY

UNTITLED

It was a cold Sunday morning. I was walking home from mass. Everybody was resting, everything was closed, but there's this man with his broom, working. So I zapped him.

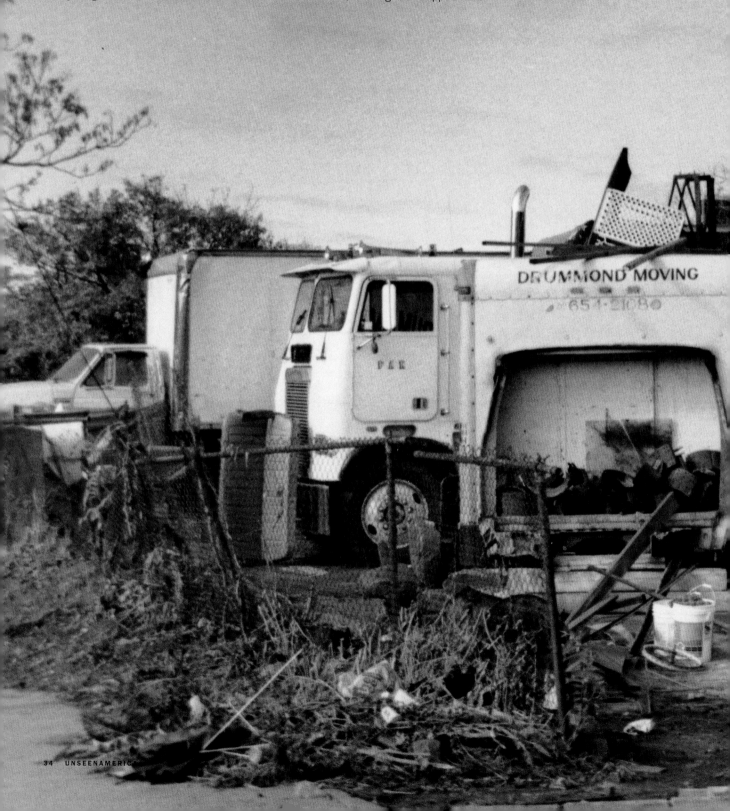

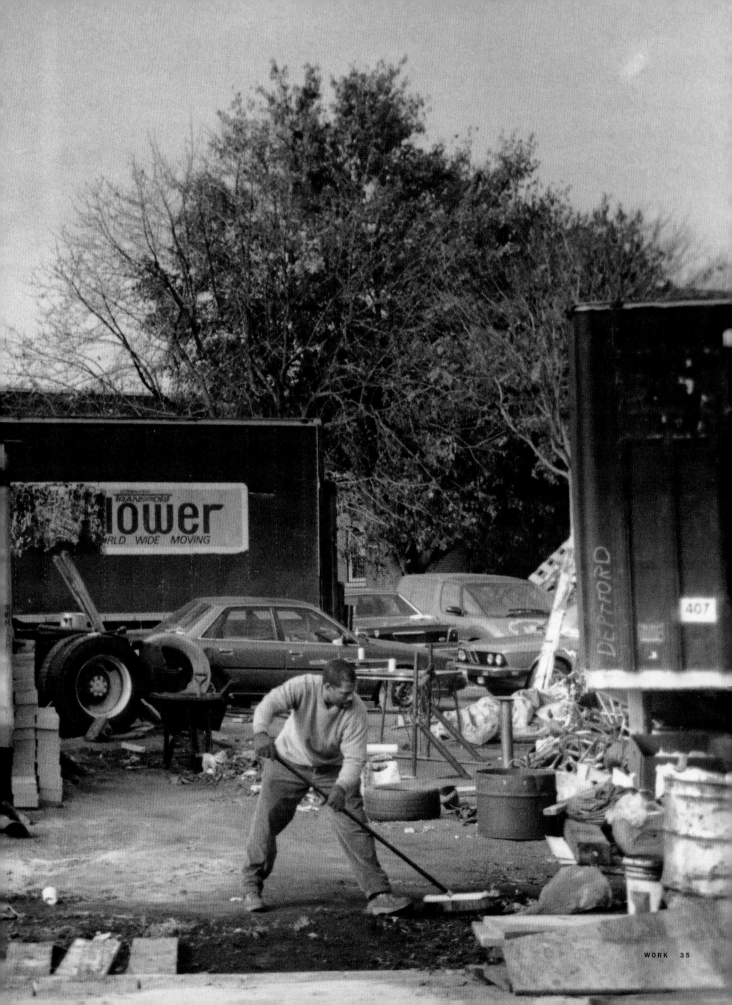

VICTOR SEVERINO
RESTAURANT WORKER
RESTAURANT OPPORTUNITIES CENTER
 OF NEW YORK
NEW YORK CITY

MAN PUSHING CART

They were working so hard while enduring the freezing cold. They did so because they had no choice, regardless of how cold it was.

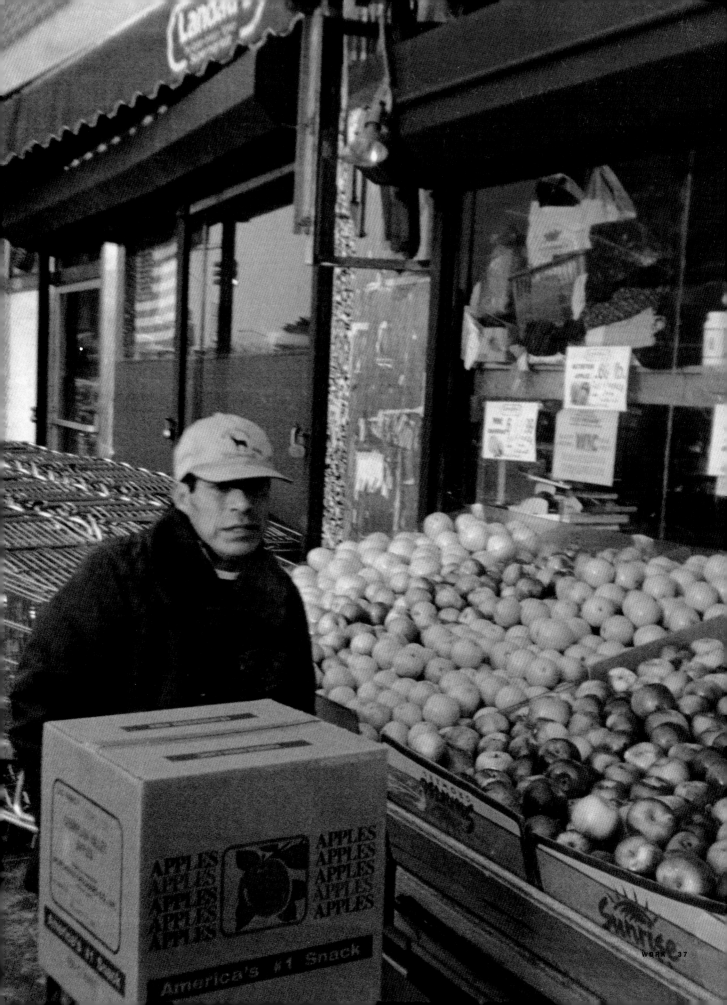

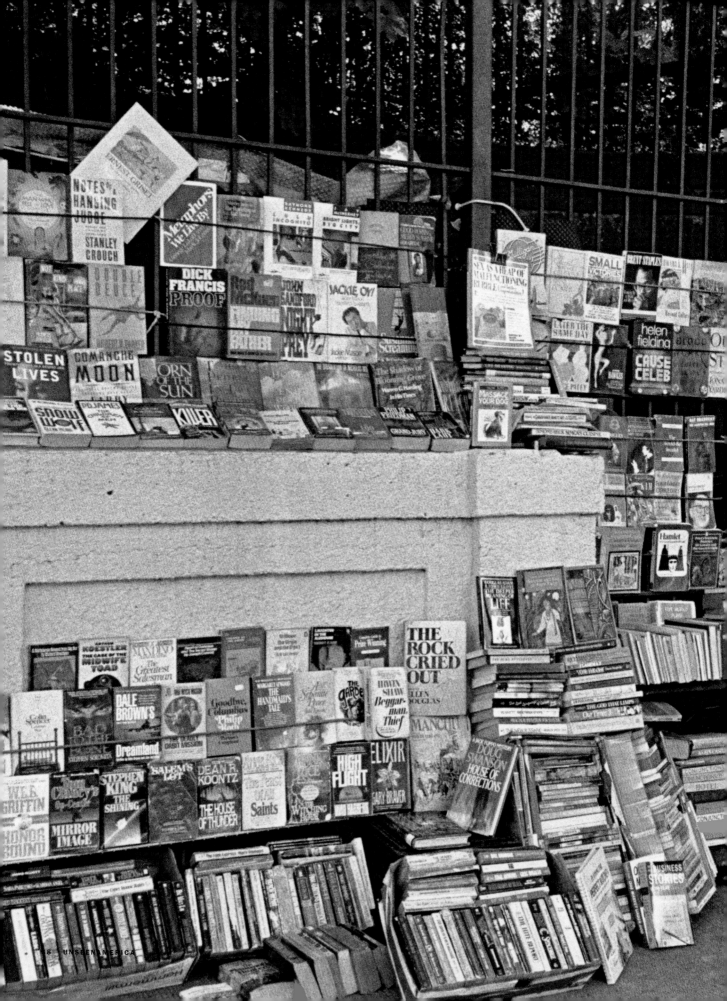

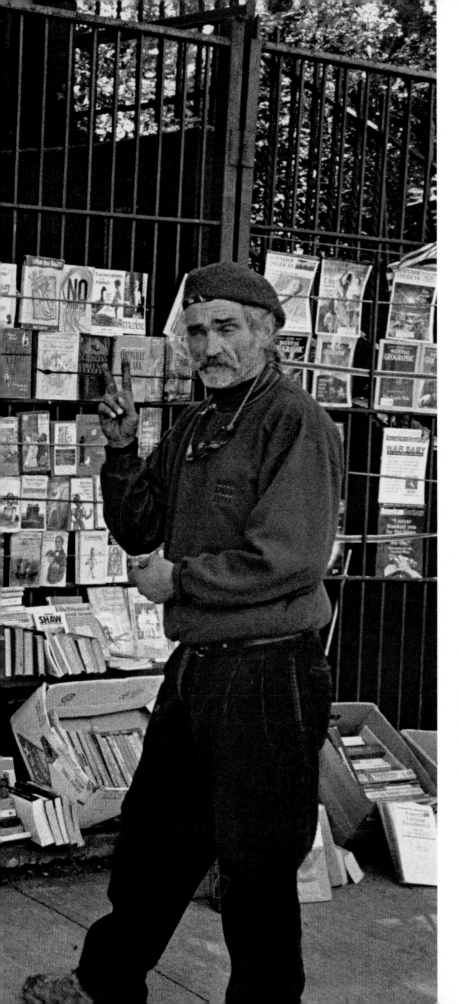

MARVA STENNETTS
SUPERVISOR
SSEU LOCAL 371 AFSCME
LINDEN JOB CENTER
NEW YORK CITY

MAN SELLING BOOKS

I've seen this man over the years, selling books on Eastern Parkway near the Botanical Garden. I've often wondered if that is his only income and how he is surviving.

KENNY SHANE
BUILDING SUPERVISOR
SEIU LOCAL 32BJ
NEW YORK CITY

LIBERTY HOUSE

This is one of the doormen. The sun was
setting, and he was just standing out
there, waiting for people to come home.

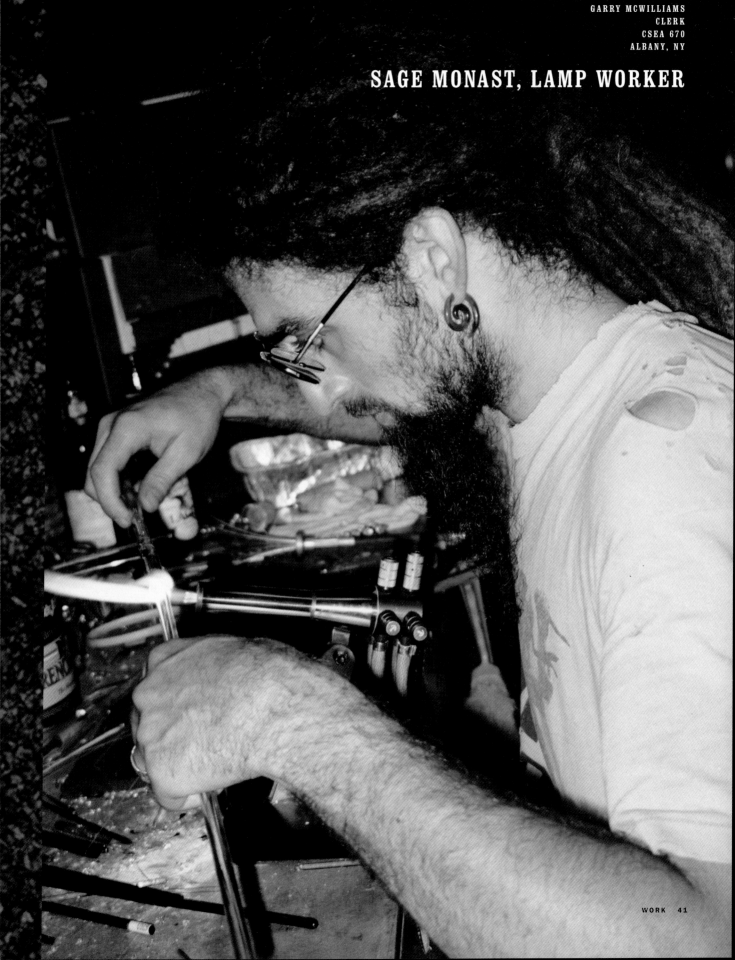

SAGE MONAST, LAMP WORKER

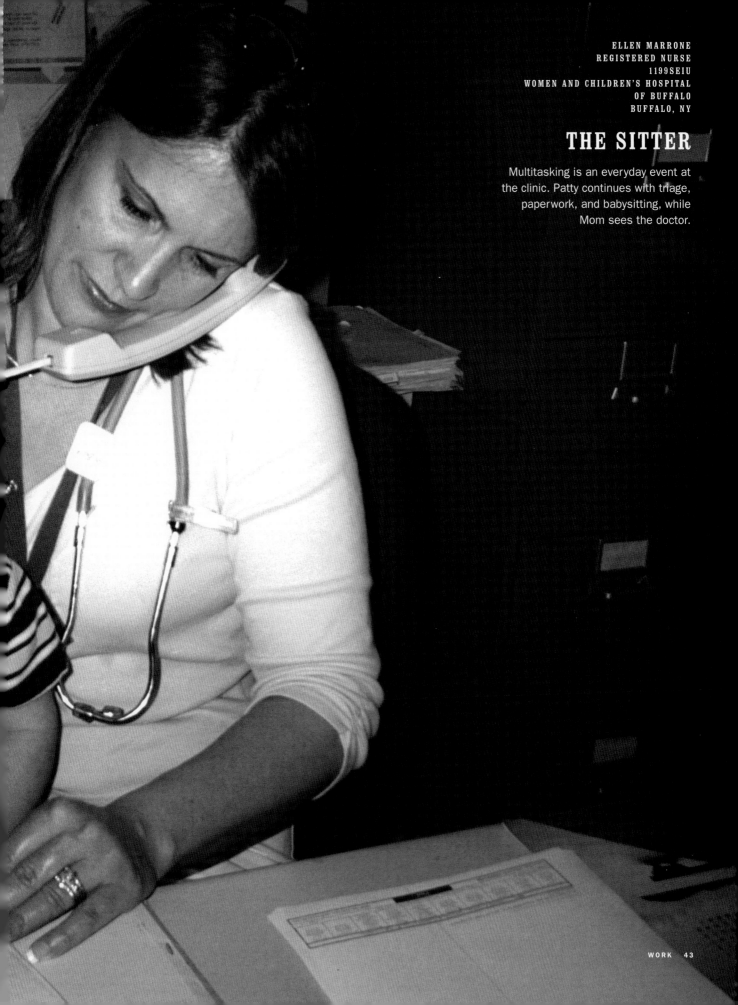

ELLEN MARRONE
REGISTERED NURSE
1199SEIU
WOMEN AND CHILDREN'S HOSPITAL
OF BUFFALO
BUFFALO, NY

THE SITTER

Multitasking is an everyday event at the clinic. Patty continues with triage, paperwork, and babysitting, while Mom sees the doctor.

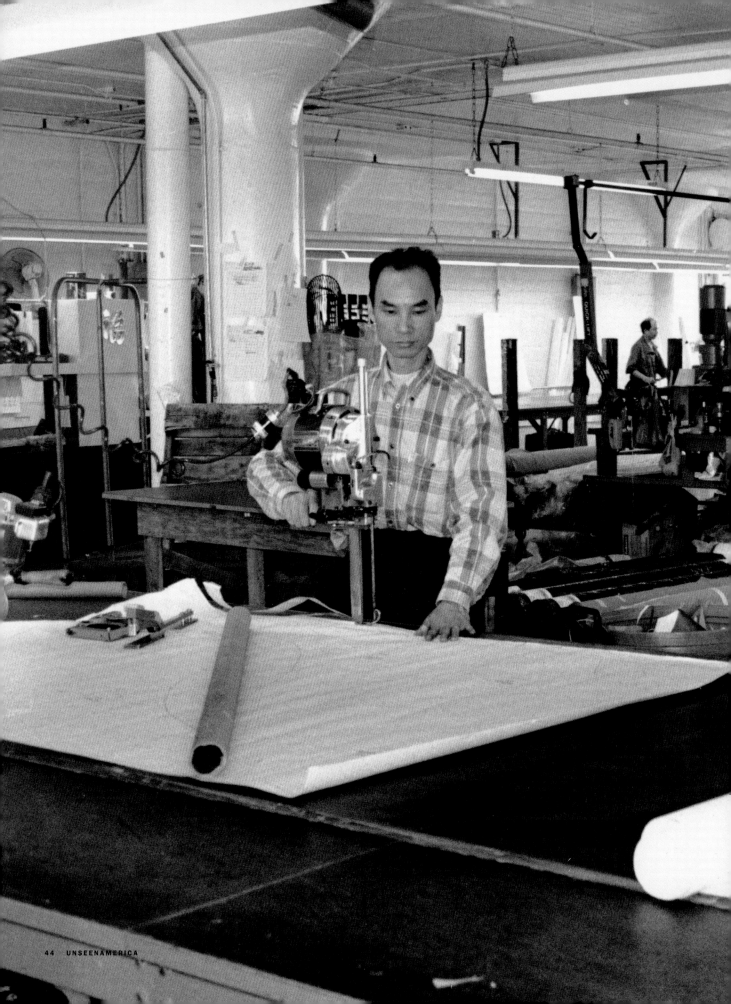

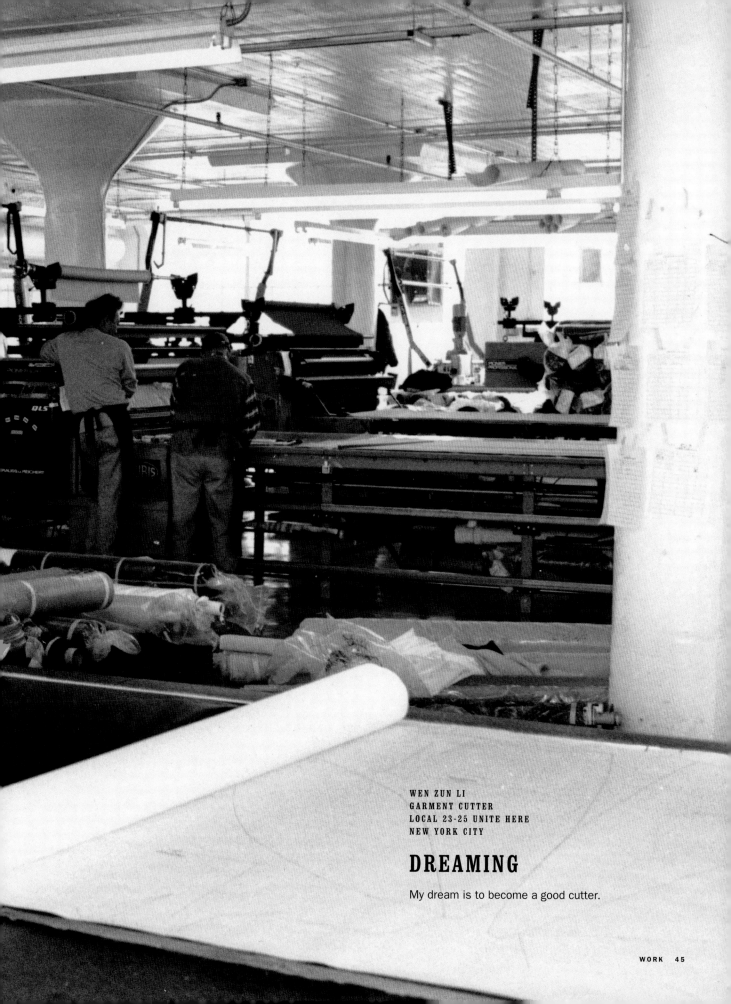

WEN ZUN LI
GARMENT CUTTER
LOCAL 23-25 UNITE HERE
NEW YORK CITY

DREAMING

My dream is to become a good cutter.

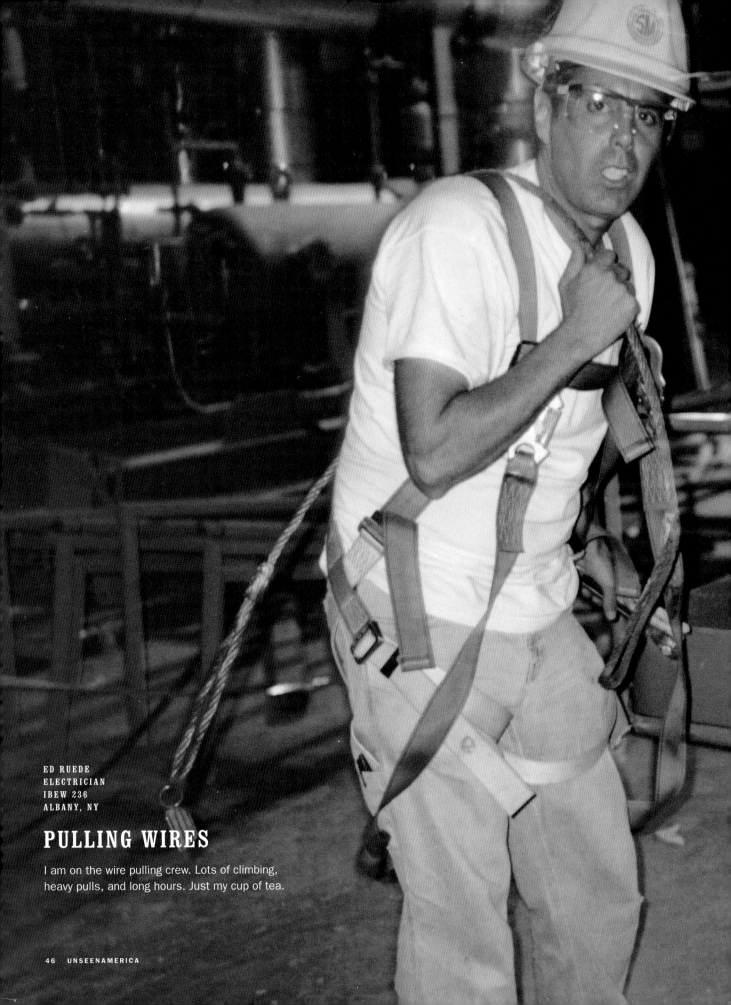

ED RUEDE
ELECTRICIAN
IBEW 236
ALBANY, NY

PULLING WIRES

I am on the wire pulling crew. Lots of climbing,
heavy pulls, and long hours. Just my cup of tea.

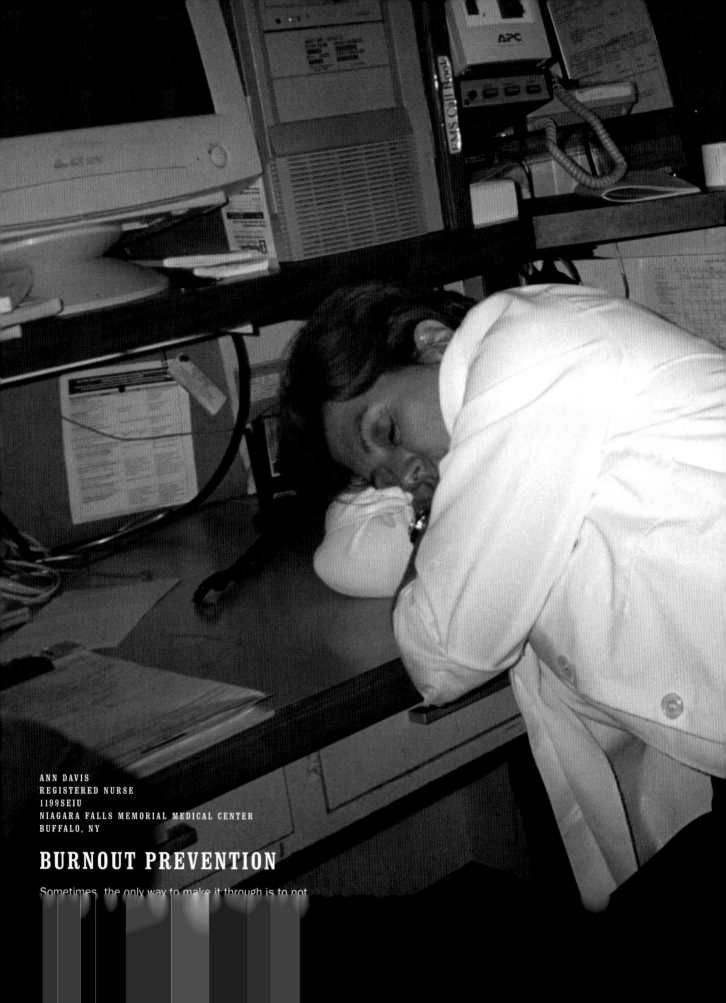

ANN DAVIS
REGISTERED NURSE
1199SEIU
NIAGARA FALLS MEMORIAL MEDICAL CENTER
BUFFALO, NY

BURNOUT PREVENTION

Sometimes, the only way to make it through is to not

LEISURE

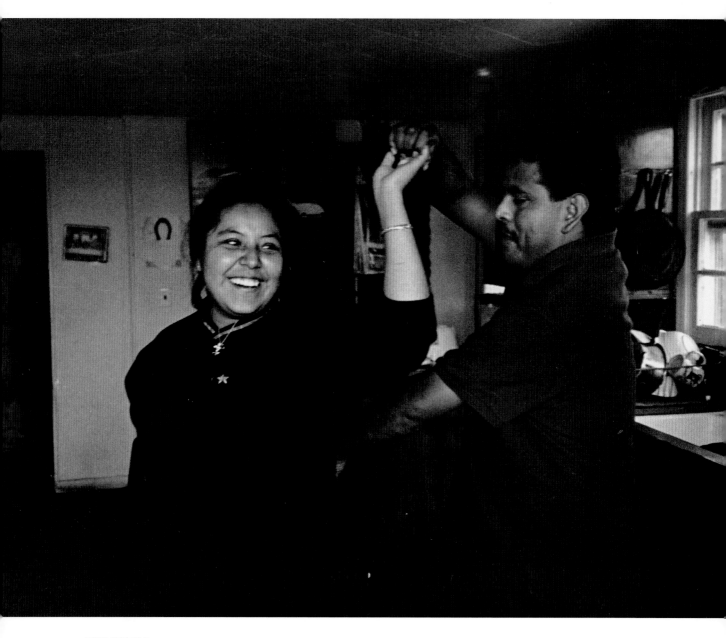

LUIS BERNAL
DAY LABORER
THE WORKPLACE PROJECT
LONG ISLAND, NY

DANCING/WHO WE ARE

This is a picture that would help everyone else know that we come to this country not to do bad things like people say. We come here to work and have fun.

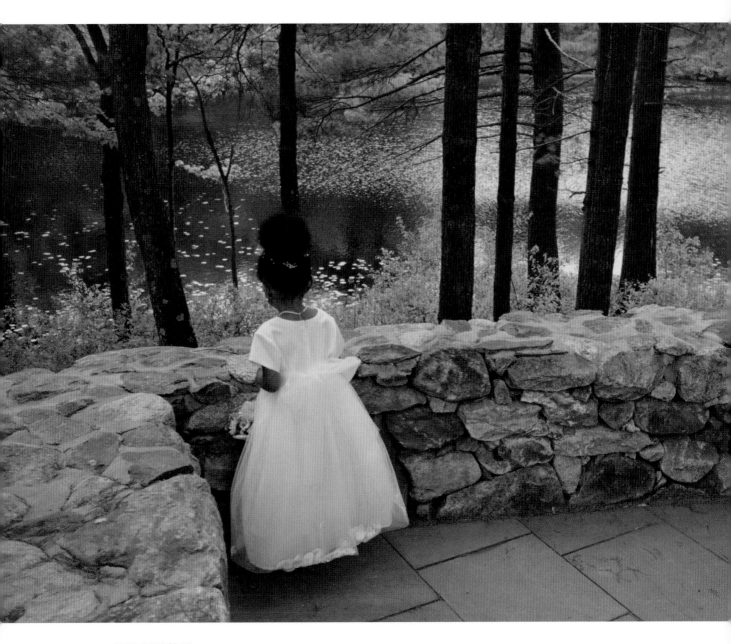

SUZY RANDOLPH
FRAUD INVESTIGATOR
SSEU LOCAL 371 AFSCME
ELIGIBILITY VERIFICATION AND REVIEW
NEW YORK CITY

UNTITLED

This was taken at a summer wedding in Massachusetts, on a lake in a very tranquil setting. My daughter is gazing at the water and asking questions. She's beautiful and very inquisitive.

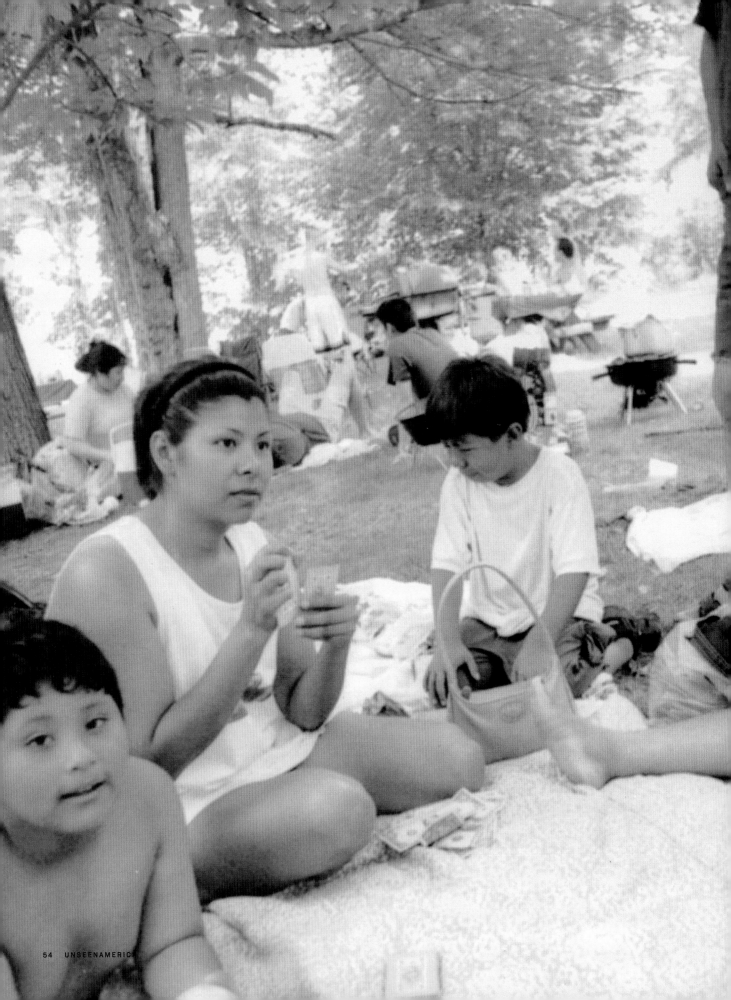

GLORIA CORTEZ
DAY LABORER
HUDSON RIVER COMMUNITY HEALTH
NEW YORK

THE CHILDREN
ENJOYING THE LAKE

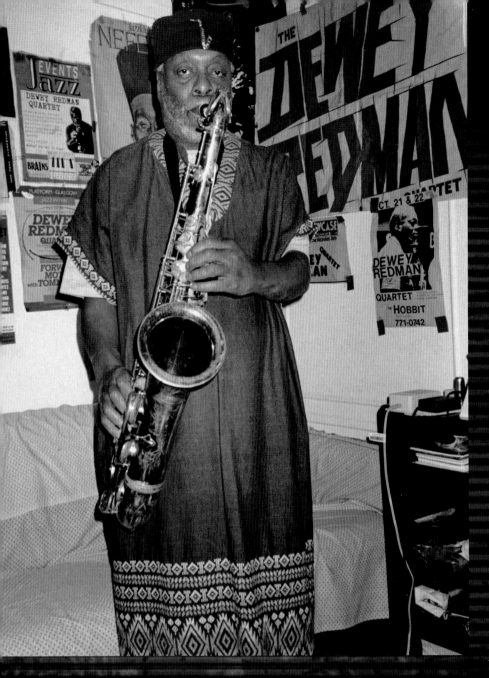

ARTHUR DEAVERS
CASHIER
RITE-AID 1199SEIU
NEW YORK CITY

SAX PLAYER

I met Dewey Redman when he came into the store for a prescription. He is a prostate cancer survivor and he's still performing. I took his picture to express hope.

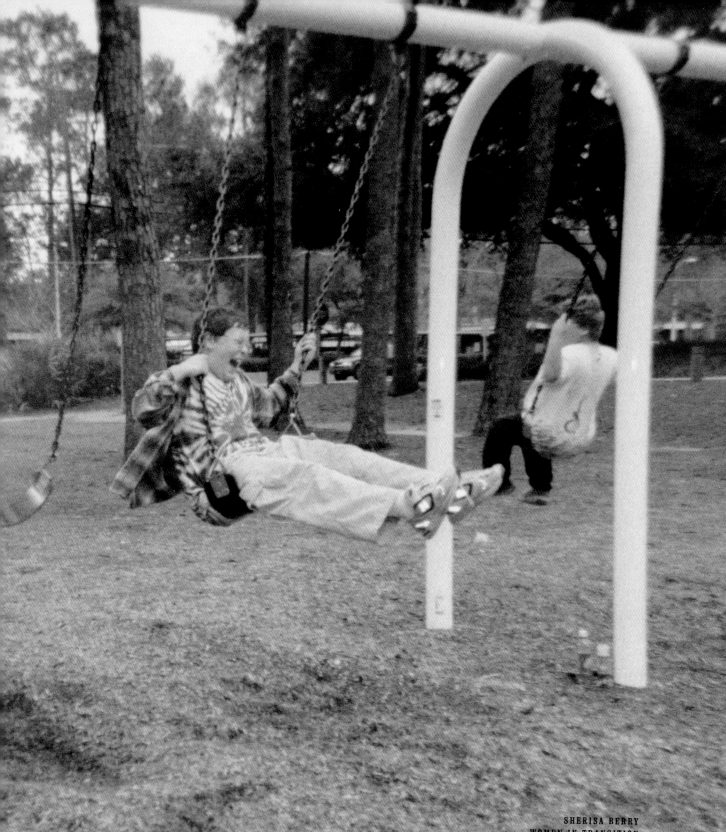

SHERISA BERRY
WOMEN IN TRANSITION
GAINESVILLE, FL

SWINGING BOY

A child's smile brings love to anyone's heart.

ARON CRUZ
DAY LABORER
THE WORKPLACE PROJECT
LONG ISLAND, NY

HAVE SOME

Immigrants intend no harm. These pictures will help others to understand us better.

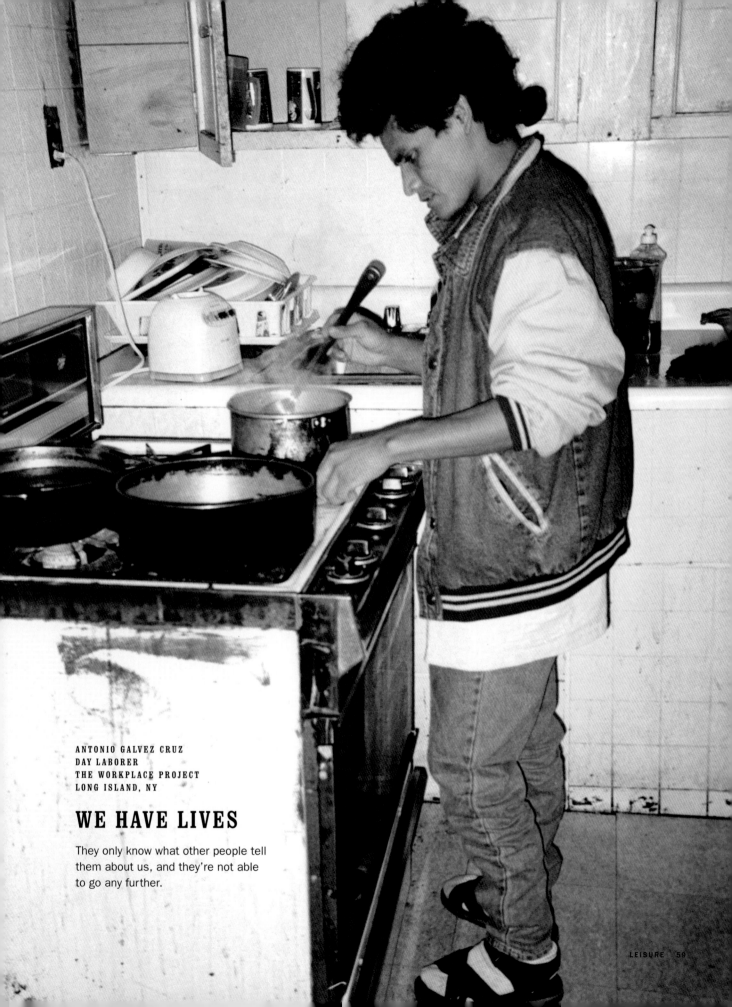

ANTONIO GALVEZ CRUZ
DAY LABORER
THE WORKPLACE PROJECT
LONG ISLAND, NY

WE HAVE LIVES

They only know what other people tell
them about us, and they're not able
to go any further.

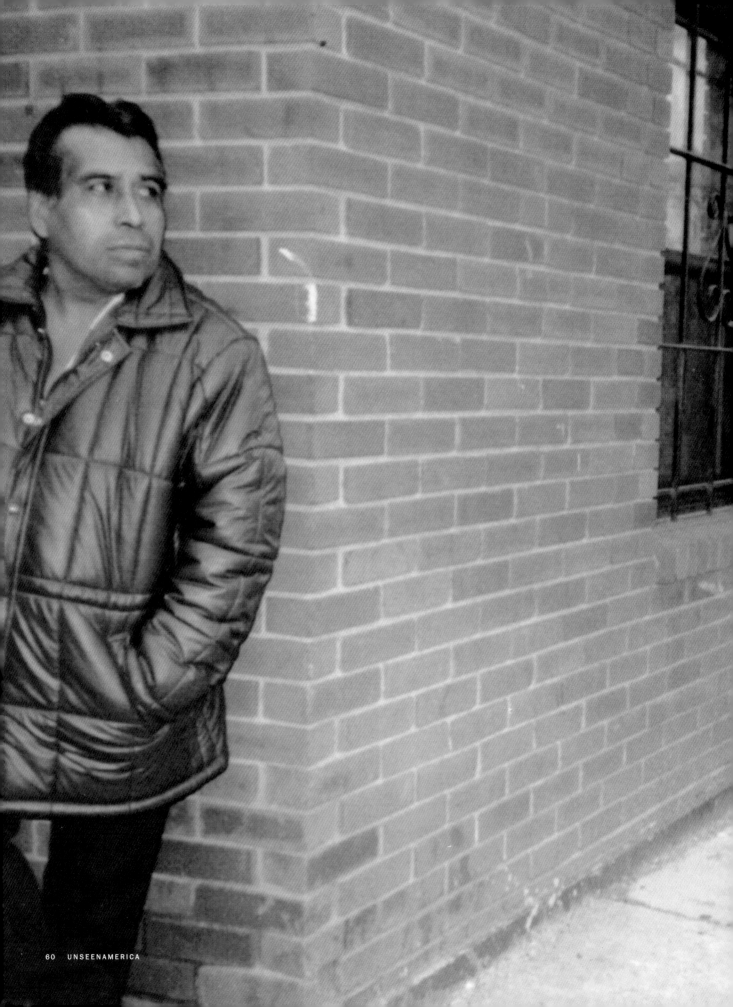

ROBERTO CRUZ SALINAS
DAY LABORER
HUDSON RIVER COMMUNITY HEALTH
NEW YORK

THE MAN ON THE WALL WAITING TO COMPLETE HIS AMERICAN DREAM

The quiet and silent wall supports us while we await a better future. Thousands of immigrants await an uncertain future, like this one, who waits to realize his dreams.

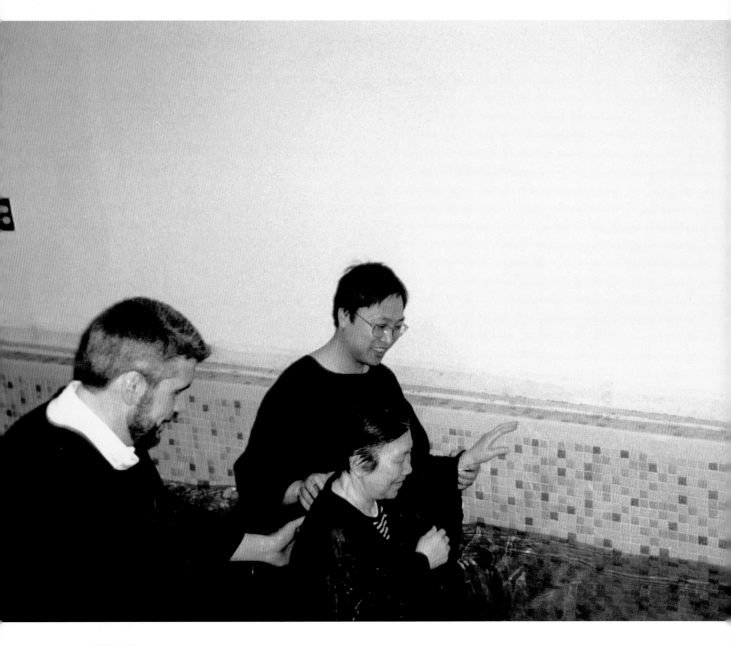

PING LAM
CUTTER
LOCAL 23-25 UNITE HERE
NEW YORK CITY

BAPTISM

This is a picture of Mrs. Wong's baptism. Mr. and Mrs. Wong had to endure a long and hard immigration process before they were finally allowed to stay in the United States to help take care of their grandchildren.

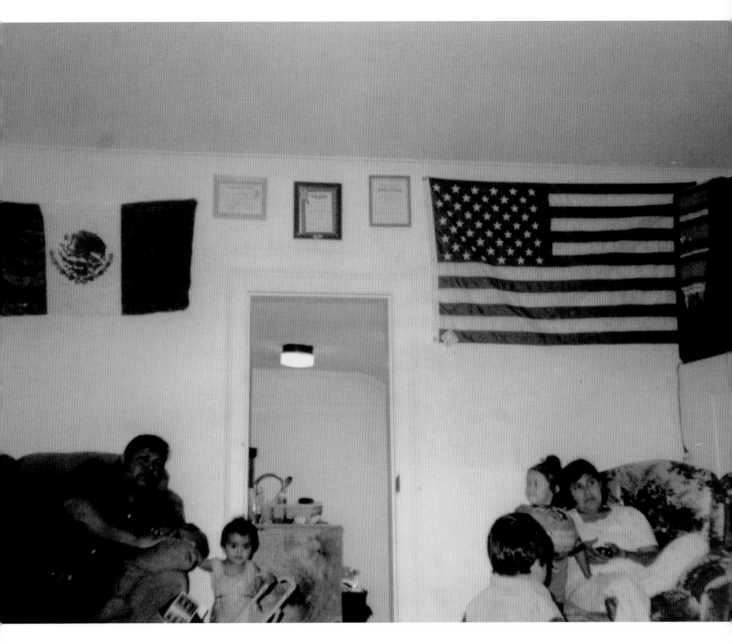

HORTENCIA GARCIA
DAY LABORER
HUDSON RIVER COMMUNITY HEALTH
NEW YORK

WHILE THE CHILDREN PLAY

In the afternoon, they remember old times or just joke around. I like to watch them chatting away in the afternoon.

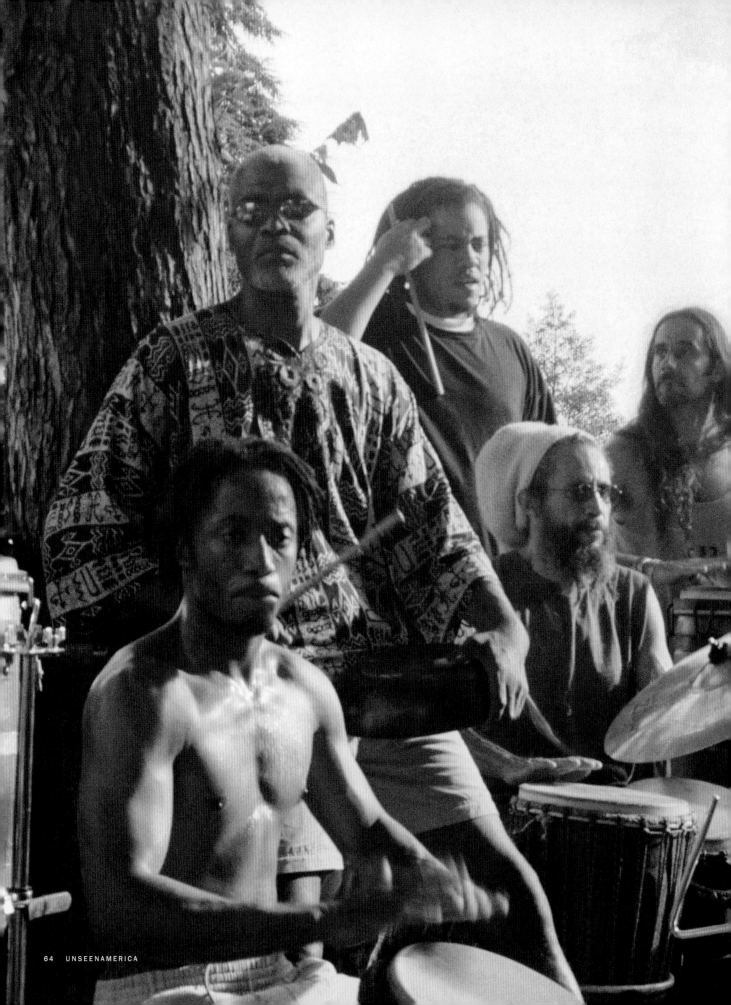

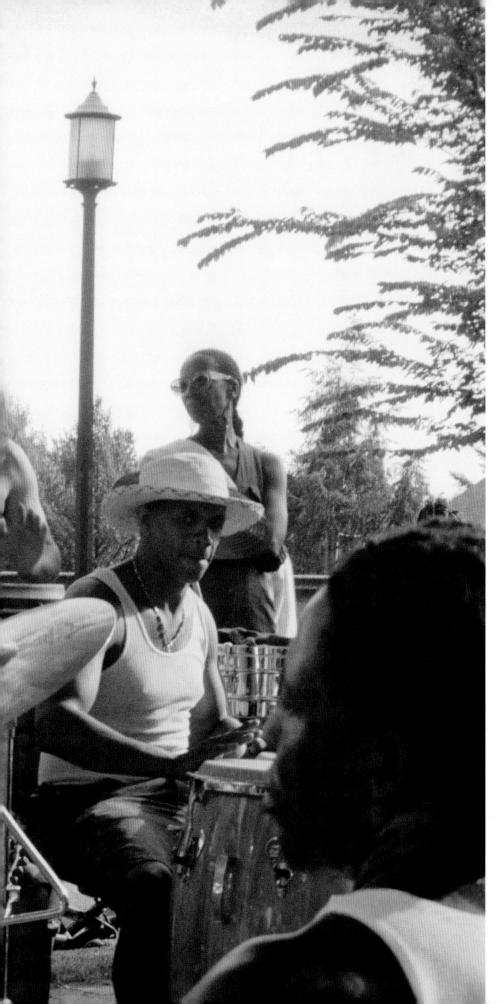

RAFAEL ERNESTO GONZALEZ
BUILDING EMPLOYEE
SEIU LOCAL 82
WASHINGTON, DC

IDENTIFYING THEMSELVES THROUGH ART

The originality and tradition of a country, Jamaica, made me take this photograph.

BERKLEY HINTON
PROJECT RENEWAL, HOLLAND HOUSE
NEW YORK CITY

PORTRAIT IN MIRROR

The essence of beauty
Skin deep
I could make any man weak
Soul to soul
I'm worth more than gold
Some ask me why I'm so bold

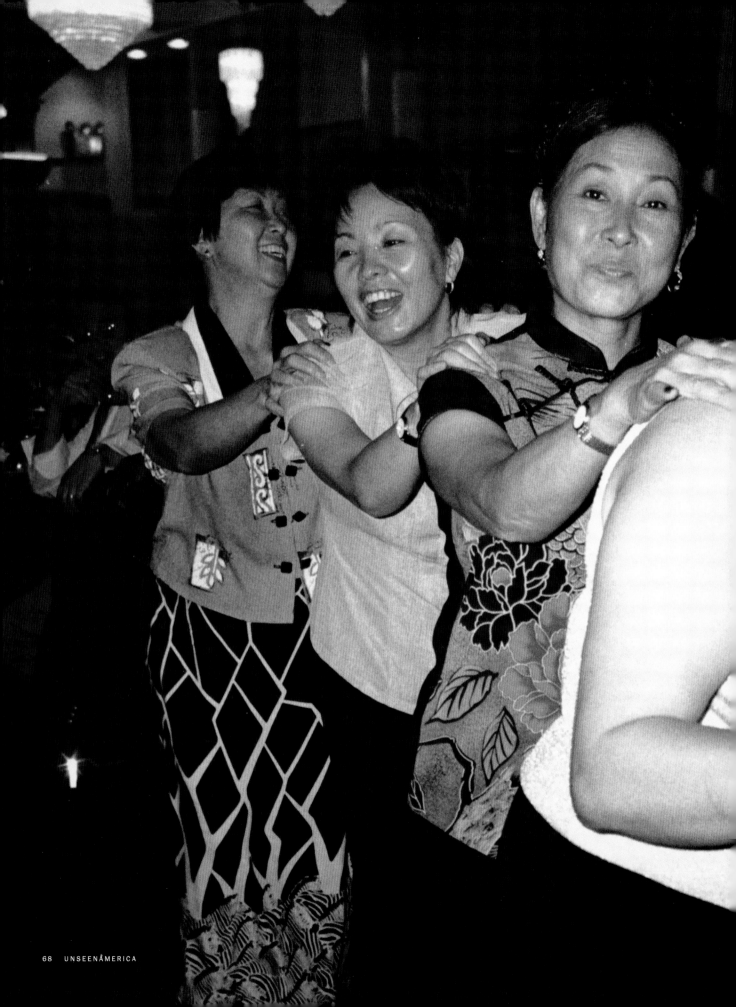

WAI CHUN NG
GARMENT WORKERS
LOCAL 23-25 UNITE HERE
NEW YORK CITY

PARTY TRAIN

The Chinese American Planning Council offered retraining classes to help people get jobs. Here, people are celebrating at CAPC graduation.

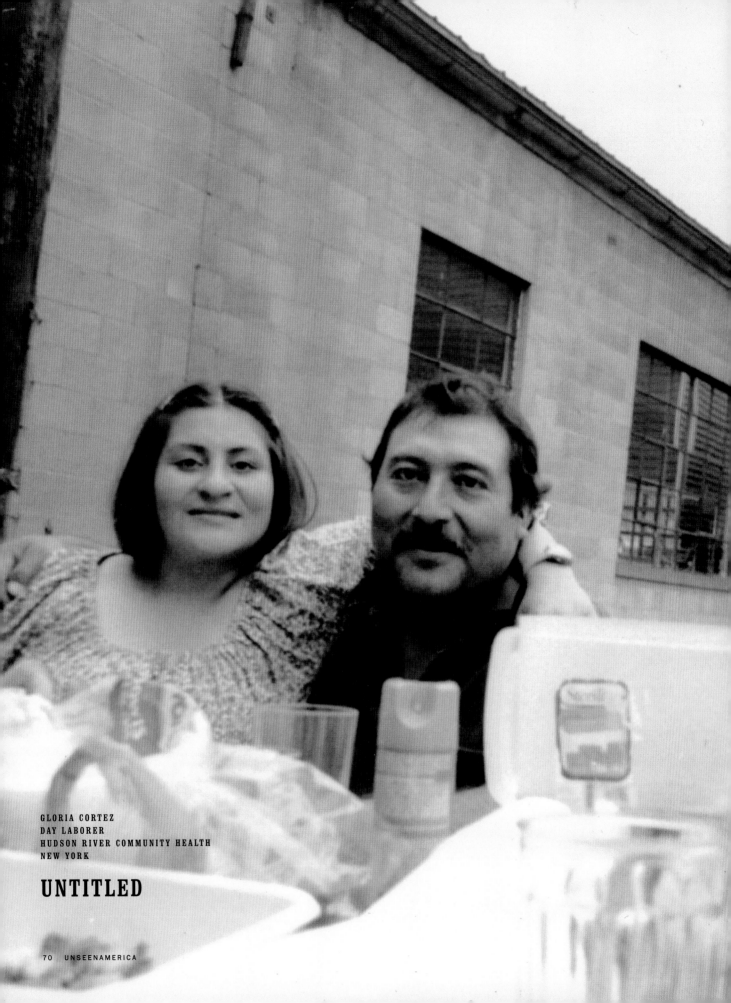

GLORIA CORTEZ
DAY LABORER
HUDSON RIVER COMMUNITY HEALTH
NEW YORK

UNTITLED

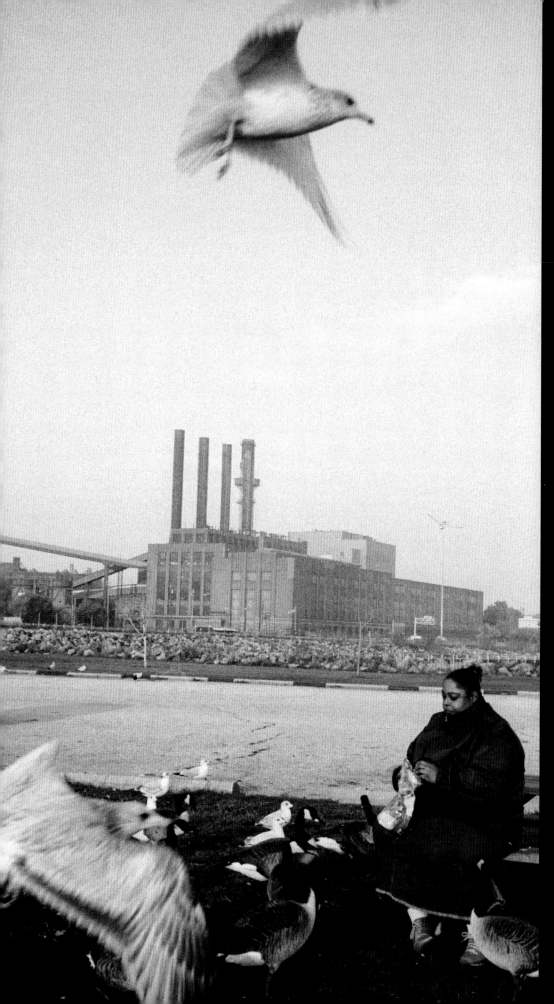

MAUREEN MCMANUS
SEIU DISTRICT 1199
WV/KY/OH
MUI INVESTIGATOR
CUYAHOGA COUNTY BOARD OF
MENTAL RETARDATION
AND DEVELOPMENTAL
DISABILITIES
CLEVELAND

BIRD LADY

Her name is Jamesetta. Ten years have passed since that walk in the park when her eyes were drawn to the old man sitting on the bench. He was engulfed by a swarm of frantic and frenzied winged creatures, which grabbed the morsels of food offered from his hands. It was frightening to her and yet her fascination wouldn't let her leave. He saw her, called her closer, and taught her that they need not be feared . . . "The secret," he said, "is to sit quietly and they will come to you." That day she began her mission and returned to the park often, but she never saw the old man again.

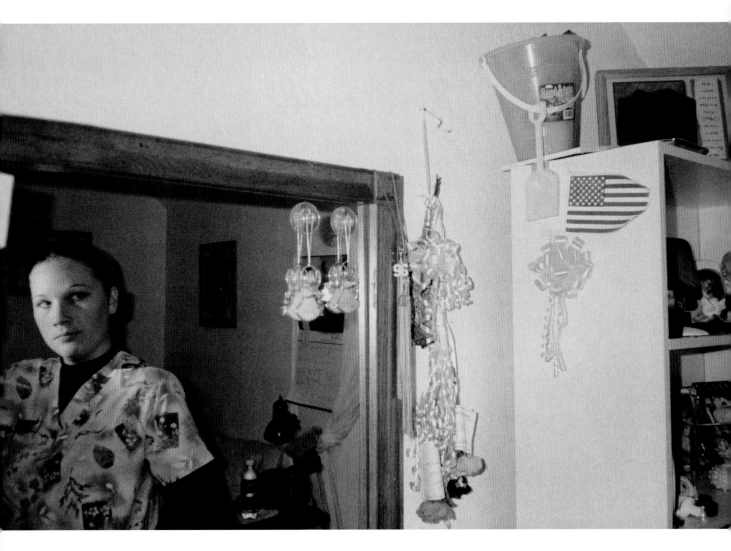

JENNIFER LONG
WOMEN IN TRANSITION
GAINESVILLE, FL

SELF PORTRAIT

When you look into my eyes, tell me what you see? Happiness? Sadness? Love? Fear? What does an outside appearance or facial expression say to people? Many people carry multiple facades, but until one knows someone truly, then the outside can say nothing about the heart. Agony and Ecstasy is how I might see my life, describing all of me. The words are few, but the meanings are quite deep. I am a mother, a daughter, a student, a medical assistant, a child of God, and a recovering drug addict.

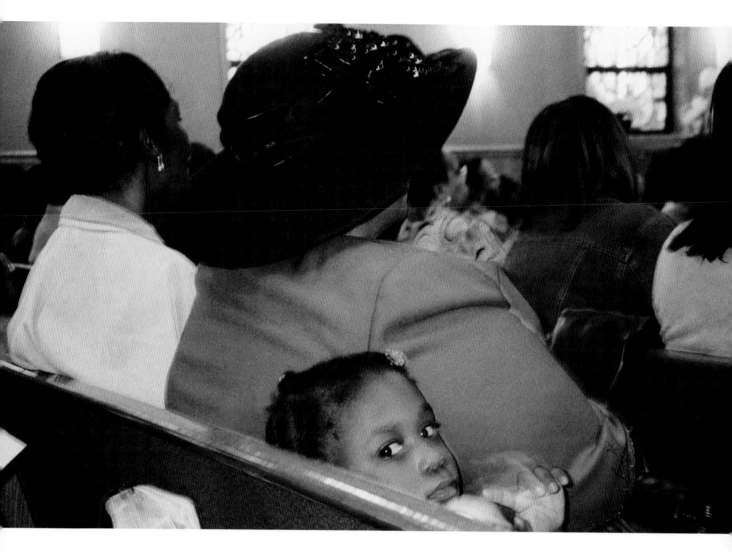

KEESHA MCMILLIAN
CHILD AND FAMILY THERAPIST
SEIU DISTRICT 1199 WV/KY/OH
CENTER FOR FAMILIES AND CHILDREN, THE RAPART OFFICE
CLEVELAND, OH

SNEAK A PEEK

Mrs. Ann's granddaughter sneaks a peek. Mrs. Ann listens attentively to the sermon. I have been attending this church for more than twelve years and I especially enjoy the church ladies as they honor God with their fashionable Sunday morning hats.

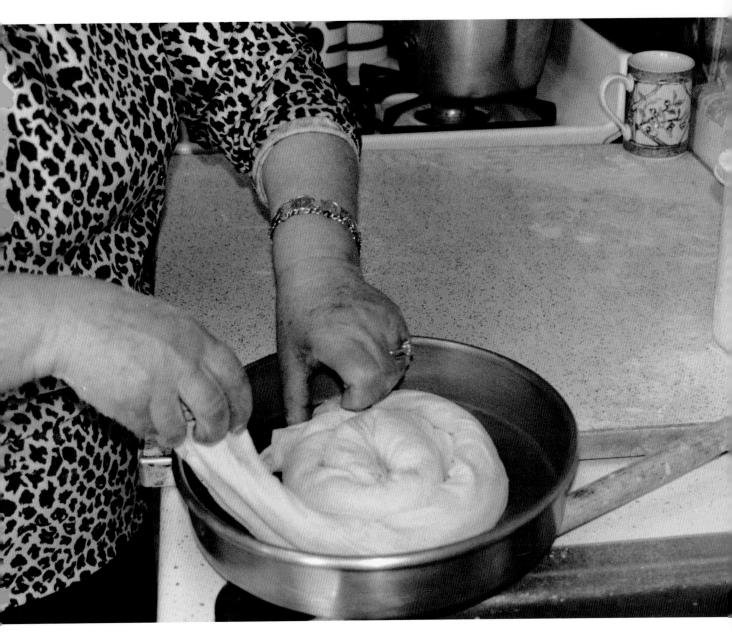

VALENTINA PALJUSAJ
DAMAYAN MIGRANT WORKERS ASSOCIATION
NEW YORK CITY

KNEADING BREAD/BREAD IN MOTION

My mother was born in Yugoslavia, as was I. Her name is Bosa. She is preparing a dish called pite. Pite is not easy to prepare. I not only see the food, but also the soft, gentle hands that have always cared for me and my siblings.

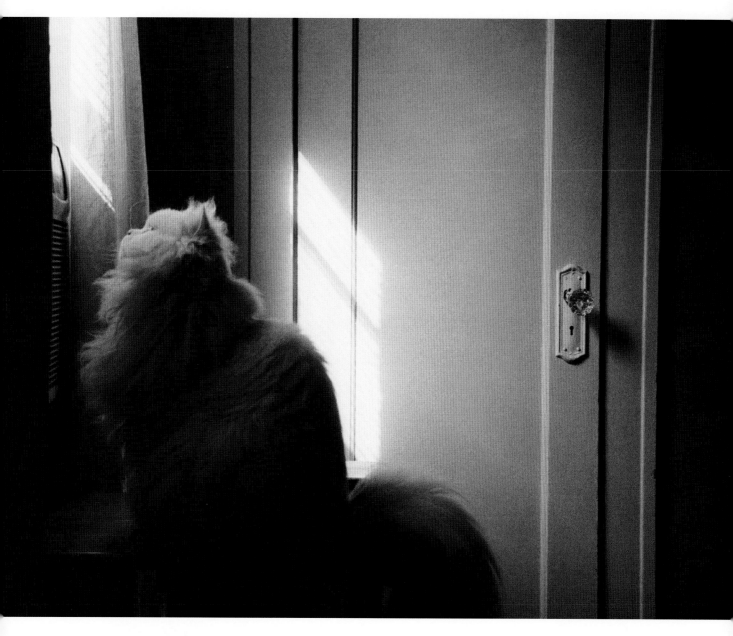

LYNLEE NORDGREN
SUPPORT ADMINISTRATOR
SEIU DISTRICT 1199 WV/KY/OH
CUYAHOGA COUNTY BOARD OF MENTAL RETARDATION AND DEVELOPMENTAL DISABILITIES
CLEVELAND, OH

CAT

As a little girl, I always wished I had a white fluffy cat to join the family. Thirty some years later, Mr. Peabody finally came into my life. Here I am resting and look up to see Mr. Peabody and he appears to be worshipping. To whom or what, I don't know. For a moment life is more pure and simple. Headache gone.

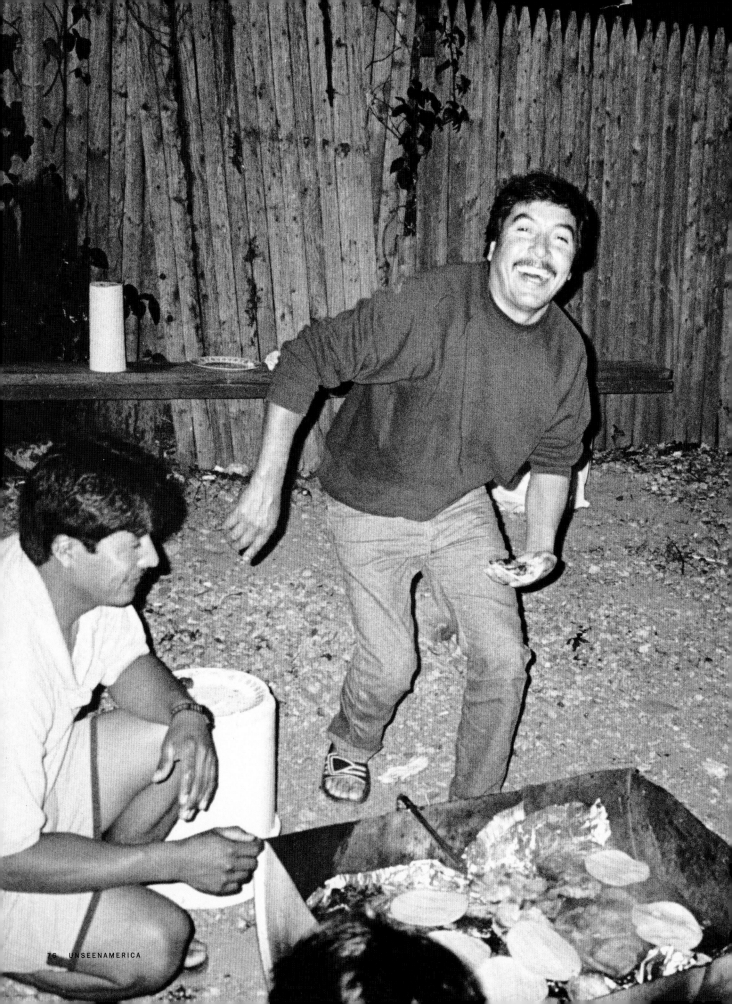

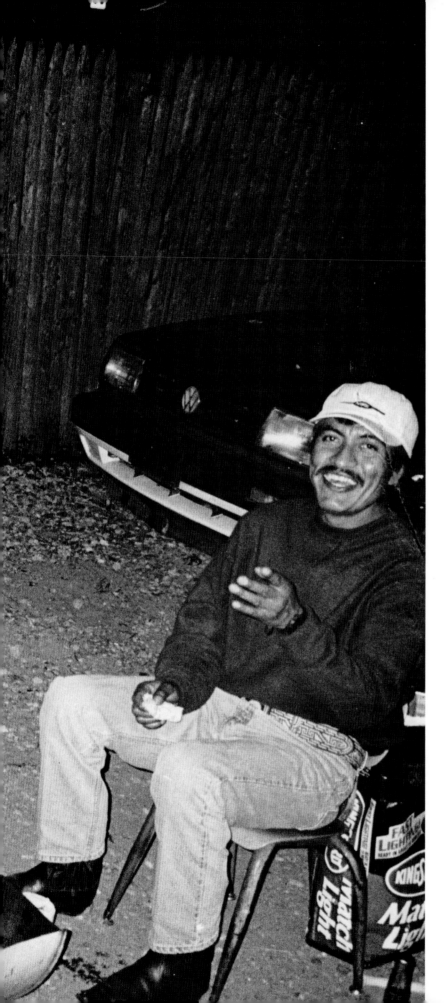

ISRAEL PEREZ
DAY LABORER
THE WORKPLACE PROJECT
LONG ISLAND, NY

THE BARBEQUE

We only want to be able to feed our
families.

SHARON PARTACZ
REGISTERED NURSE
1199SEIU
WOMEN AND CHILDREN'S HOSPITAL OF BUFFALO
BUFFALO, NY

MEMORIAL DAY

A WWII veteran from our community honors a fallen comrade on Memorial Day.

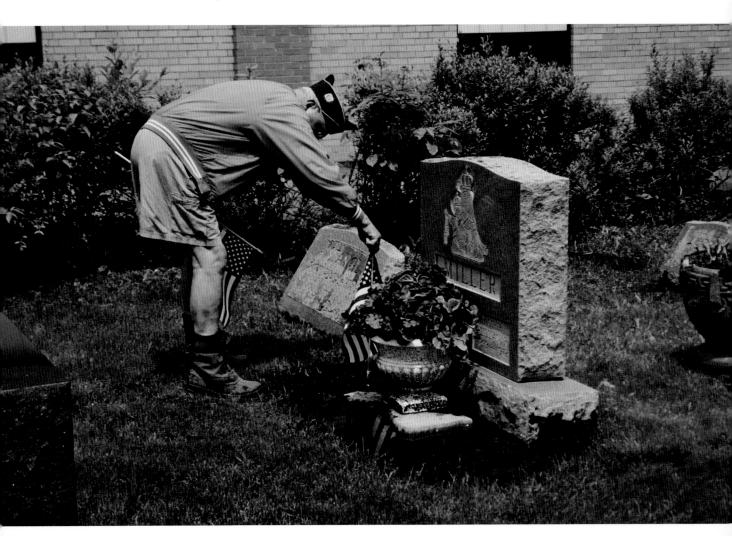

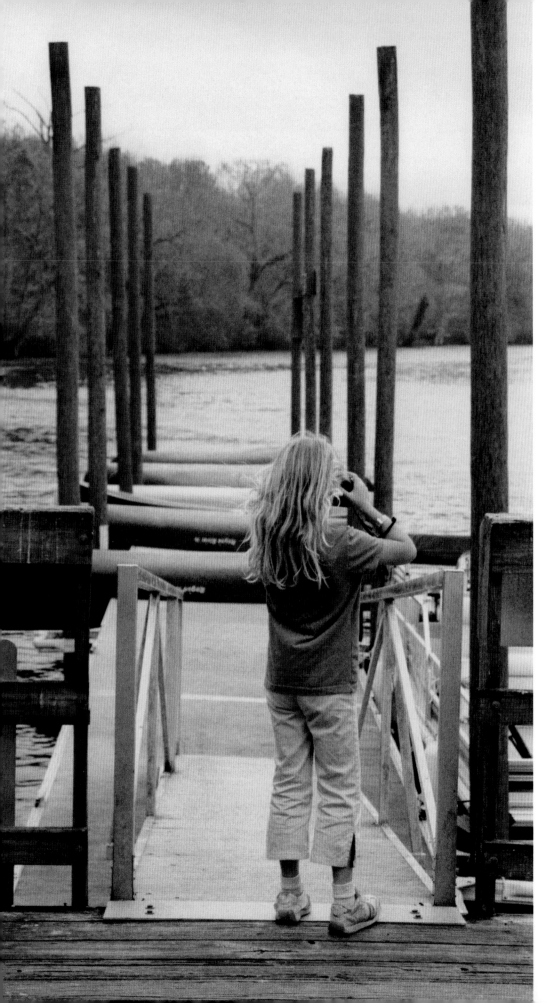

CONNIE PORTER
WOMEN IN TRANSITION
GAINESVILLE, FL

UNTITLED

A six-year-old girl who sent a note of love by balloons at her Grammy's funeral. She asked her mom, later that evening, if she thought it had gotten to Grammy yet. She will be able to photograph life and beauty and love better than anyone.

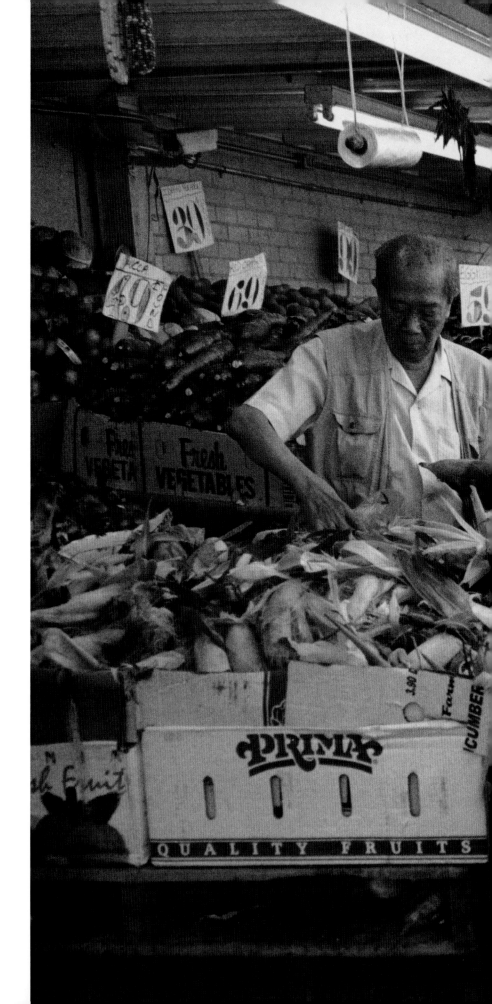

DUEN YEE LAM
SEWING MACHINE OPERATOR
LOCAL 23-25 UNITE HERE
NEW YORK CITY

SHOPPING

I immigrated to the United States from Hong Kong. I have a child. I started working in New York's Chinatown when I arrived. The working hours are long and the workload is heavy. After work, I return home and do the housework and go to the supermarket. Life is kind of boring. Every year, my family goes on vacation for 4–5 days. In order to broaden my horizons, I try to make time to participate in union and community activities. I recently joined the union's photography class, which is both educational and recreational. I've learned a lot.

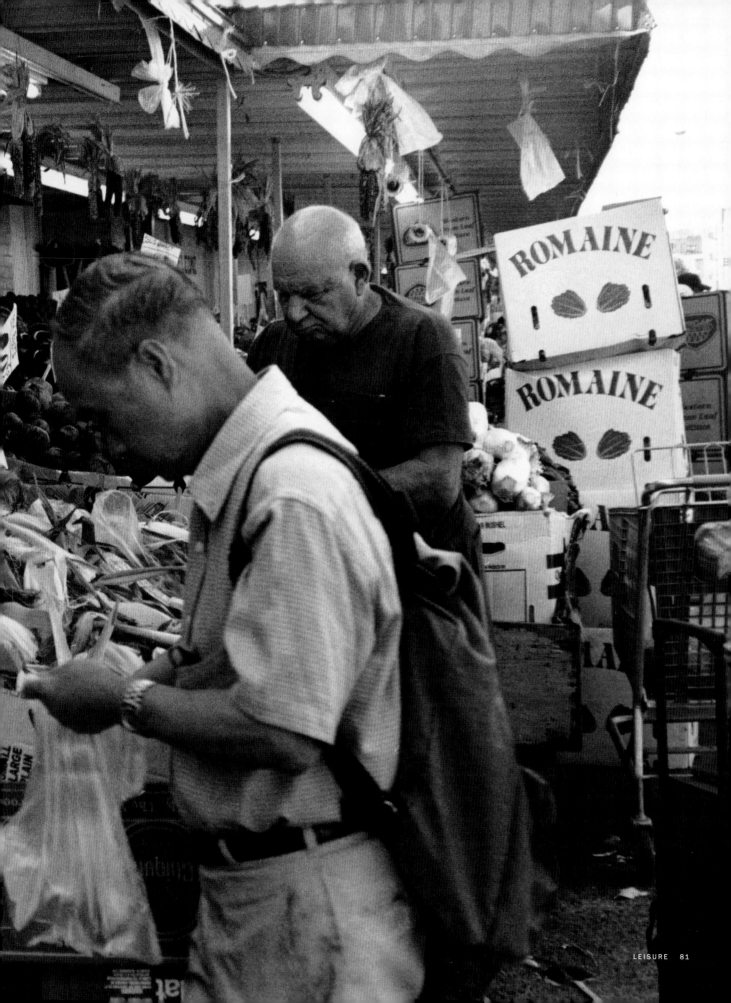

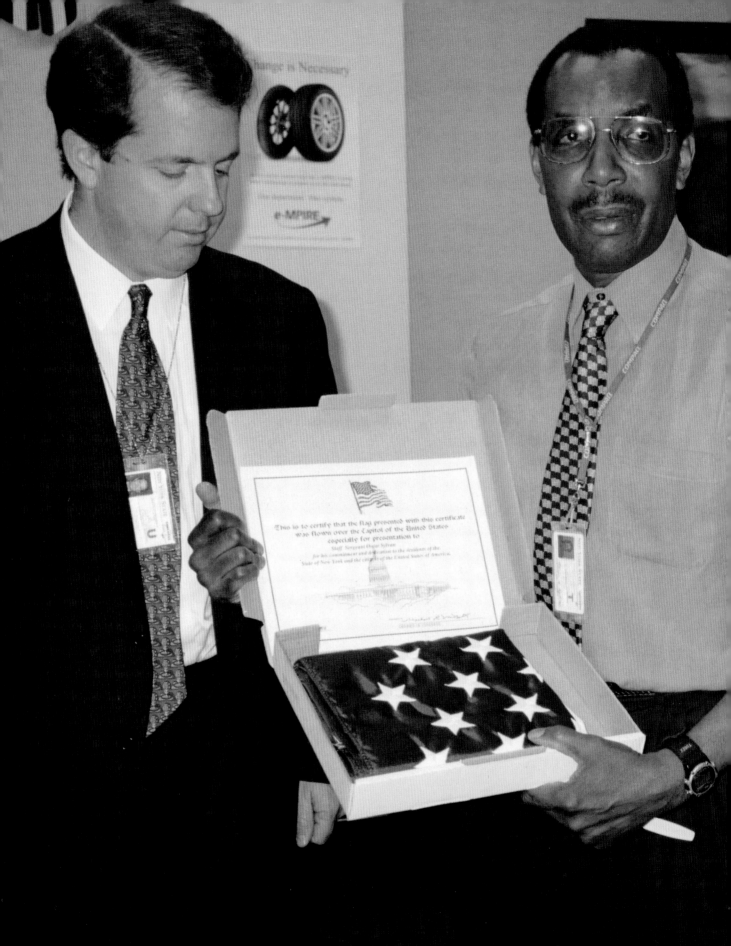

CRAIG WALTZ
TAX COMPLIANCE REPRESENTATIVE
CSEA 690
ALBANY, NY

COME BACK CARRYING IT... NOT WEARING IT

That was the only condition placed on the gift, an American flag, given to Staff Sergeant Oscar Sylvan. Oscar is my boss and friend, a fifty-two-year-old civil servant with bad knees. Oscar's Reserve Unit has been sent to Iraq for an eighteen-month tour. Before leaving, Oscar presented the flag to his parents. Let us pray it is the last flag they are presented with.

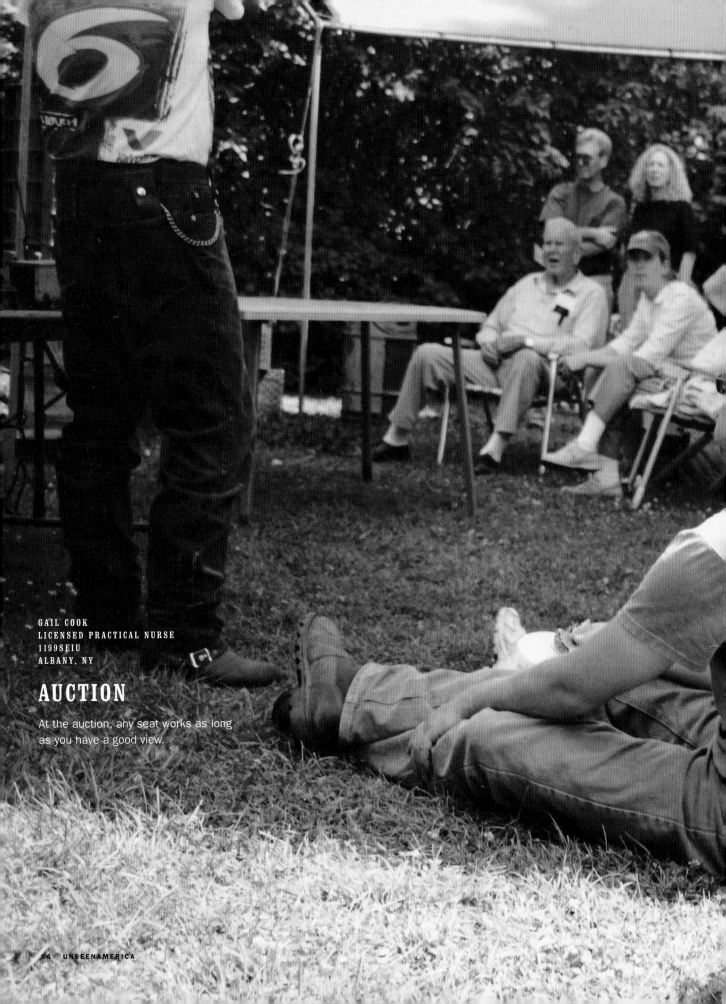

GAIL COOK
LICENSED PRACTICAL NURSE
1199SEIU
ALBANY, NY

AUCTION

At the auction, any seat works as long
as you have a good view.

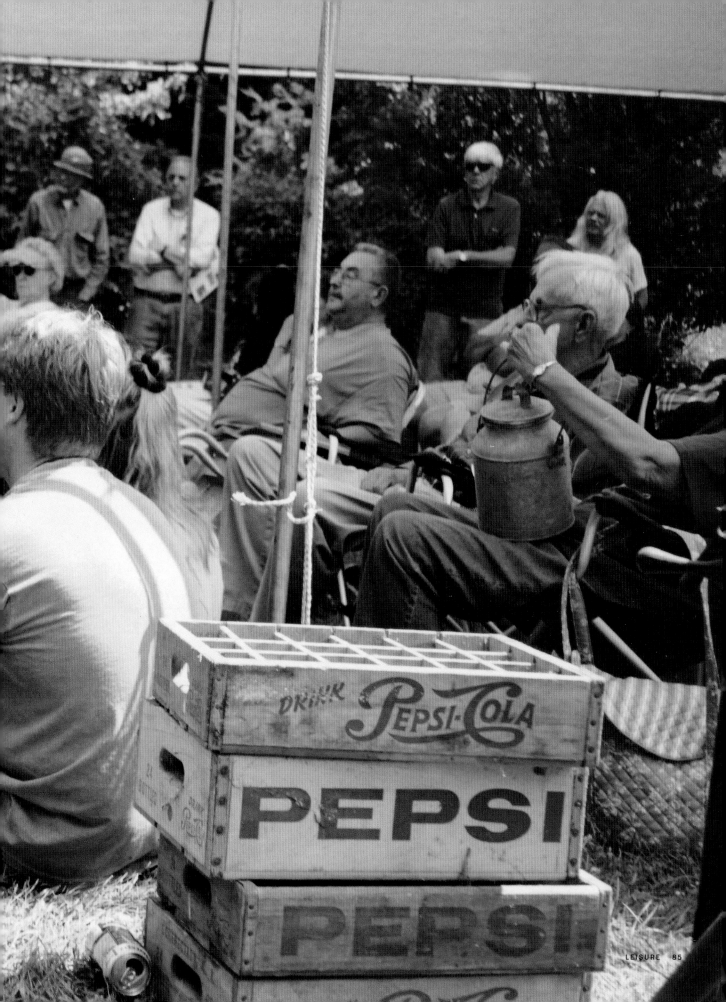

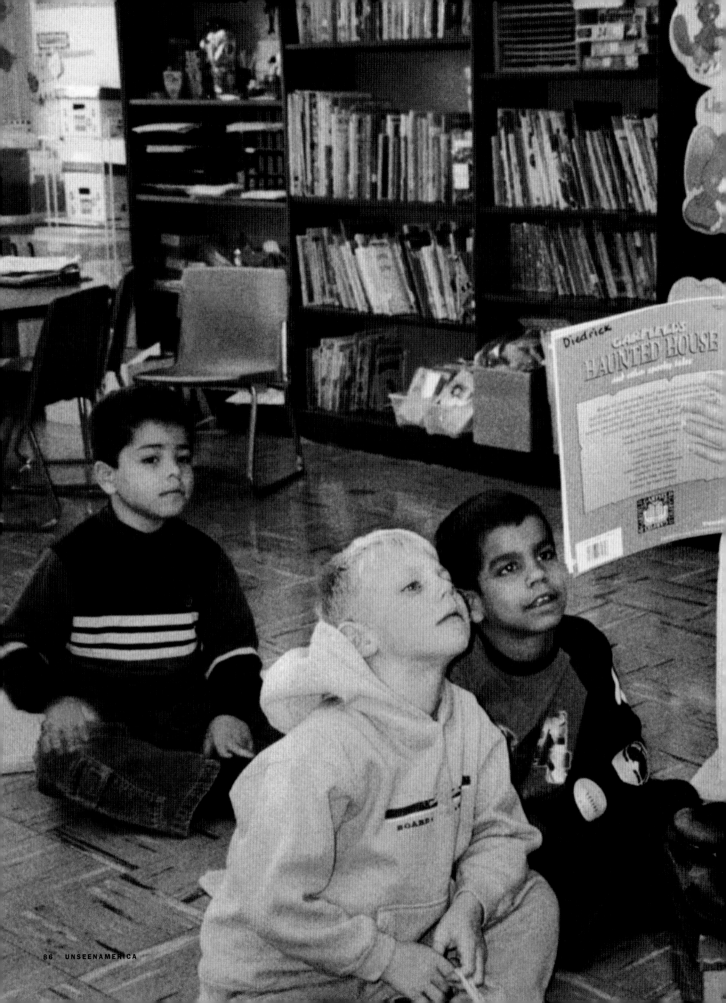

SANDRA RUTH
LIBRARY ASSISTANT
SEIU DISTRICT 1199 WV/KY/OH
CLEVELAND, OH

GIRL READING BOOK TO CHILDREN IN LIBRARY

This girl teaches in a primary classroom for students with special needs. Here she rewards some of her students with an interesting story. They have learned to sit still for longer periods of time and can enjoy stories more.

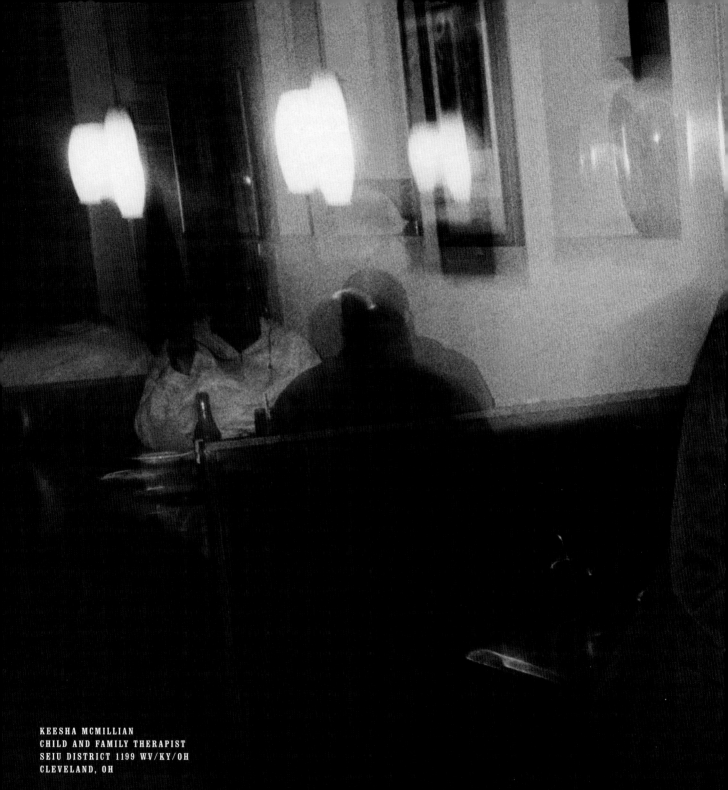

KEESHA MCMILLIAN
CHILD AND FAMILY THERAPIST
SEIU DISTRICT 1199 WV/KY/OH
CLEVELAND, OH

TWO ELDERLY WOMEN, ONE IN WHITE HAT, ONE IN BLACK

Sister Juanita is one of the first African American nuns in the Catholic Diocese. Her birth sister Miss Aurelia planned her a birthday celebration with family and friends. The two birth sisters in this picture are over seventy years old.

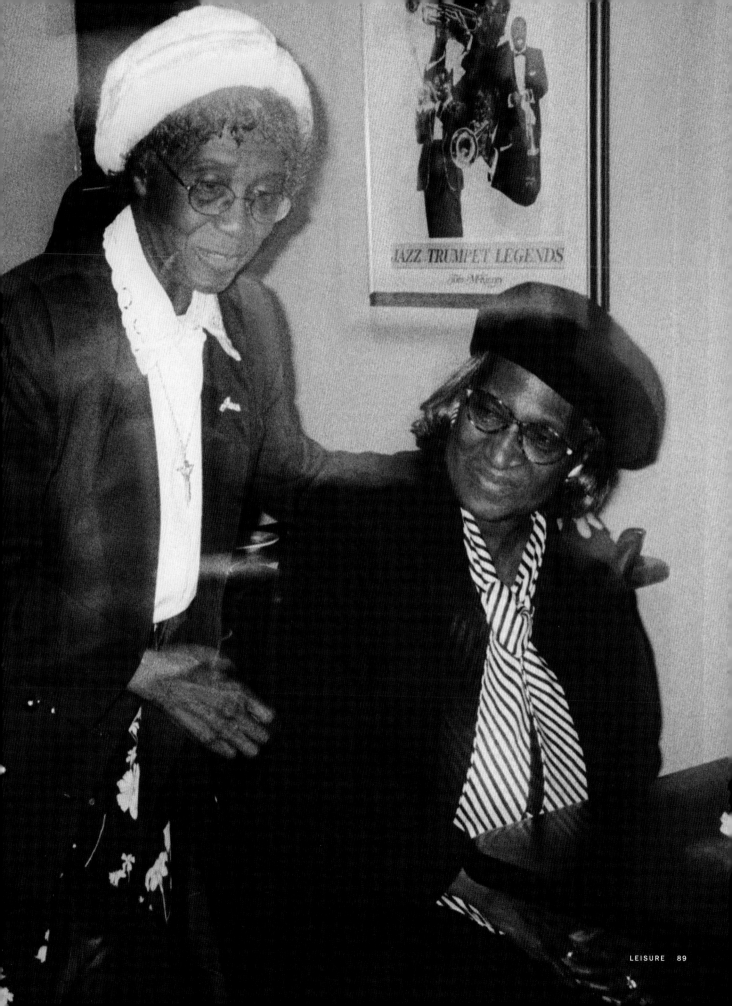

COMM

BERTA ALICIA GOMEZ
JANITOR
SEIU LOCAL 82
WASHINGTON, DC

AN OLD BUILDING

I live one block from the new Convention Center. It was promised that all the old buildings around it would get a facelift when the beautiful new building was complete, but it doesn't look so.

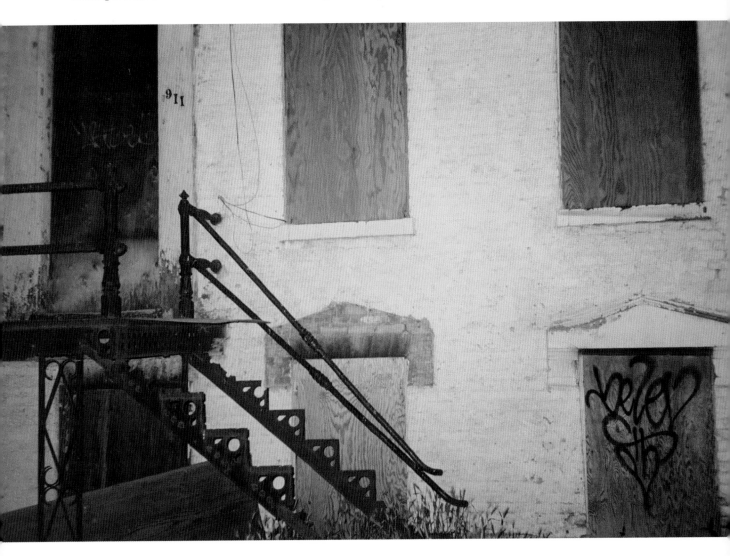

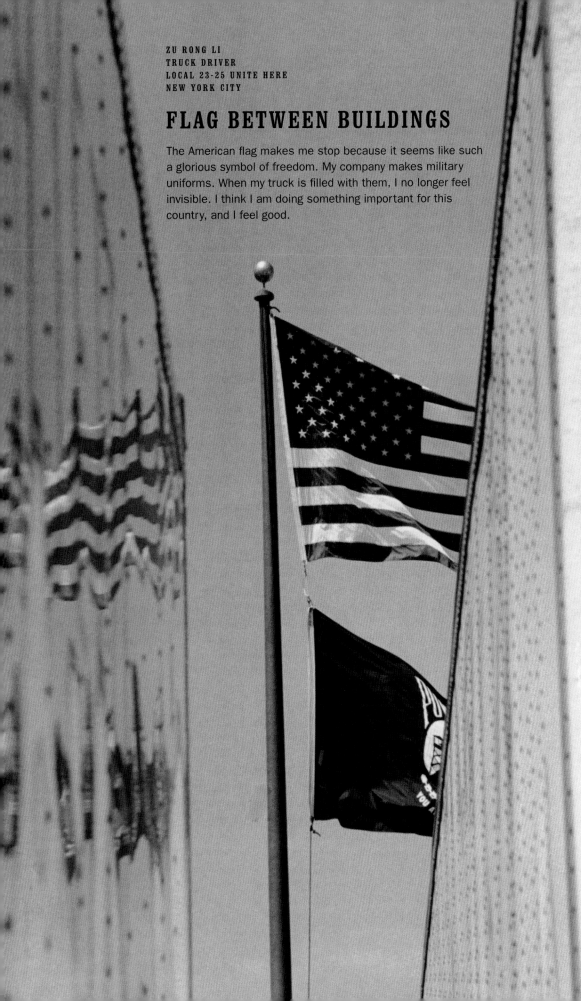

ZU RONG LI
TRUCK DRIVER
LOCAL 23-25 UNITE HERE
NEW YORK CITY

FLAG BETWEEN BUILDINGS

The American flag makes me stop because it seems like such
a glorious symbol of freedom. My company makes military
uniforms. When my truck is filled with them, I no longer feel
invisible. I think I am doing something important for this
country, and I feel good.

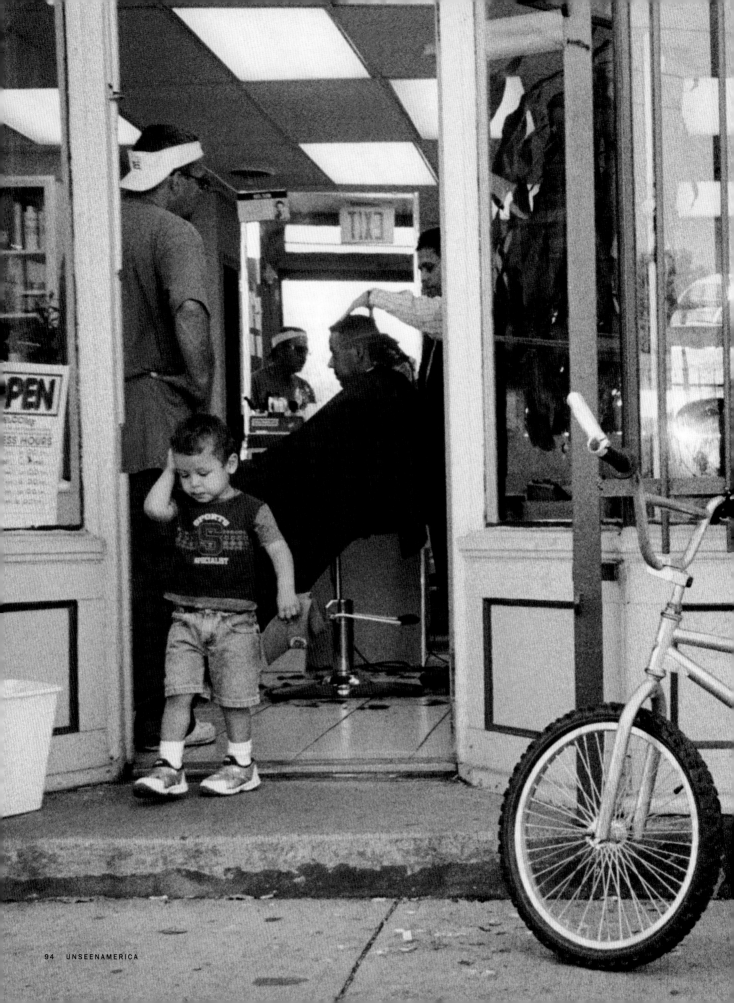

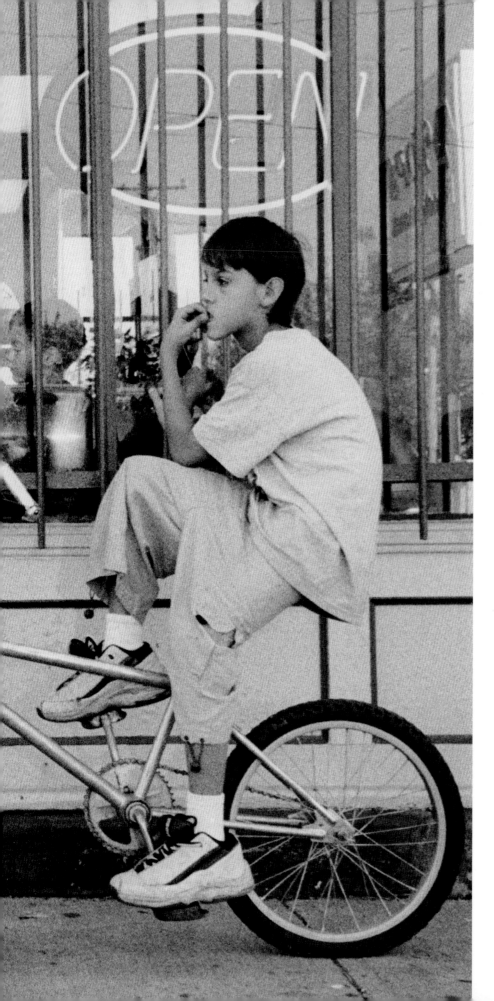

KIVIN BAUZO
SUPPORT ADMINISTRATOR
SEIU DISTRICT 1199 WV/KY/OH
CUYAHOGA COUNTY BOARD OF MENTAL
 RETARDATION AND DEVELOPMENTAL
 DISABILITIES
CLEVELAND, OH

WAITING

A year ago I had an interview for the job I have now. Since I really wanted this job, my mother made a promise to God that she would not cut her hair for one year in faith that I got the job. After the year was completed my mother had a nice hair cut in a nearby unisex salon. I decided to get my haircut too, and saw this salon eight blocks from my house. I gave them a try, and as I was leaving, noticed a boy resting on his bike. I thought it was neat the way you could see somebody outside and people inside the barber shop.

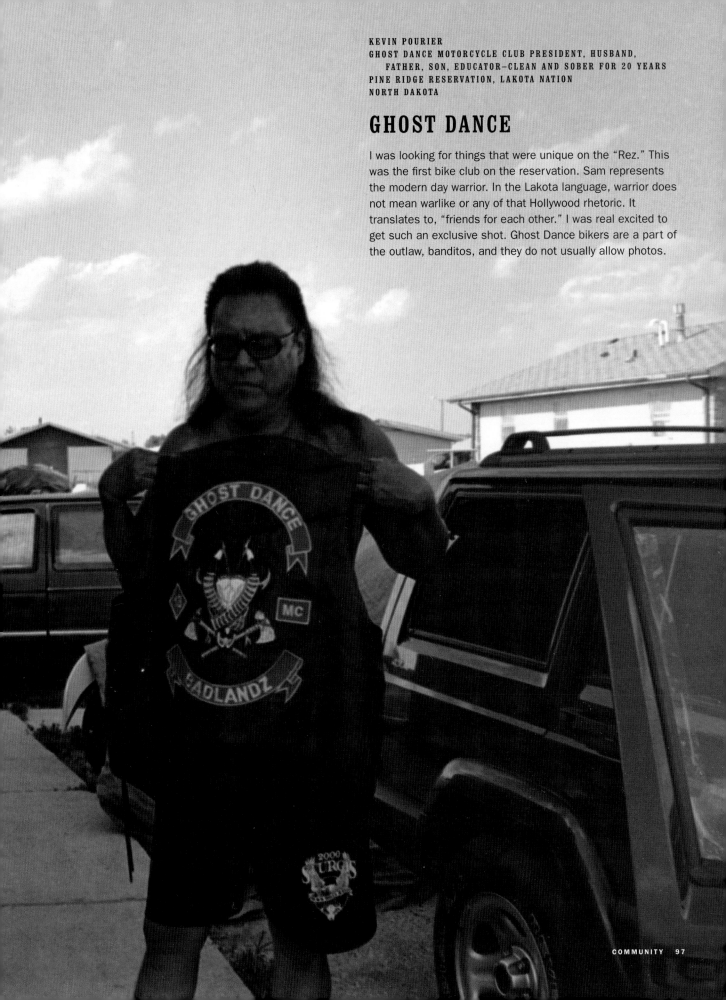

KEVIN POURIER
GHOST DANCE MOTORCYCLE CLUB PRESIDENT, HUSBAND,
 FATHER, SON, EDUCATOR—CLEAN AND SOBER FOR 20 YEARS
PINE RIDGE RESERVATION, LAKOTA NATION
NORTH DAKOTA

GHOST DANCE

I was looking for things that were unique on the "Rez." This was the first bike club on the reservation. Sam represents the modern day warrior. In the Lakota language, warrior does not mean warlike or any of that Hollywood rhetoric. It translates to, "friends for each other." I was real excited to get such an exclusive shot. Ghost Dance bikers are a part of the outlaw, banditos, and they do not usually allow photos.

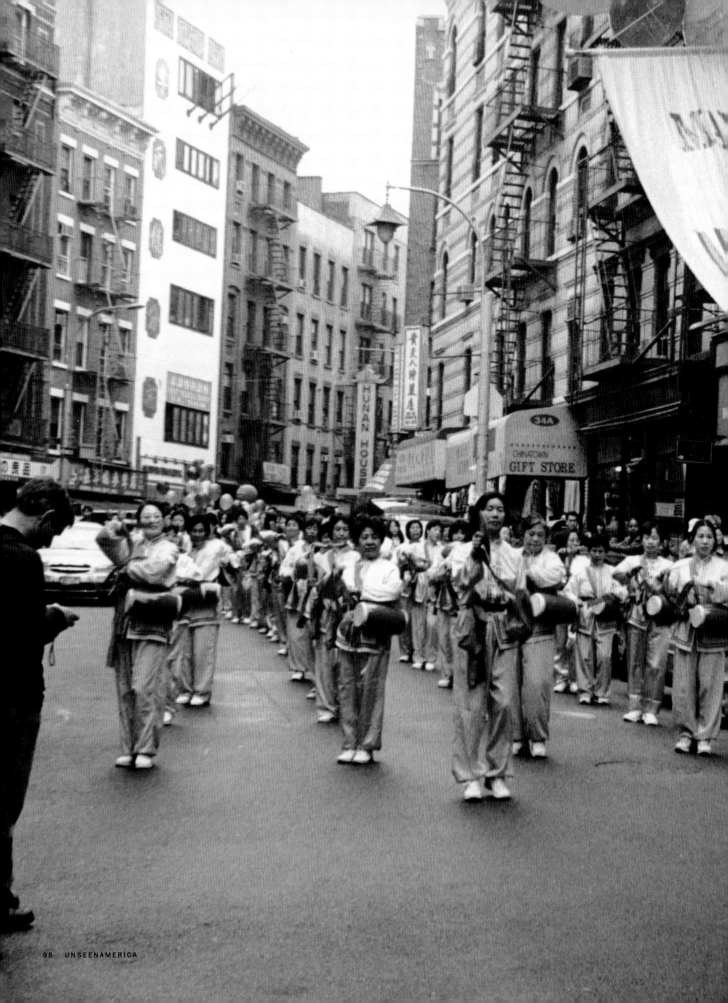

LILY CHAN
GARMENT WORKER
LOCAL 23-25 UNITE HERE
NEW YORK CITY

UNTITLED

Parade in Chinatown celebrating a Falun Gong religious holiday. This religious group is persecuted in China, but they are free to worship in America.

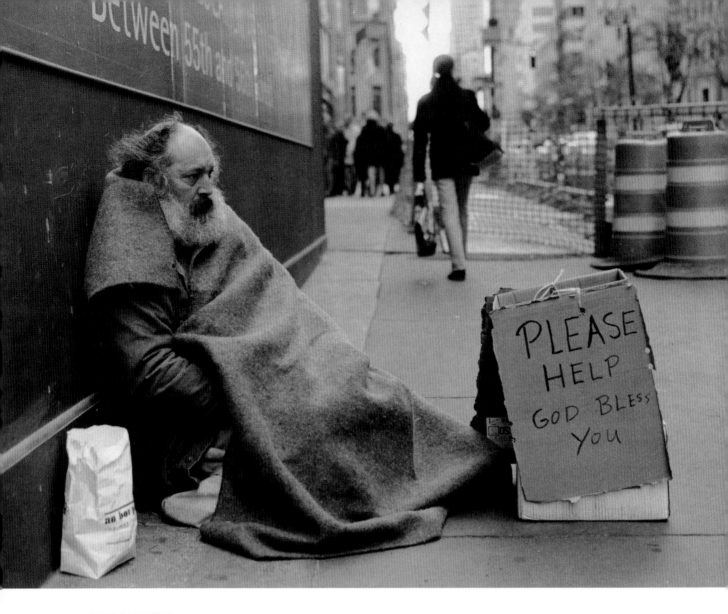

MARIA LAGUARDIA
DENTAL ASSISTANT
1199SEIU
PRISON HEALTH SYSTEMS—RIKERS ISLAND
NEW YORK CITY

UNTITLED

I didn't ask him. He wasn't moving. I just took his picture and gave him a dollar. It was as if he was in his own world.

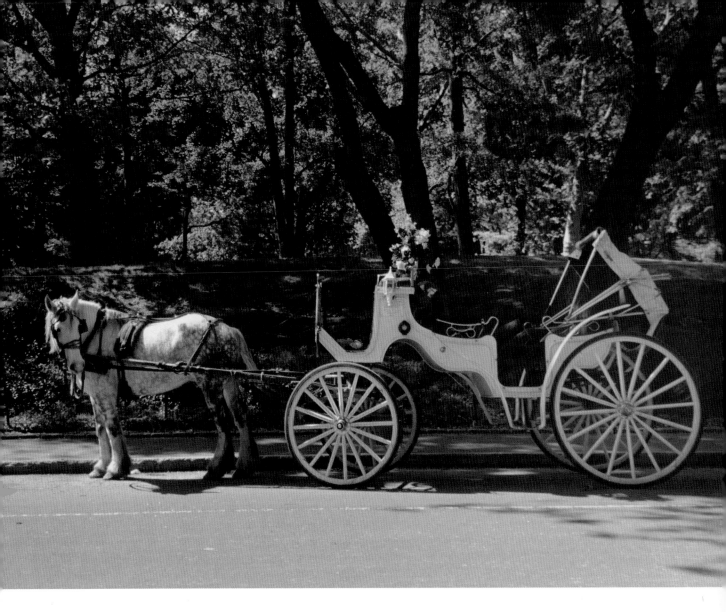

BARBARA FU
BILL PROCESSOR
1199SEIU
VISITING NURSE SERVICE OF NEW YORK
NEW YORK CITY

UNTITLED

I took this picture of a horse pulling a carriage outside Central Park. The horse represents my work life. I am doing my work and living my life by the company rules, not according to my free will. I am like the horse.

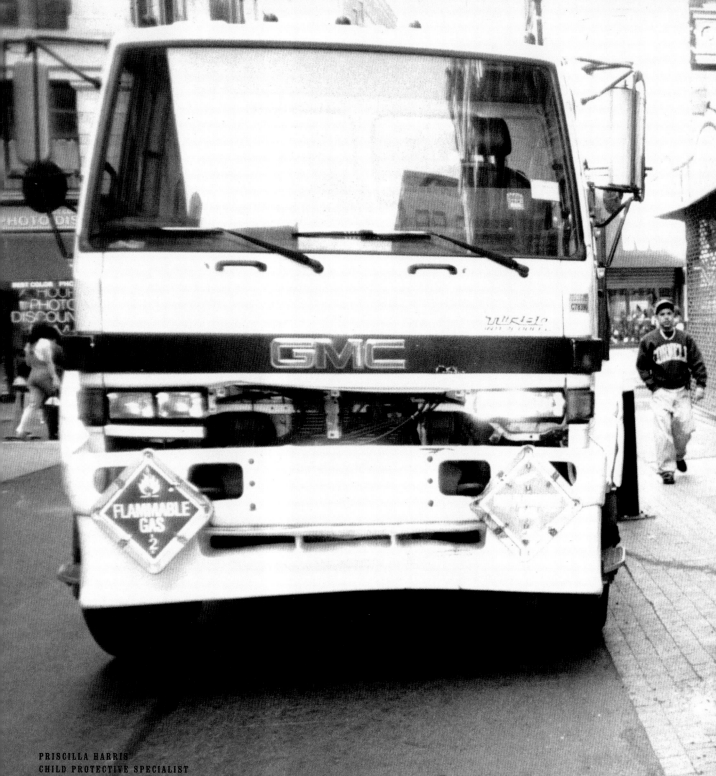

PRISCILLA HARRIS
CHILD PROTECTIVE SPECIALIST
SUPERVISOR II
SSEU LOCAL 371 AFSCME
ADMINISTRATION FOR CHILDREN'S SERVICE
NEW YORK CITY

UNTITLED

I pass this gentleman every day coming to work, and sometimes we speak. I get to work at 8:00 a.m., and he's already out there. I'm awed by his diligence.

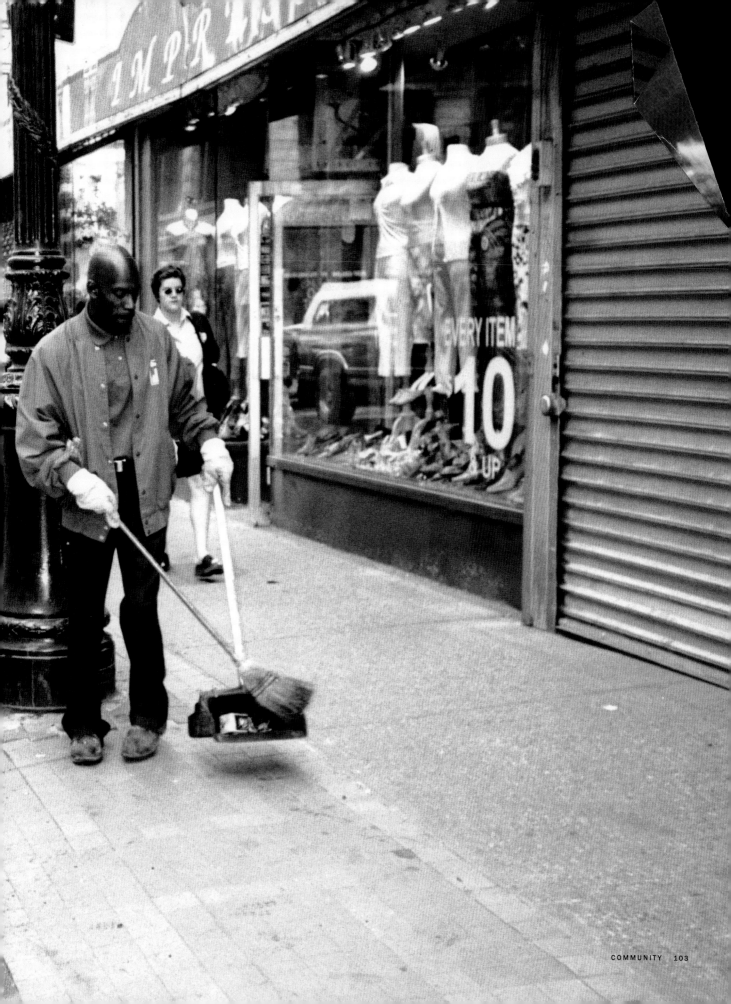

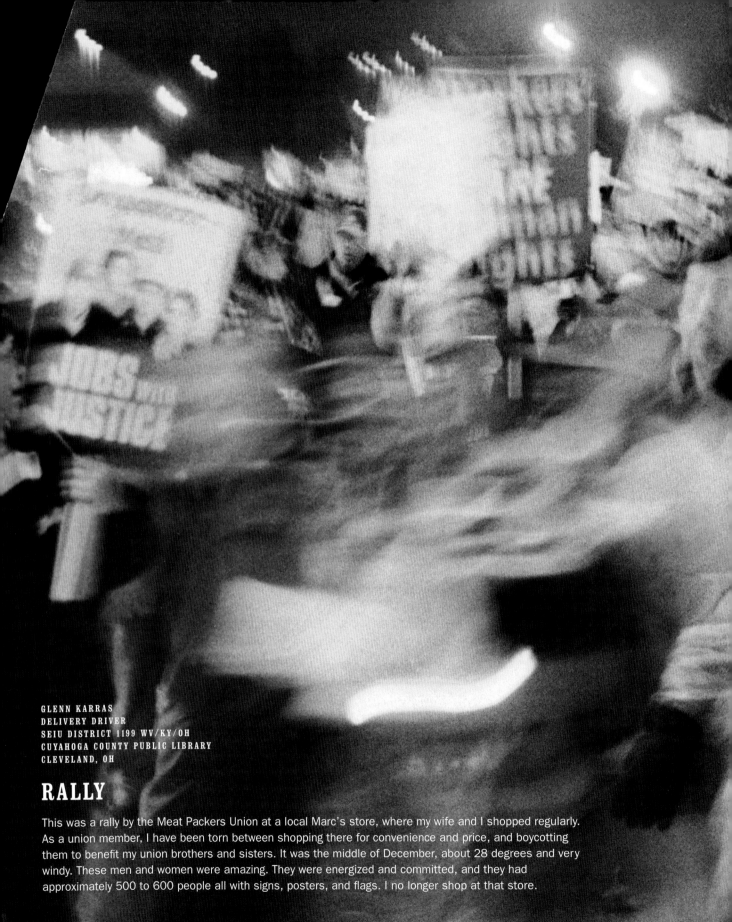

GLENN KARRAS
DELIVERY DRIVER
SEIU DISTRICT 1199 WV/KY/OH
CUYAHOGA COUNTY PUBLIC LIBRARY
CLEVELAND, OH

RALLY

This was a rally by the Meat Packers Union at a local Marc's store, where my wife and I shopped regularly. As a union member, I have been torn between shopping there for convenience and price, and boycotting them to benefit my union brothers and sisters. It was the middle of December, about 28 degrees and very windy. These men and women were amazing. They were energized and committed, and they had approximately 500 to 600 people all with signs, posters, and flags. I no longer shop at that store.

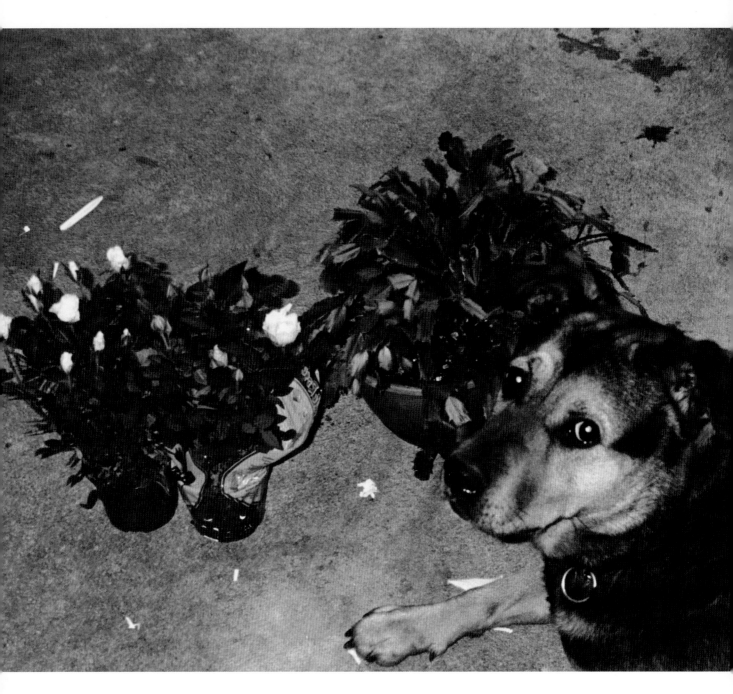

EVA CHEN
GARMENT WORKER
LOCAL 23-25 UNITE HERE
NEW YORK CITY

UNTITLED

This is my dog, Andy. She understands everything in Chinese and English! She is bilingual!

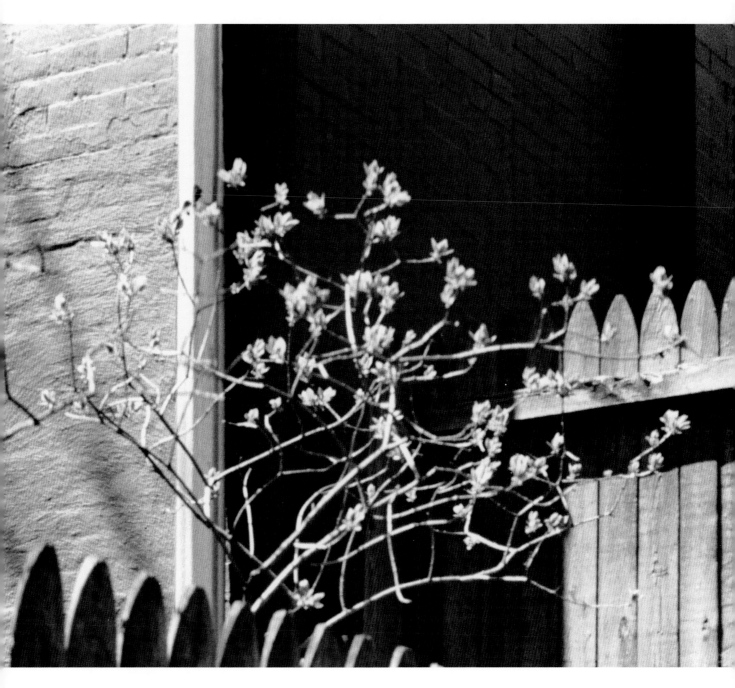

YING LI
GARMENT WORKER
LOCAL 23-25 UNITE HERE
NEW YORK CITY

UNTITLED

A flowering tree in a backyard in New York. It was the end of winter and I was looking for spring.

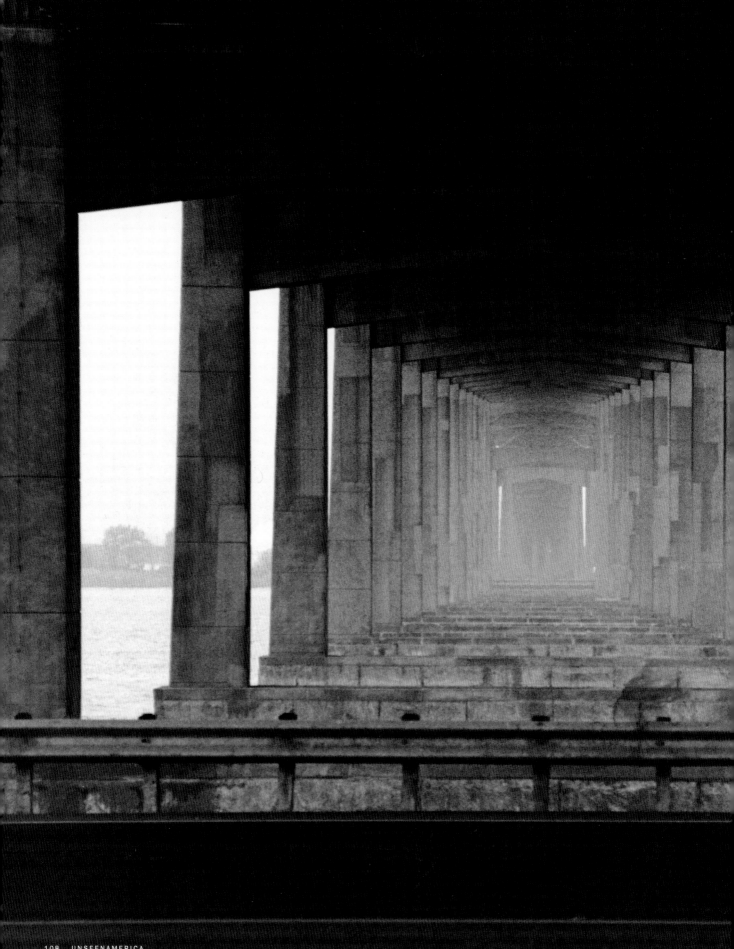

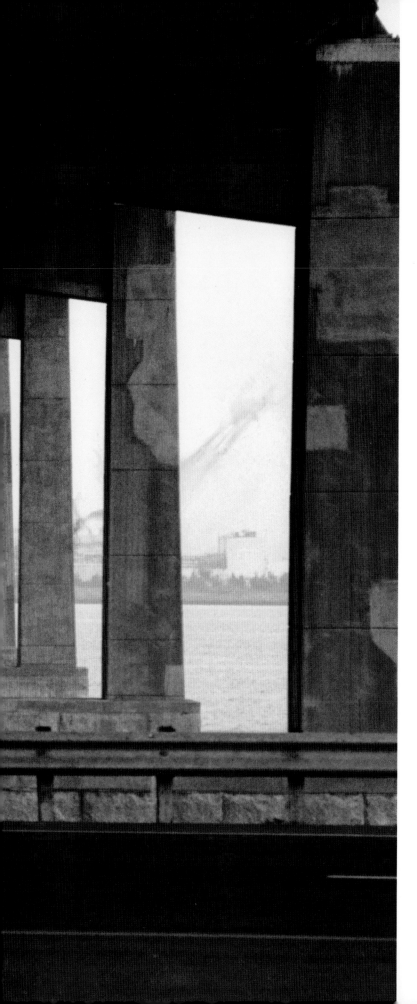

ZU RONG LI
TRUCK DRIVER
LOCAL 23-25 UNITE HERE
NEW YORK CITY

BRIDGE OF OUR DREAMS

Beneath a bridge I saw a long row of columns that I considered an image of continuity and friendship.

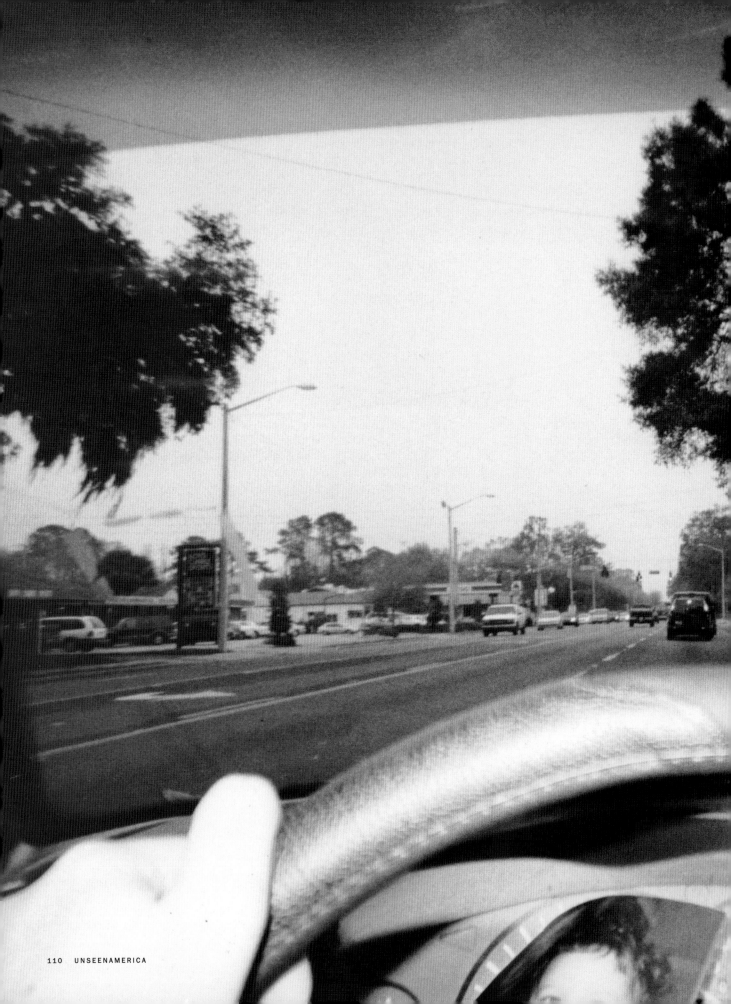

JENNIFER LONG
WOMEN IN TRANSITION
GAINESVILLE, FL

DRIVING WITH STEERING WHEEL

This is me daily. Constantly going from home to work, from work to school, from school to home. Somehow, time doesn't always permit driving the speed limit. But my eyes stay on the road, determined to make it to my destination safely. My son remains a constant thought as well, because it is he I desire to see at the end of a long day. I feel like I live in my car.

...ce f... ...ich ...nkawa...

...therefore, mind... ...e g... ...s, the bl... ...sister... ...joy... ...icipation ofthat I accept the ...nor the Swedish Ac... ...y has done to share what for me a moment of grace."

— Toni Morrison, winner of the 1993 Nobel Prize... Literature
Banquet speech deli... ...the...

ENEDINA LOZANO
LIBRARY SPECIALIST
SEIU DISTRICT 1199 WV/KY/OH
LORAIN PUBLIC LIBRARY
CLEVELAND, OH

WINDOW WRITING

This is Louie, a patron that comes into the library every morning. He reads the papers and checks his stock. We wave every time we see each other. He's always telling jokes or stories. He sits in the same spot, right in front of the writing on the glass.

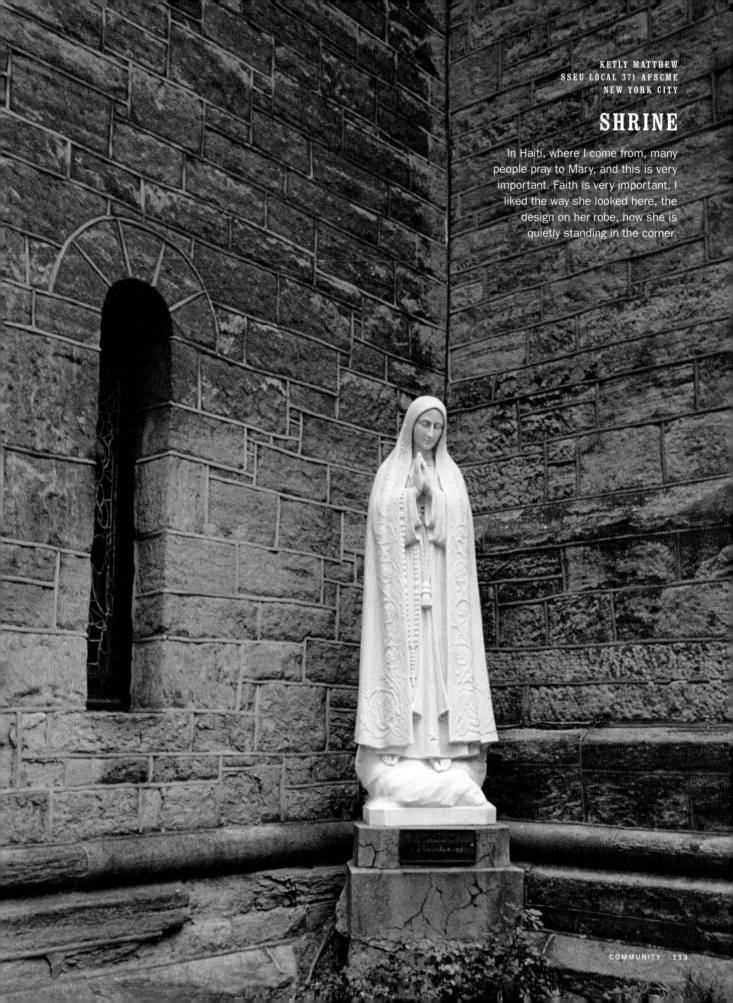

KETLY MATTHEW
SSEU LOCAL 371 AFSCME
NEW YORK CITY

SHRINE

In Haiti, where I come from, many people pray to Mary, and this is very important. Faith is very important. I liked the way she looked here, the design on her robe, how she is quietly standing in the corner.

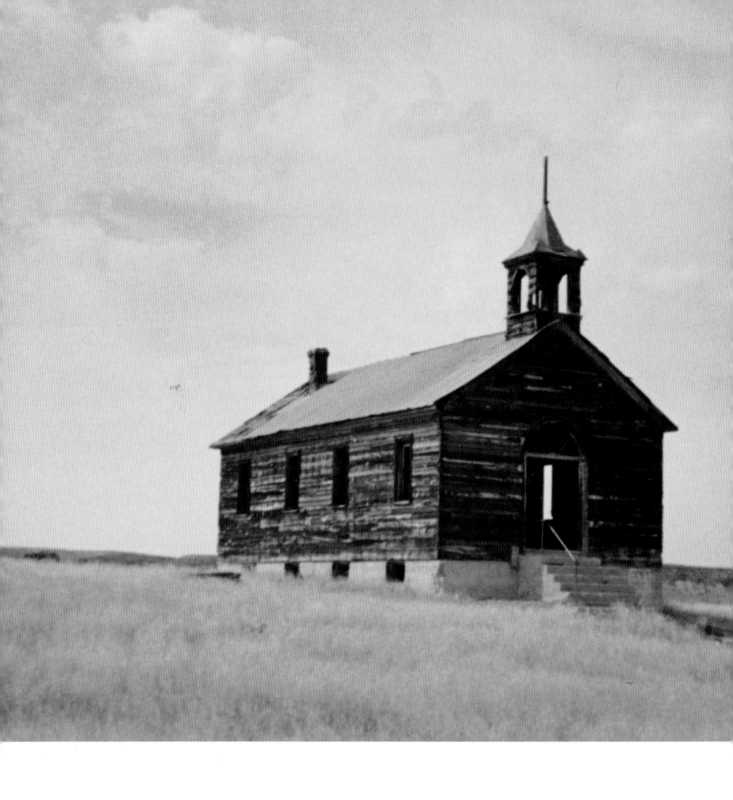

TRAVIS NELSON
PINE RIDGE RESERVATION, LAKOTA NATION
NORTH DAKOTA

CHURCH

This abandoned church in the badlands is a scar on the land. It represents a mark in American history with no resemblance to the history of the Lakota People. Like a ghost town, this picture represents the disregard we have for things that a non-Indian might define his life by.

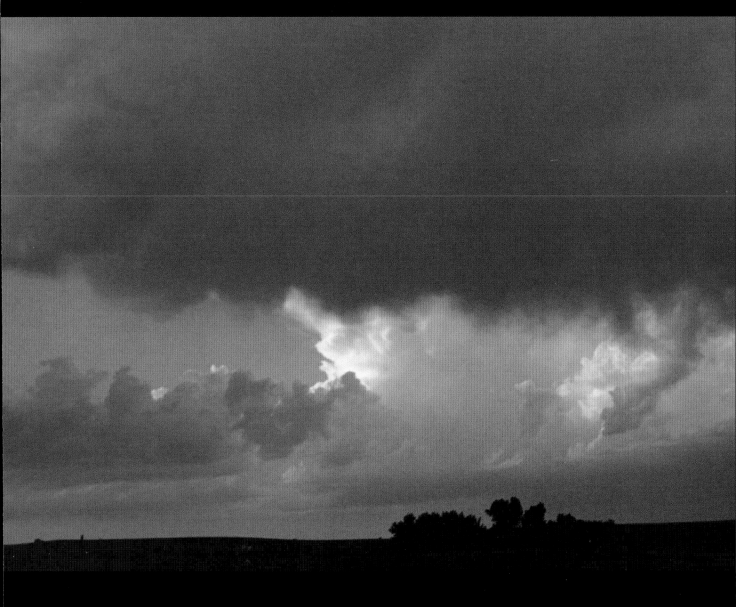

TRAVIS NELSON
PINE RIDGE RESERVATION, LAKOTA NATION
NORTH DAKOTA

CLOUDS

The power of these clouds aroused me to make this picture, because the clouds were so angry. I was completely overwhelmed by the sheer energy that was forming in the sky. This was the kind of sky where tornadoes are born.

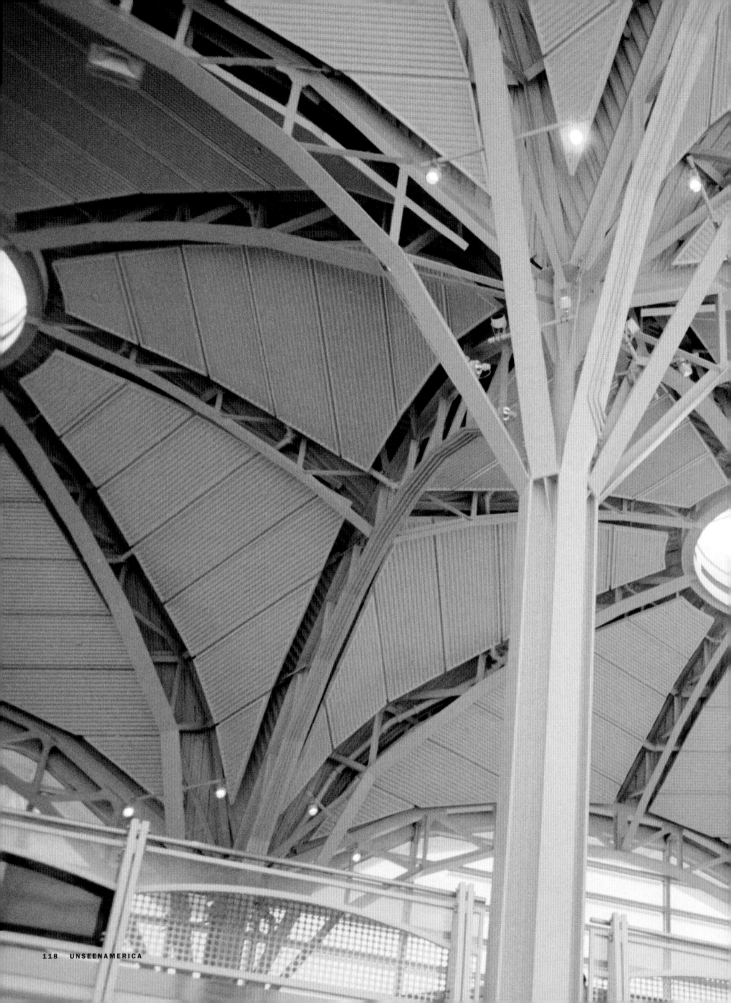

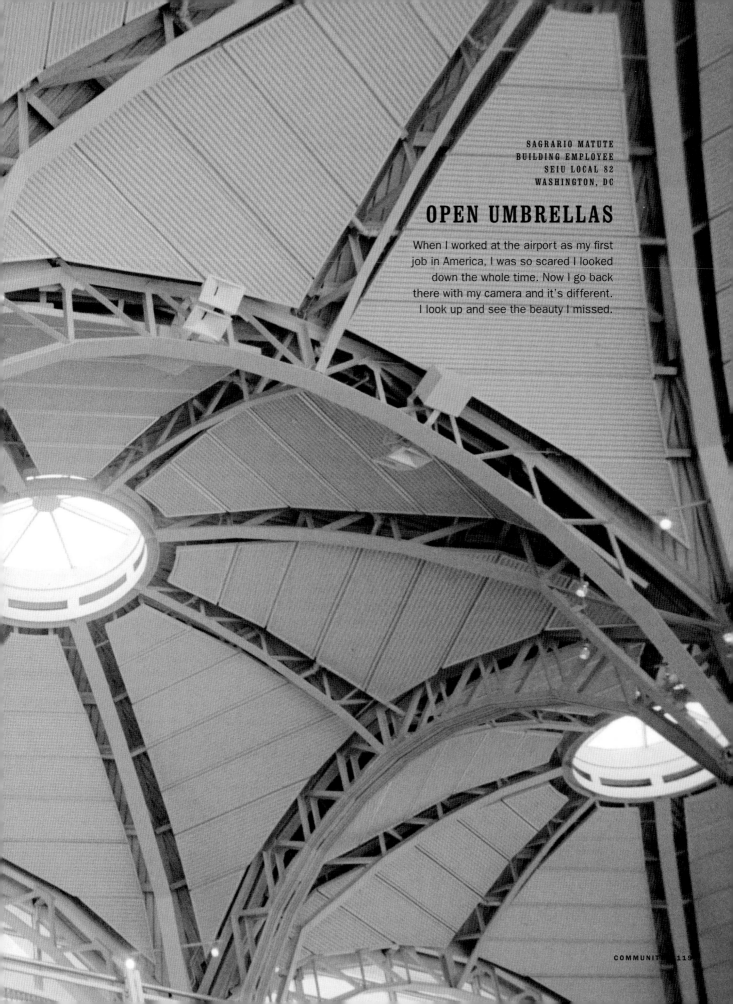

SAGRARIO MATUTE
BUILDING EMPLOYEE
SEIU LOCAL 82
WASHINGTON, DC

OPEN UMBRELLAS

When I worked at the airport as my first
job in America, I was so scared I looked
down the whole time. Now I go back
there with my camera and it's different.
I look up and see the beauty I missed.

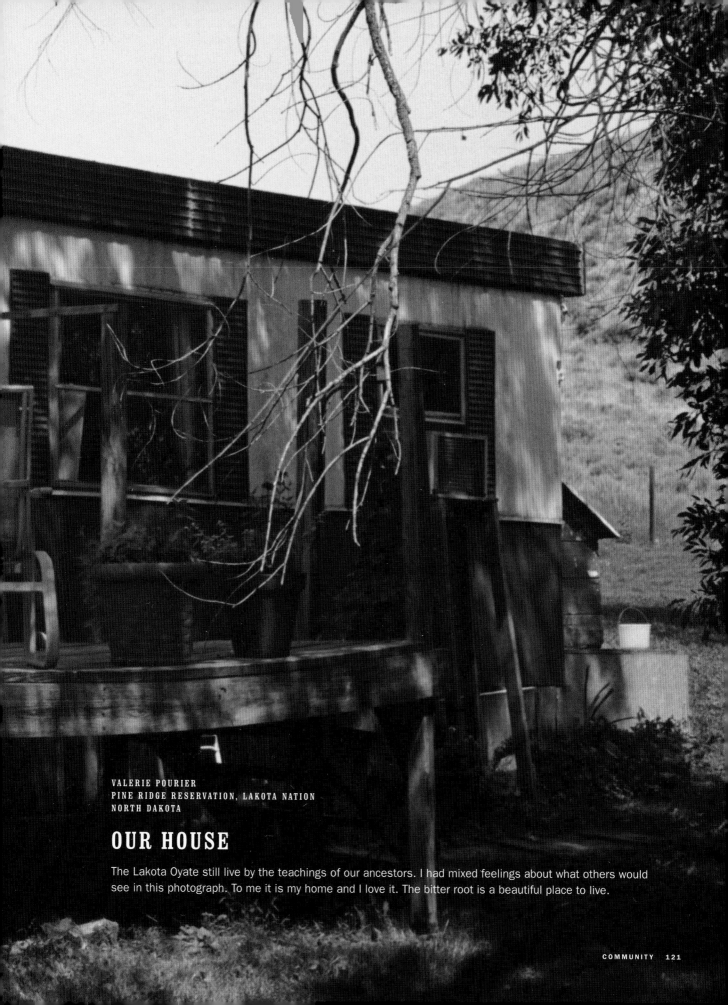

VALERIE POURIER
PINE RIDGE RESERVATION, LAKOTA NATION
NORTH DAKOTA

OUR HOUSE

The Lakota Oyate still live by the teachings of our ancestors. I had mixed feelings about what others would see in this photograph. To me it is my home and I love it. The bitter root is a beautiful place to live.

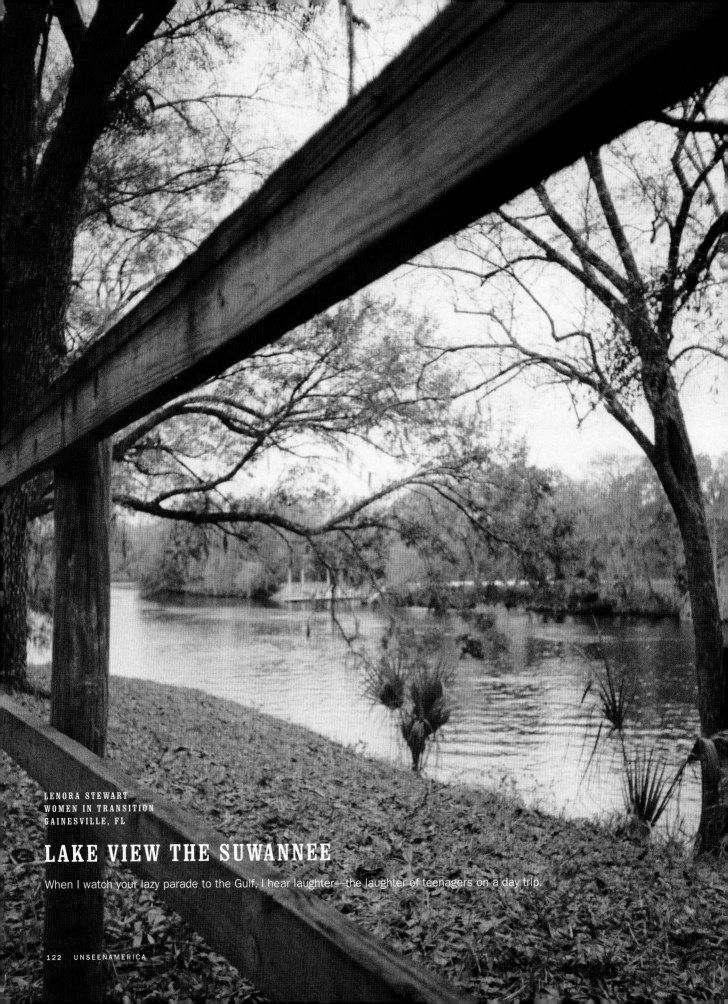

LENORA STEWART
WOMEN IN TRANSITION
GAINESVILLE, FL

LAKE VIEW THE SUWANNEE

When I watch your lazy parade to the Gulf, I hear laughter—the laughter of teenagers on a day trip.

ROXANA SANDOVAL
BUILDING EMPLOYEE
SEIU LOCAL 82
WASHINGTON, DC

SWEET DREAMS

A man sleeping on a hard bench. I imagine that he just
sleeps whenever he feels tired, no matter where he is.

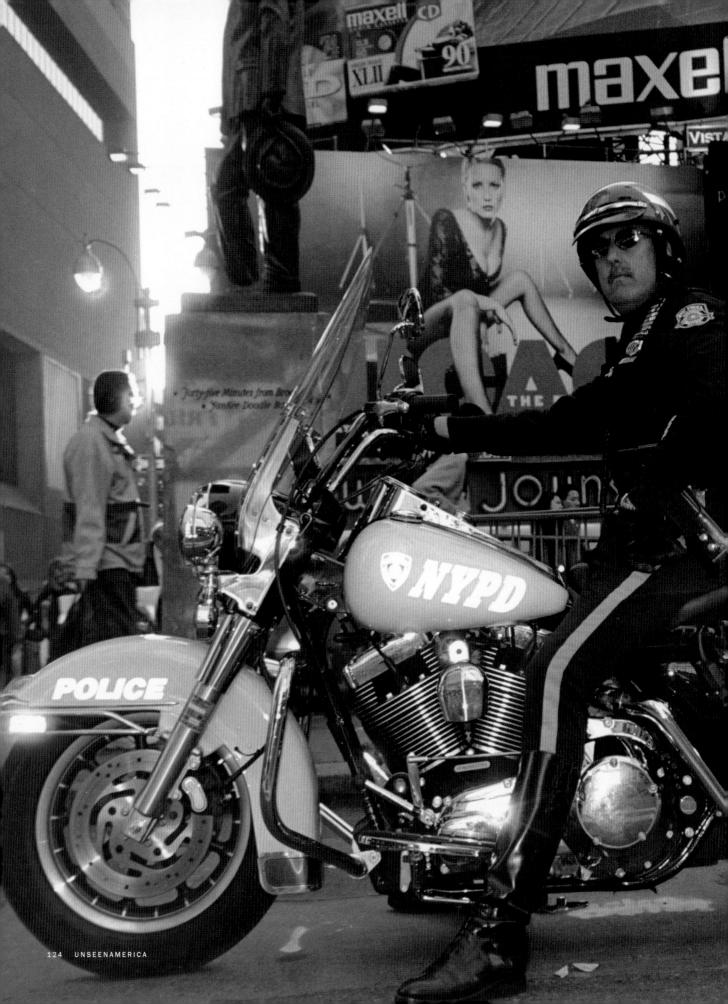

BASIL SAUNDERS JR.
CHILD PROTECTIVE SPECIALIST
SUPERVISOR II
SSEU LOCAL 371 AFSCME
ADMINISTRATION FOR CHILDREN'S
 SERVICES
NEW YORK CITY

COP ON MOTORCYCLE

This picture in Times Square has echoes of the glamorous 1920s. I like the contrast of the policemen with the big signs.

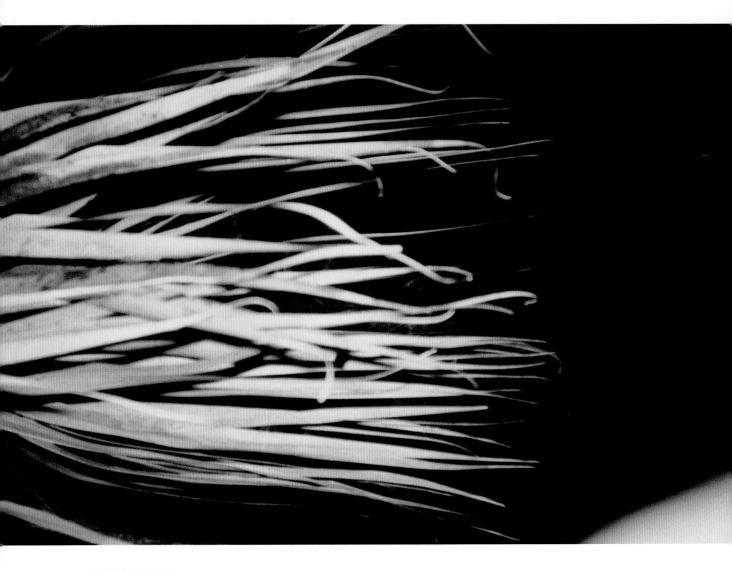

LENORA STEWART
WOMEN IN TRANSITION
GAINESVILLE, FL

A PALM AT MIDNIGHT

Only the weird walk at midnight.

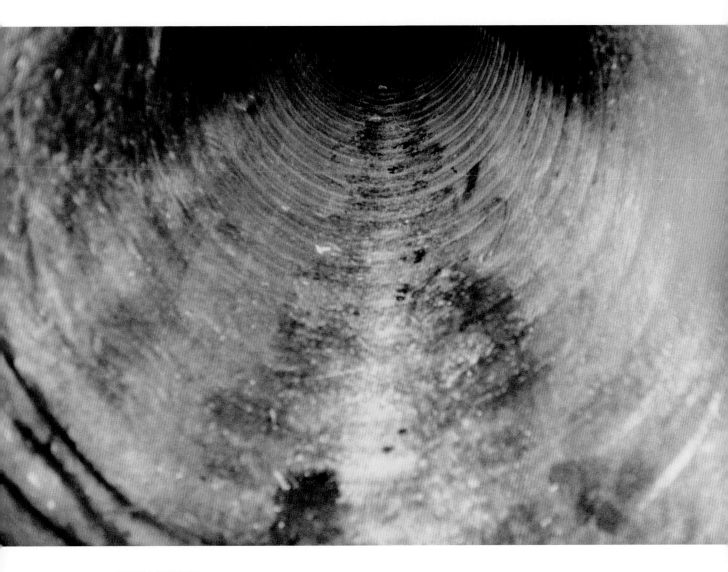

LENORA STEWART
WOMEN IN TRANSITION
GAINESVILLE, FL

A DRAINAGE PIPE

If I were to walk by on a cold, rainy night, I would see an oak snake hurrying to take refuge in your warmth. But I don't.

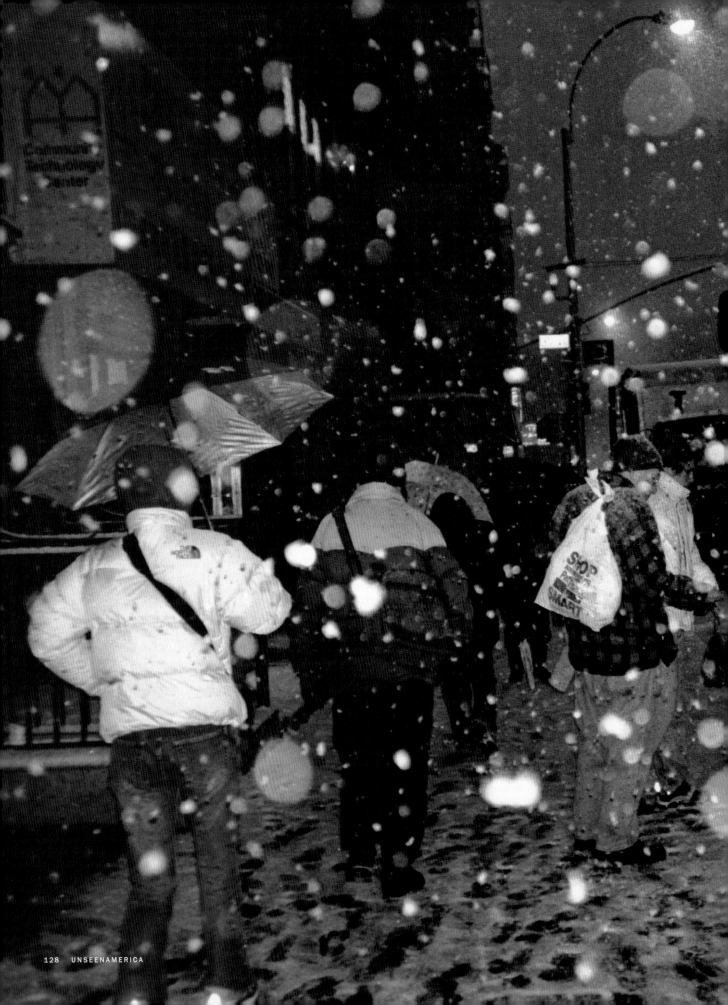

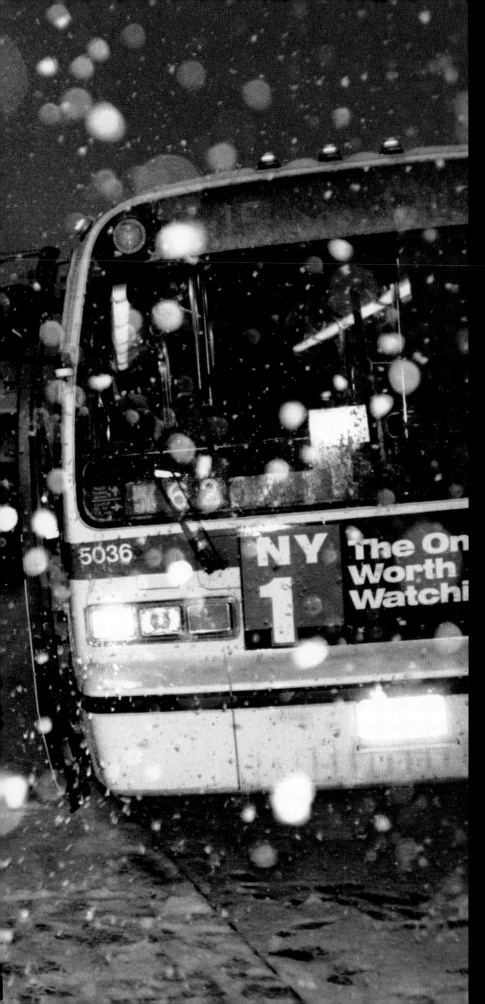

SING KONG WONG
RETIRED PRESSER/PRESIDENT OF
 THE CHINESE RETIREES CLUB
LOCAL 23-25 UNITE HERE
NEW YORK CITY

ON THE WAY
BACK IN RAIN
AND SNOW

We are anxious to return home.

KENNY SHANE
BUILDING SUPERVISOR
SEIU LOCAL 32BJ
NEW YORK CITY

PIPES

Everybody has a creative side. It is just a question of giving them the tools to express themselves.

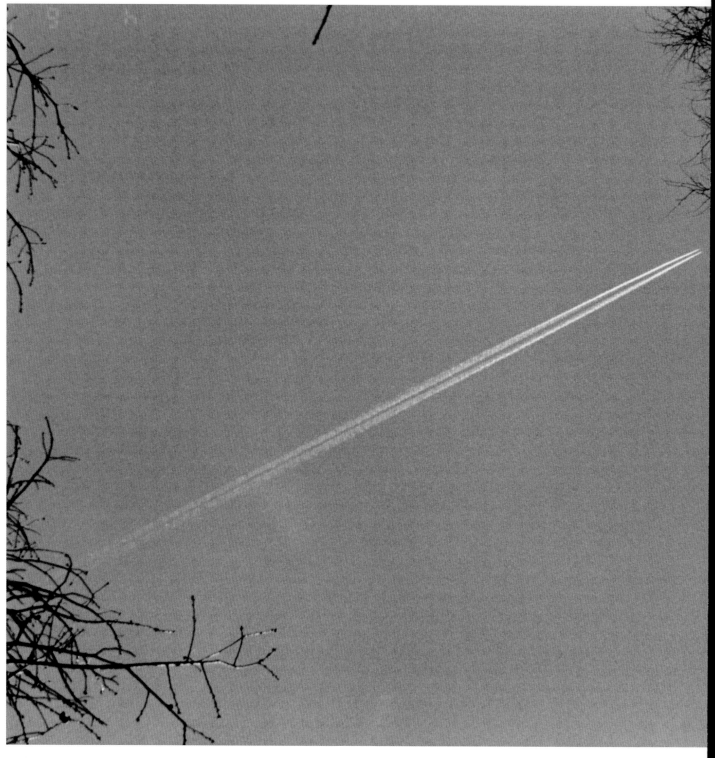

YING LI
GARMENT WORKER
LOCAL 23-25 UNITE HERE
NEW YORK CITY

SKY WRITING

A jet stream over New York. I was hoping that
someone would write my name in the sky.

KEVIN POURIER
PINE RIDGE RESERVATION, LAKOTA NATION
NORTH DAKOTA

SWEET GRASS AND EAGLE FEATHERS

The sweet grass and eagle feathers in this photo are the artifacts used in our spiritual ceremonies. Most Lakota people have them in their possession. An integral part of our everyday life, they are cared for with great respect. To the Lakota, these are gifts from the Creator. They are a direct connection to our spirituality. Learning who we are as human beings, we are aware of all things, not denying any part of our humanness or our connection to our benefits.

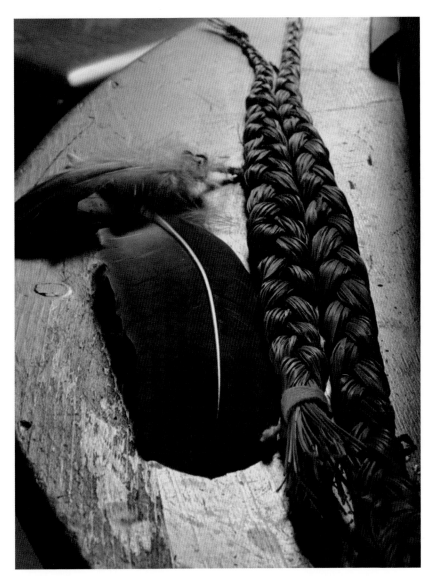

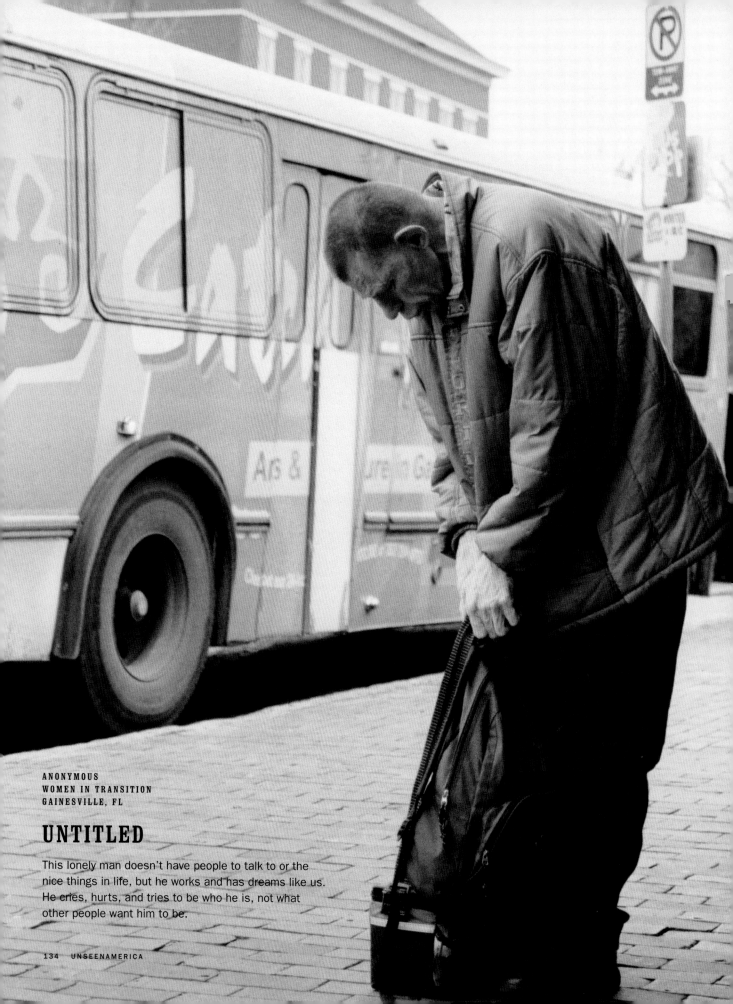

ANONYMOUS
WOMEN IN TRANSITION
GAINESVILLE, FL

UNTITLED

This lonely man doesn't have people to talk to or the
nice things in life, but he works and has dreams like us.
He cries, hurts, and tries to be who he is, not what
other people want him to be.

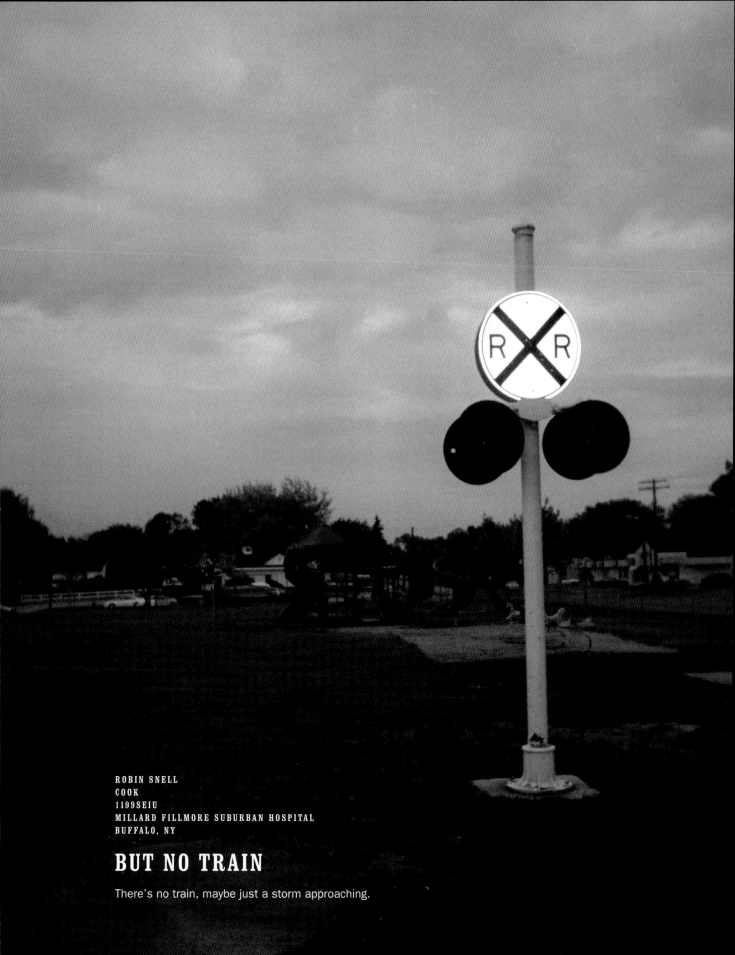

ROBIN SNELL
COOK
1199SEIU
MILLARD FILLMORE SUBURBAN HOSPITAL
BUFFALO, NY

BUT NO TRAIN

There's no train, maybe just a storm approaching.

DAWN GRATTINO
LIBRARIAN TECHNICAL SERVICES
SEIU DISTRICT 1199 WV/KY/OH
CLEVELAND, OH

WINDOW

This is a view of Cleveland that most people never see, and those who can see it mostly don't pay any attention. The library holds many treasures that most people are not aware of, and not all of them are in the collections!

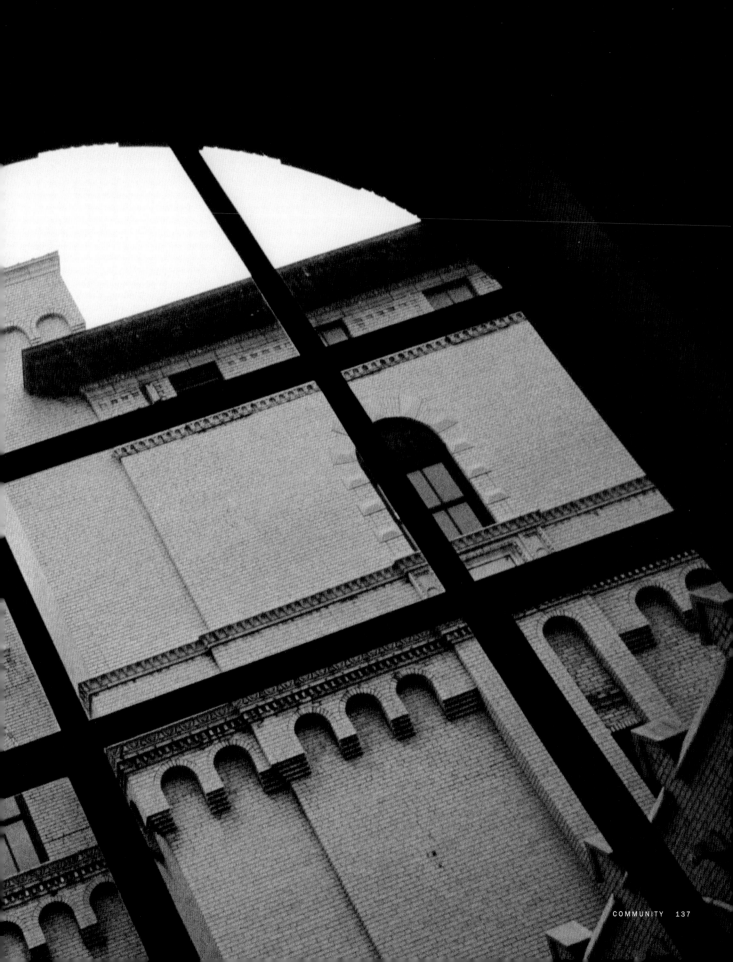

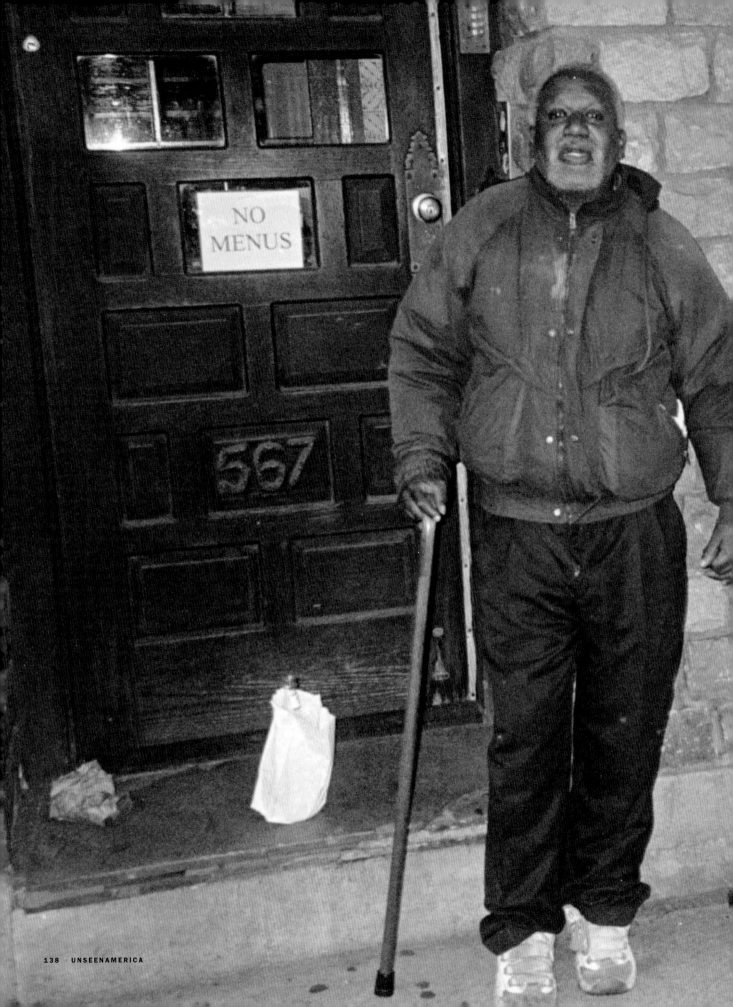

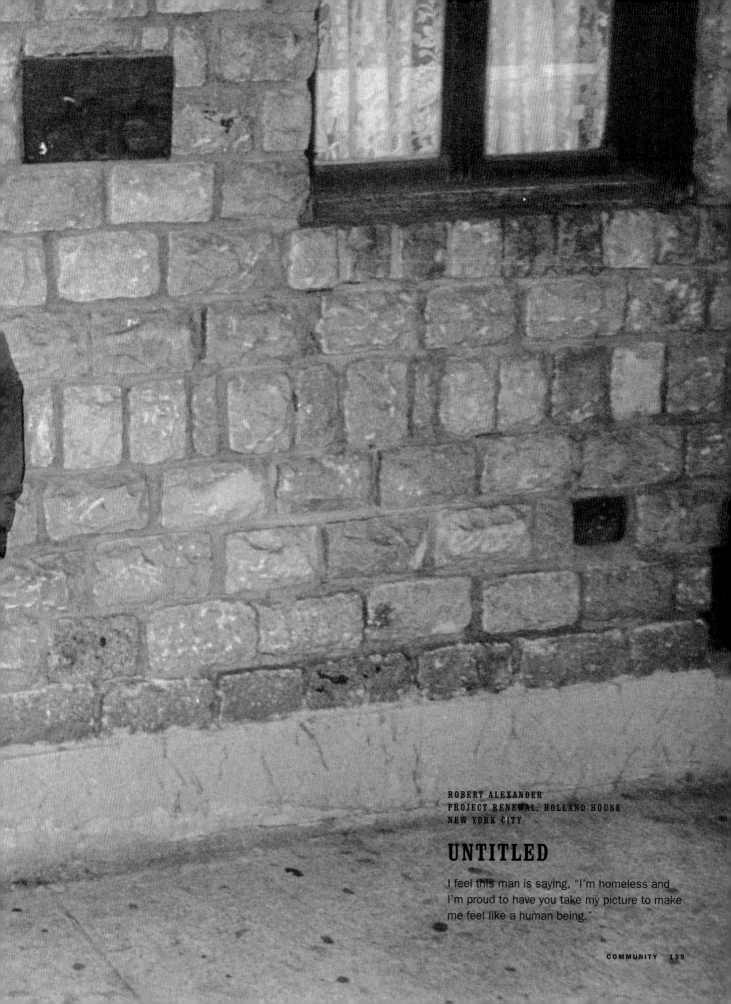

ROBERT ALEXANDER
PROJECT RENEWAL, HOLLAND HOUSE
NEW YORK CITY

UNTITLED

I feel this man is saying, "I'm homeless and
I'm proud to have you take my picture to make
me feel like a human being."

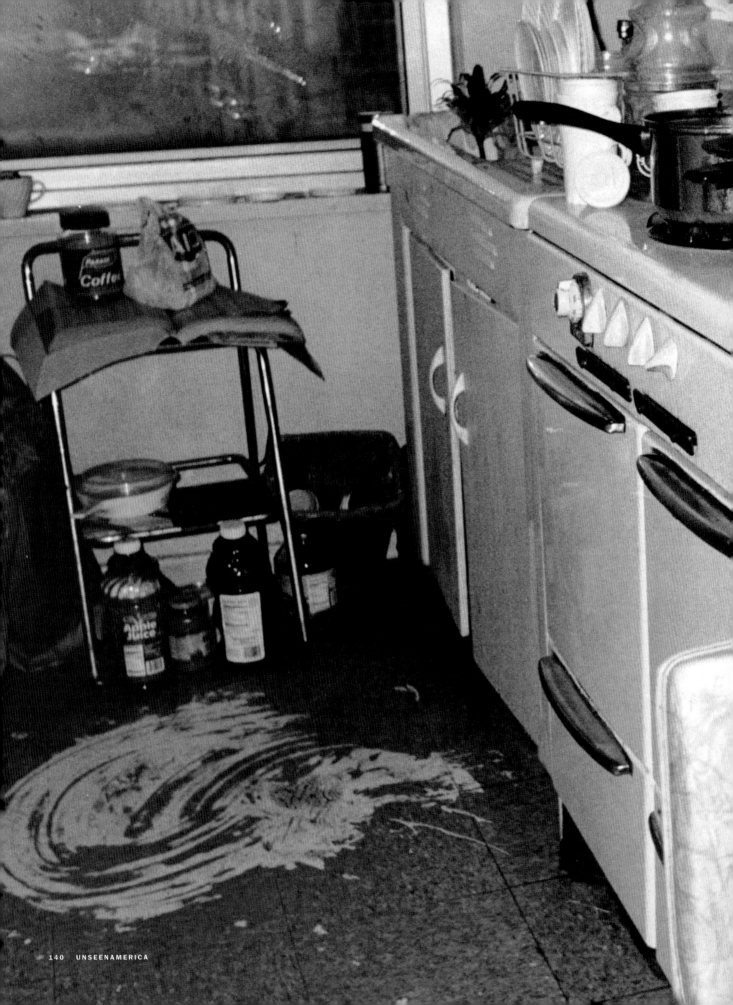

ELSIE KESSLER
PROJECT EZRA
NEW YORK CITY

UNTITLED

I have a very noisy neighbor. I have no choice but to sleep on the couch to avoid the noise. One evening, it was too cold, so I went to the kitchen to shut the window. I moved a step stool out of the way without realizing there was a can of paint on the lower step. The jar fell and the paint splashed all over the floor. If there is a court case, then this picture will serve as evidence of an accident caused indirectly by my noisy neighbor.

SYLVANIE CHARLES
CLERK
1199SEIU NATIONAL BENEFIT FUND
NEW YORK CITY

43RD & 44TH STREET— HOMELESS MAN

Many people still think of America as a land of plenty, but they might not see that America is also a land of many homeless people. Taking this photograph made me see this man in a different way.

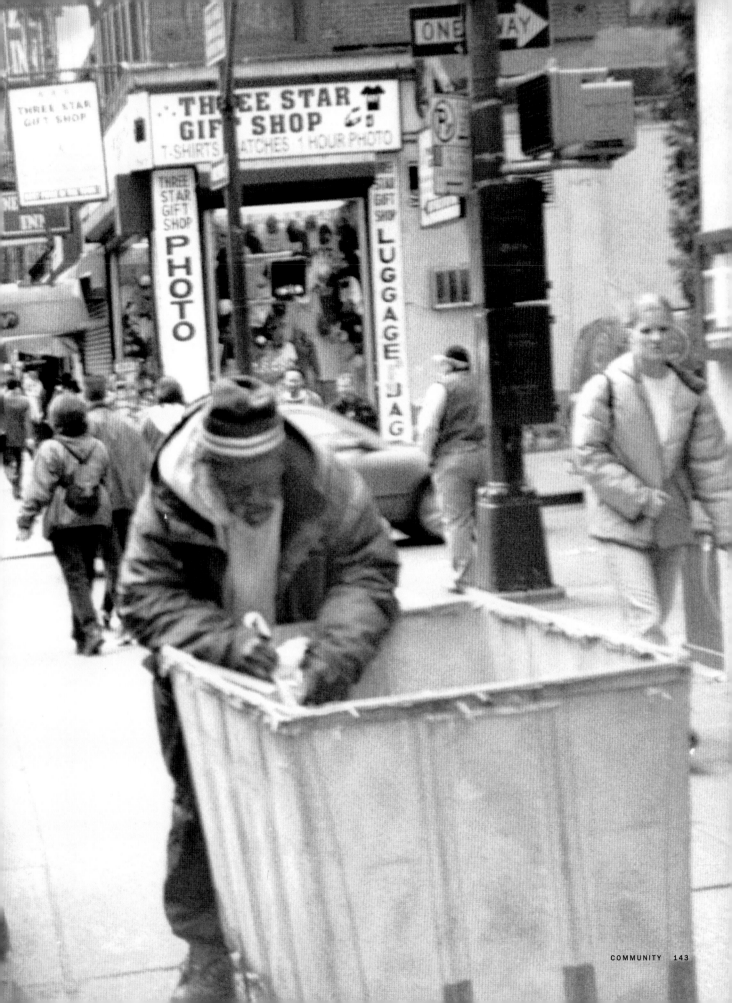

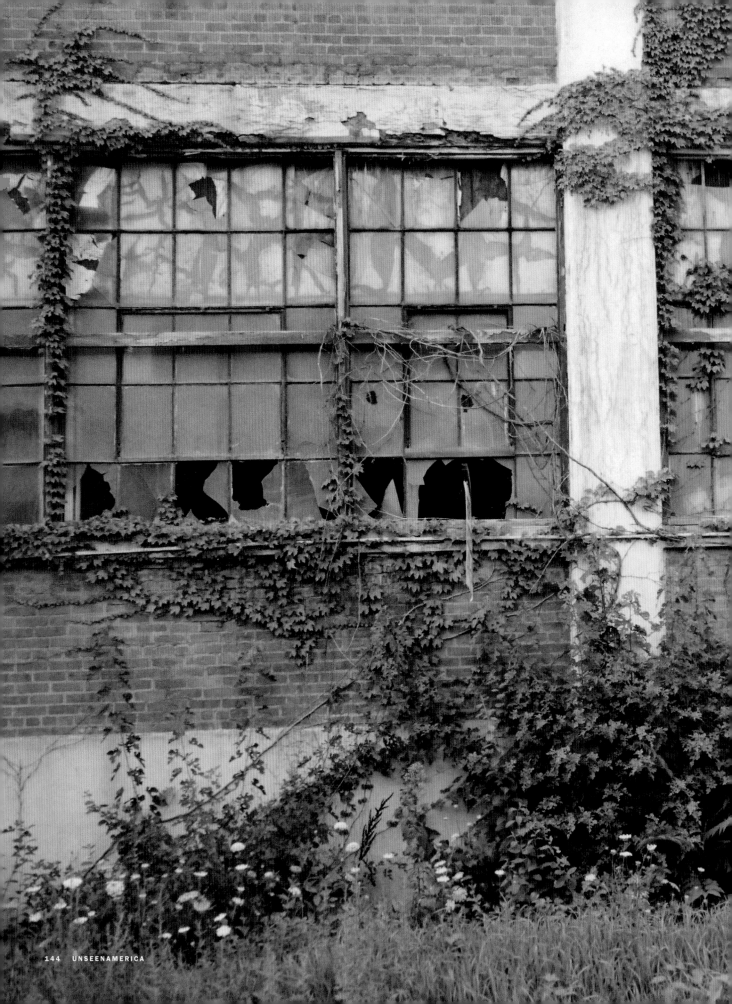

WANDA LUBINSKI
PRESIDENT OF LOCAL CSEA 673
ALBANY, NY

ABANDONED PLANT

Mother Nature takes back yet another abandoned building. The steel mills, GE, Tobin, the garment industry, and others took their profits and left those skeletons behind.

TRACY THOMAS
LICENSED PRACTICAL NURSE
1199SEIU
GRACE MANOR NURSING HOME
BUFFALO, NY

CUTTING THE GRASS

Our homes take time to maintain.

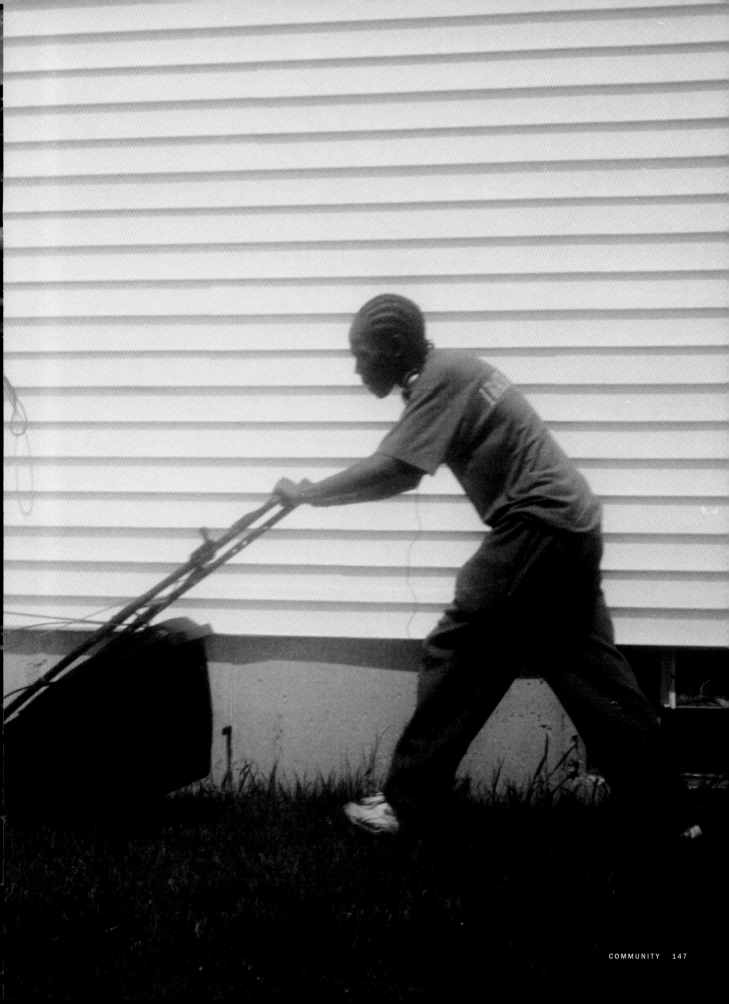

UNTITLED

UNTITLED

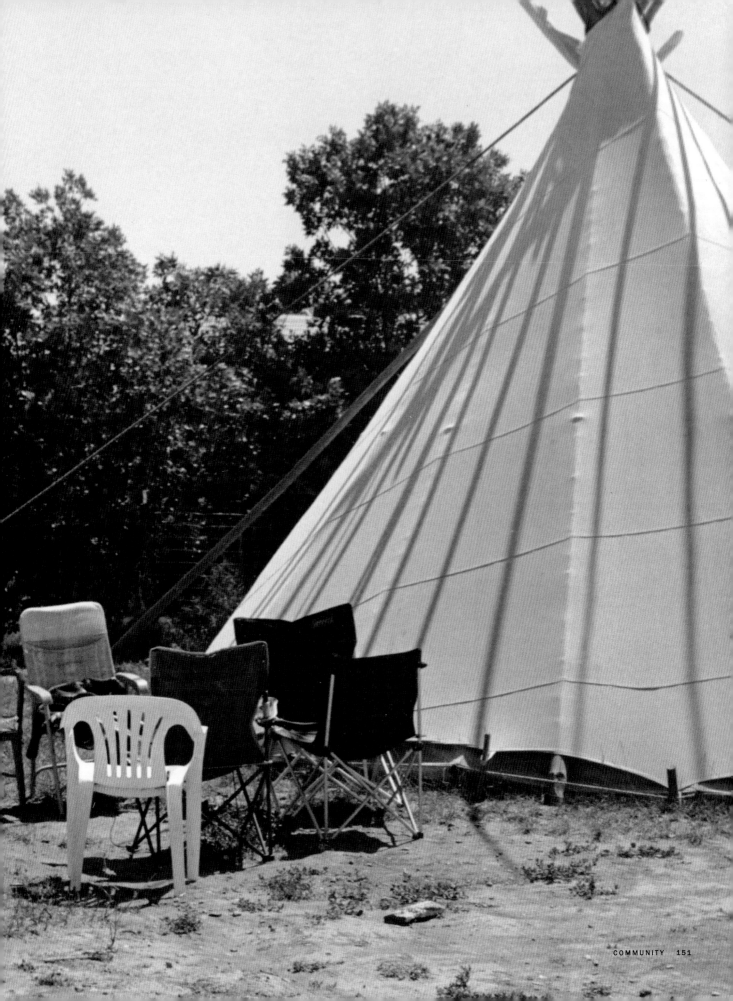

FAMILY

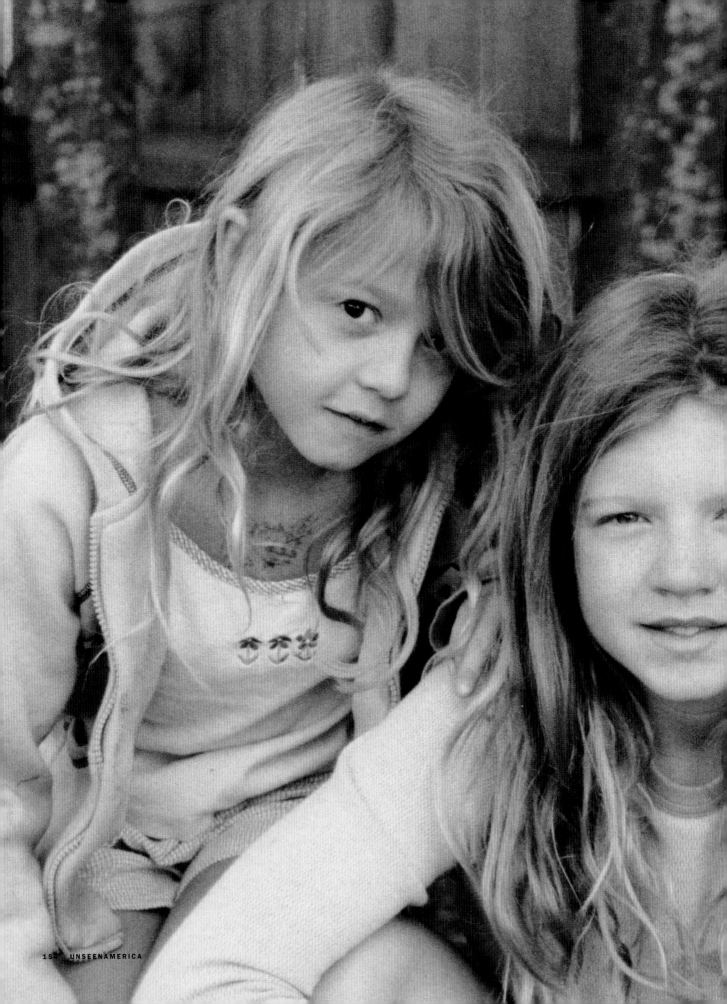

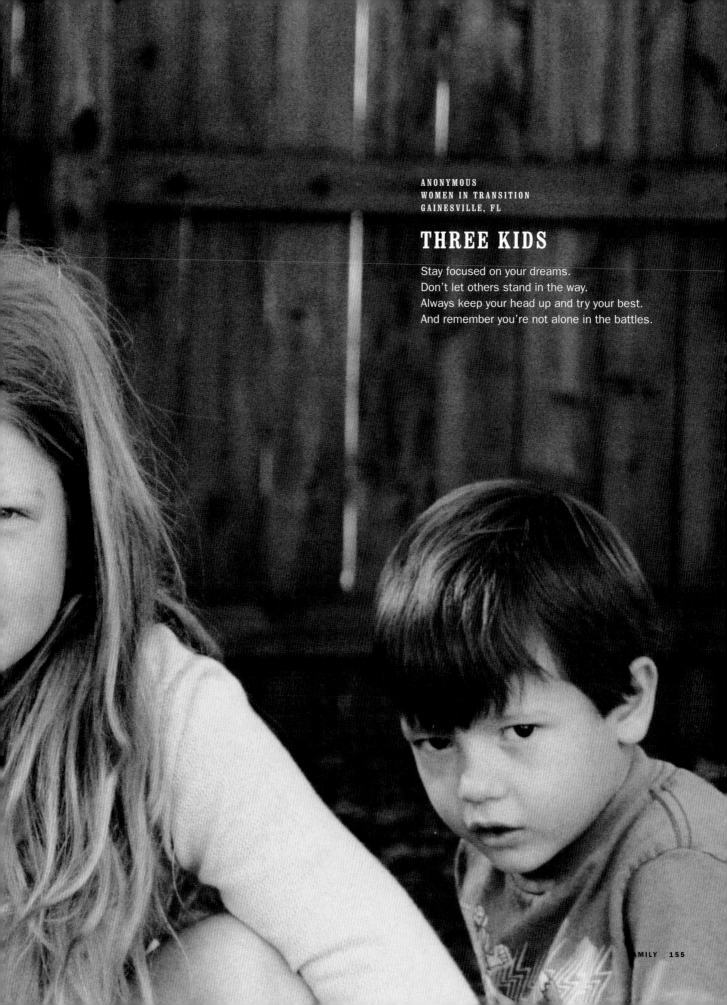

ANONYMOUS
WOMEN IN TRANSITION
GAINESVILLE, FL

THREE KIDS

Stay focused on your dreams.
Don't let others stand in the way.
Always keep your head up and try your best.
And remember you're not alone in the battles.

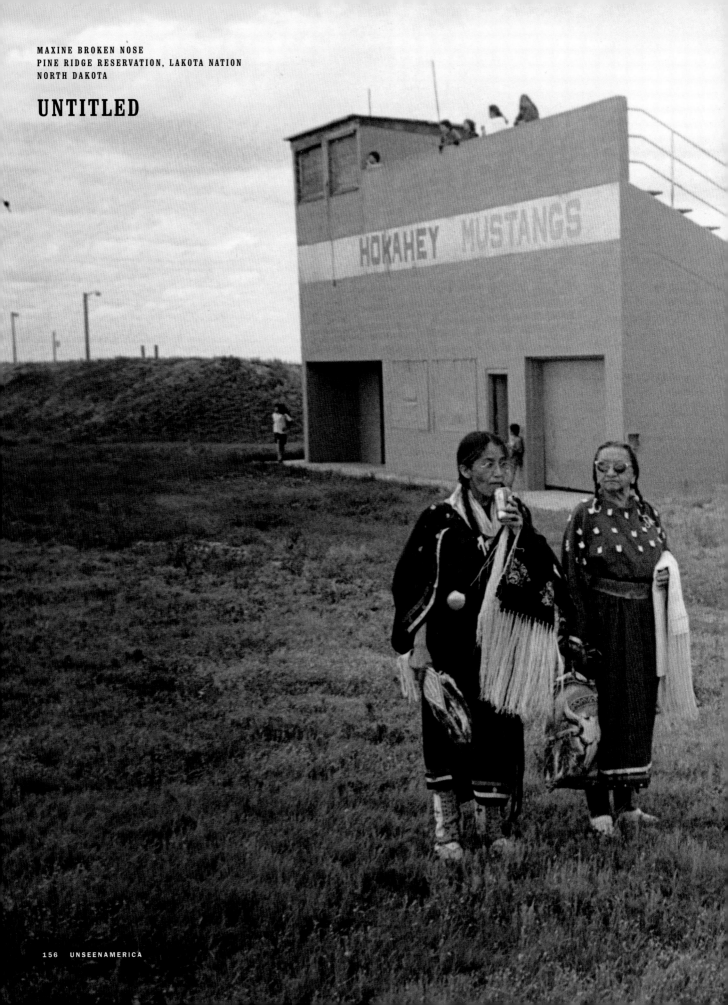

MAXINE BROKEN NOSE
PINE RIDGE RESERVATION, LAKOTA NATION
NORTH DAKOTA

UNTITLED

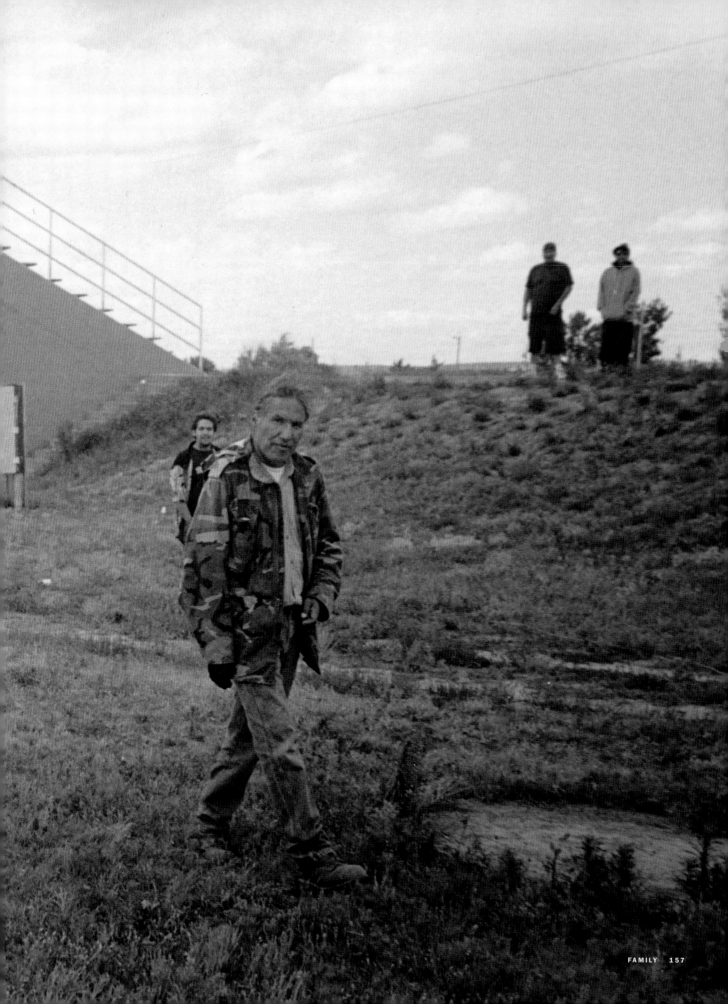

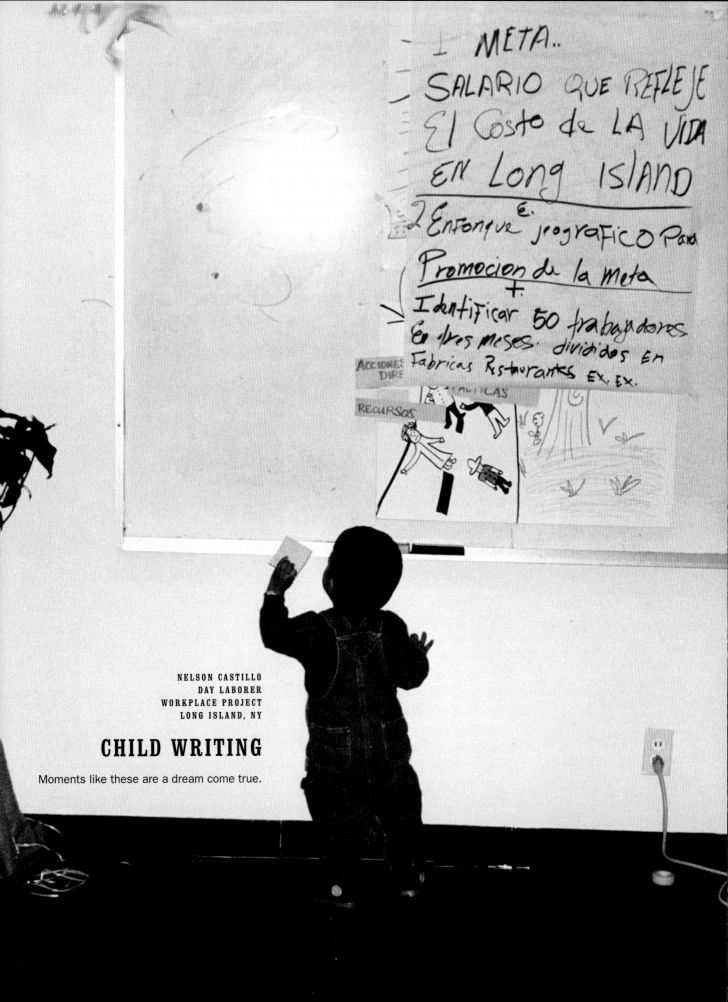

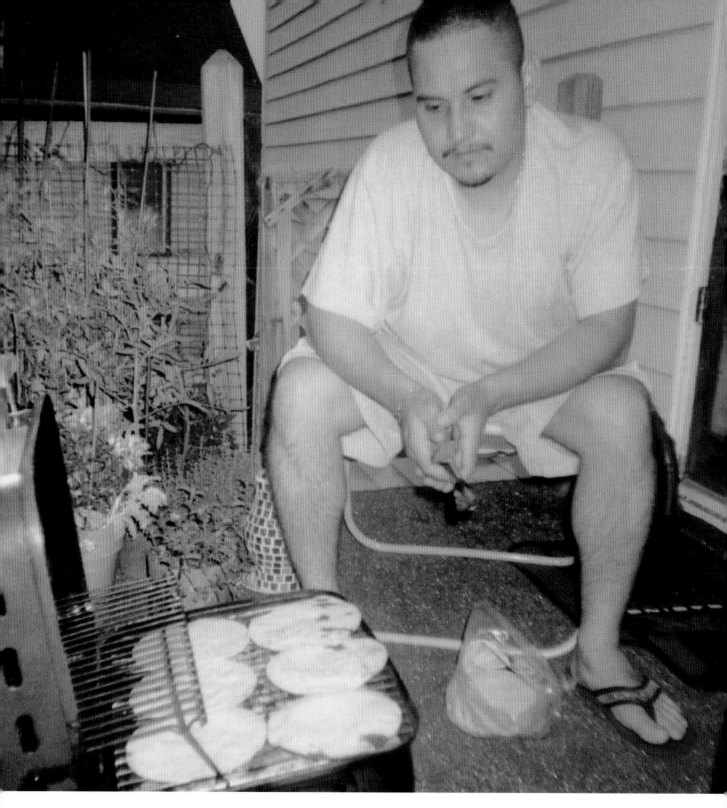

ALEJANRO CELAYA AND ELIZABETH DRUBACK
DAY LABORERS
HUDSON RIVER COMMUNITY HEALTH
NEW YORK

ALEX COOKING OUR DINNER

It was one of the first warm days of the year and Alex was heating up the tortillas.
Even if it's spaghetti and meatballs, he has to heat up some tortillas to eat it with!

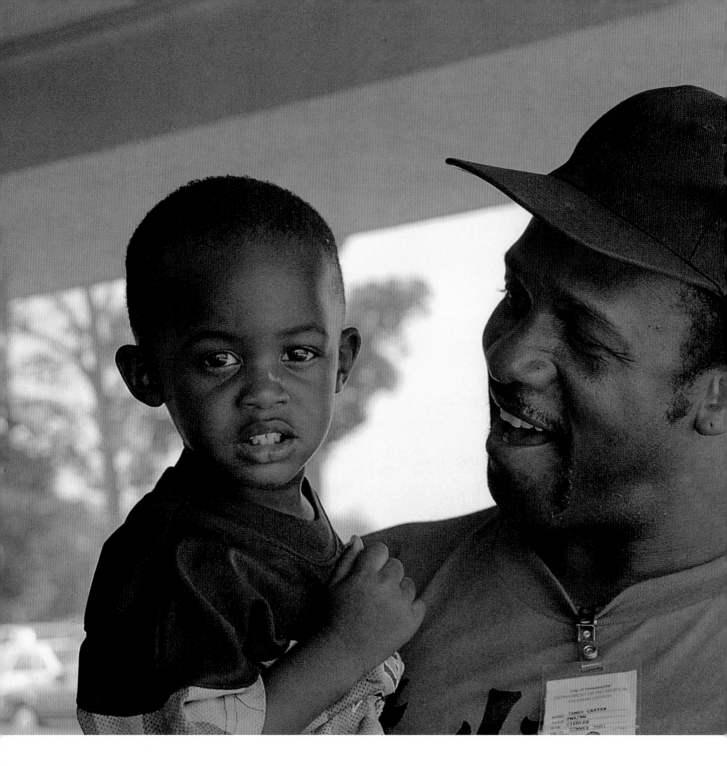

REBECCA SMITH DANIELS
CUNY CENTER FOR WORKER EDUCATION
NEW YORK CITY

JAMES CARTER

James Carter III is a single father. He does not know where James Carter the IV's mother is. When I met him he was soliciting funds to begin an after-school sports program geared toward keeping children off the streets of Philadelphia. He had lost one son and you would think that he would be an angry man. Instead, I saw a content and loving man who told me that he thanks God for all of his blessings.

EVA CHEN
GARMENT WORKER
LOCAL 23-25 UNITE HERE
NEW YORK CITY

UNTITLED

My ninety-two-year old mother.

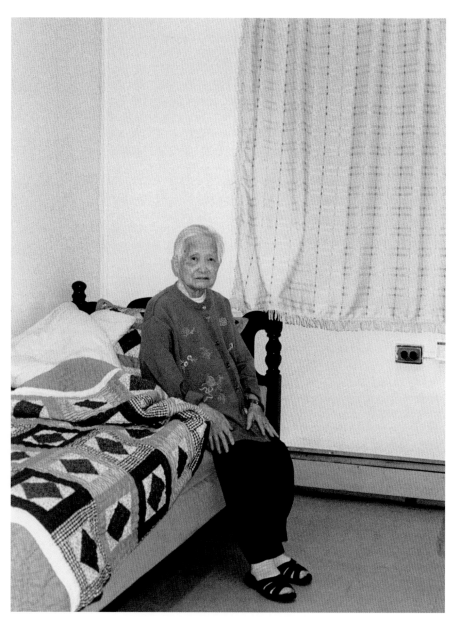

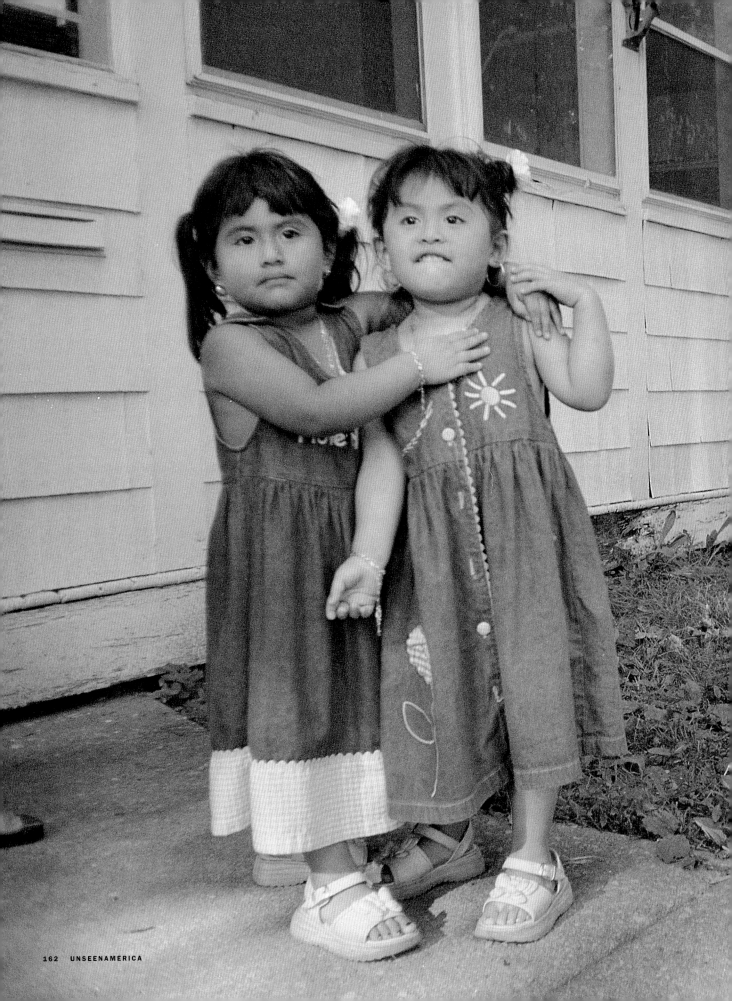

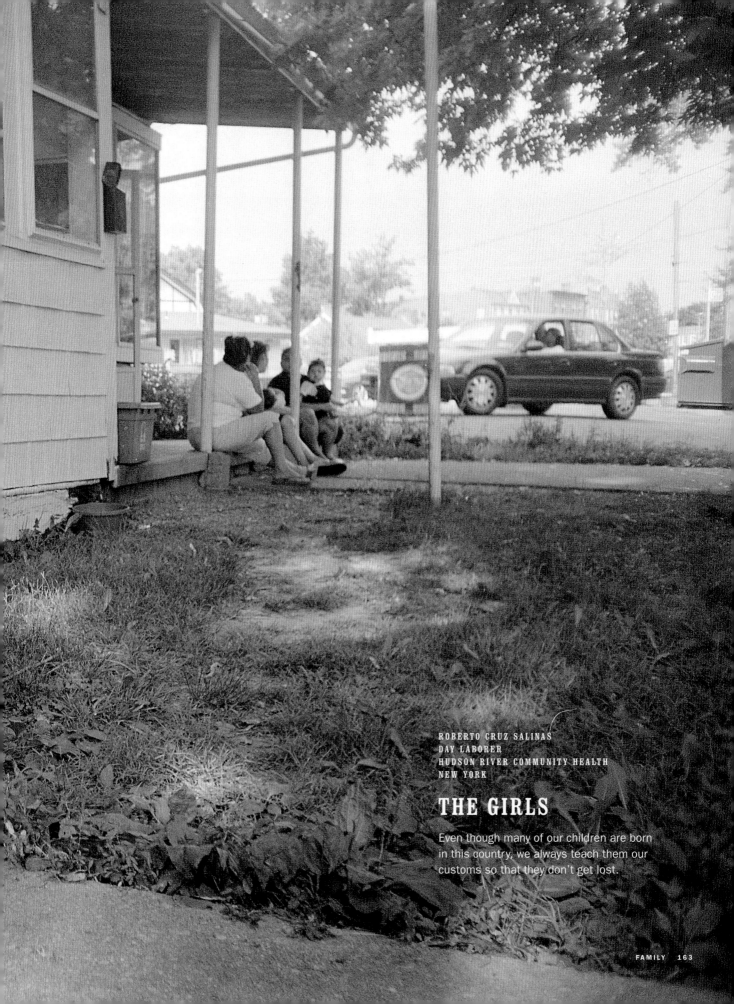

ROBERTO CRUZ SALINAS
DAY LABORER
HUDSON RIVER COMMUNITY HEALTH
NEW YORK

THE GIRLS

Even though many of our children are born
in this country, we always teach them our
customs so that they don't get lost.

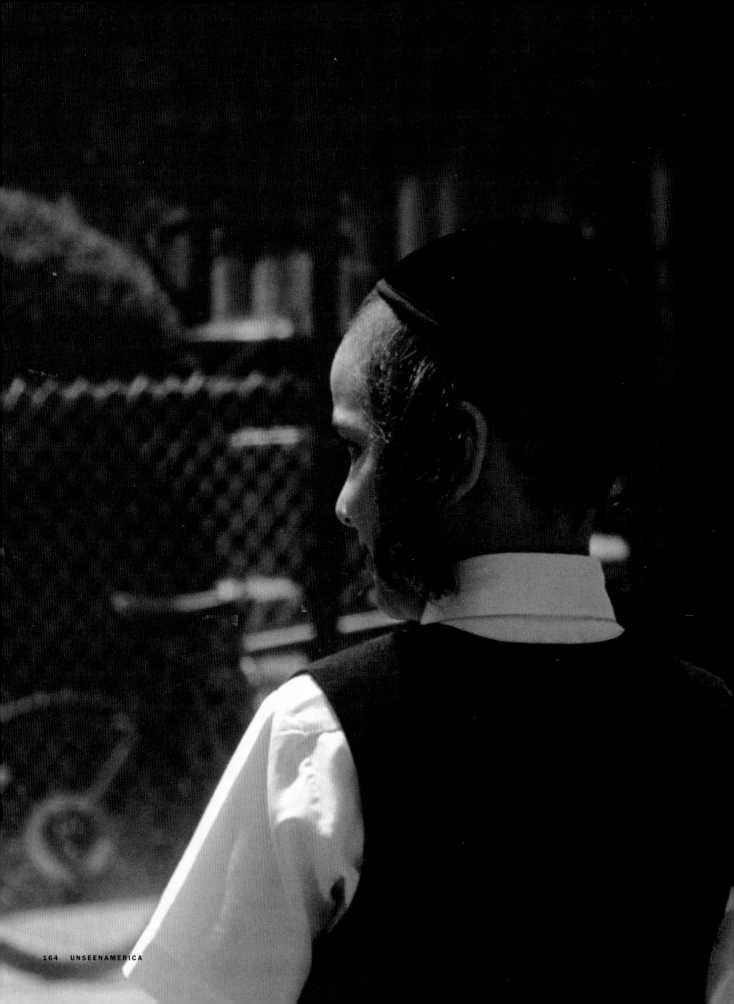

DONNA TIRADO
ADMINISTRATOR FOR CHILDREN'S SERVICES
SSEU LOCAL 371 AFSCME
NEW YORK CITY

HASSIDIC BOY

Many of the people there are living in a
world that is totally different from them.

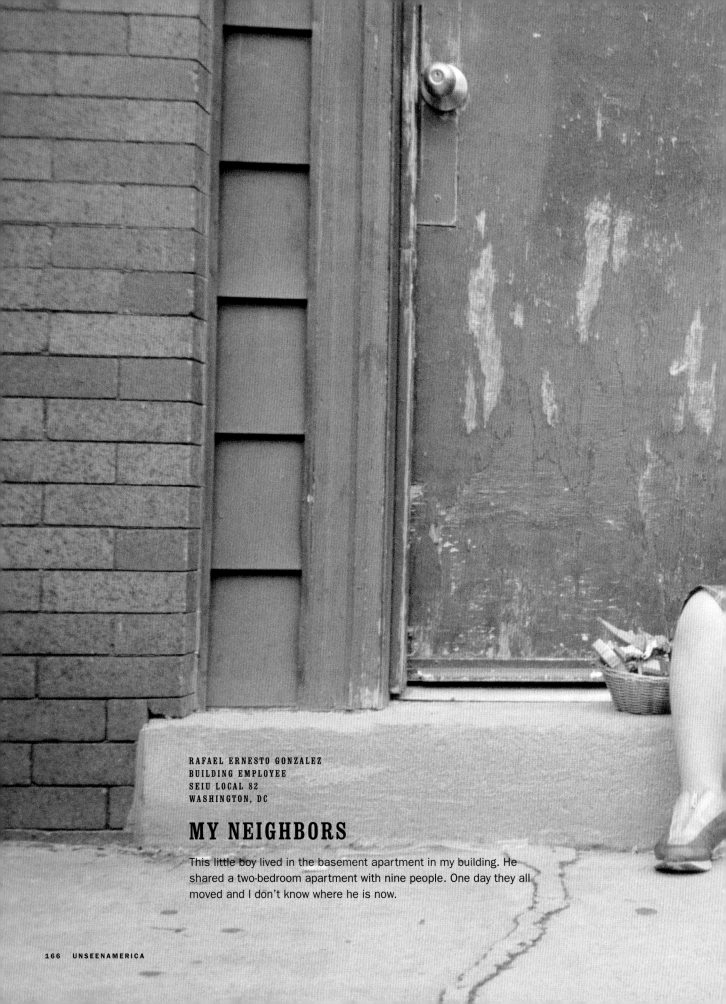

RAFAEL ERNESTO GONZALEZ
BUILDING EMPLOYEE
SEIU LOCAL 82
WASHINGTON, DC

MY NEIGHBORS

This little boy lived in the basement apartment in my building. He shared a two-bedroom apartment with nine people. One day they all moved and I don't know where he is now.

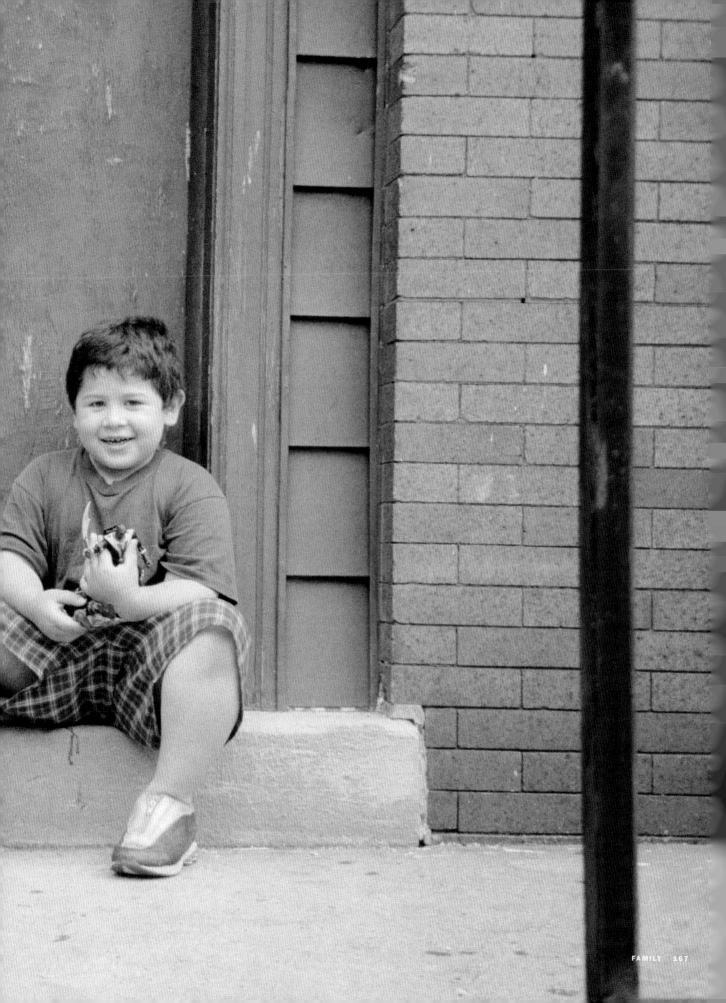

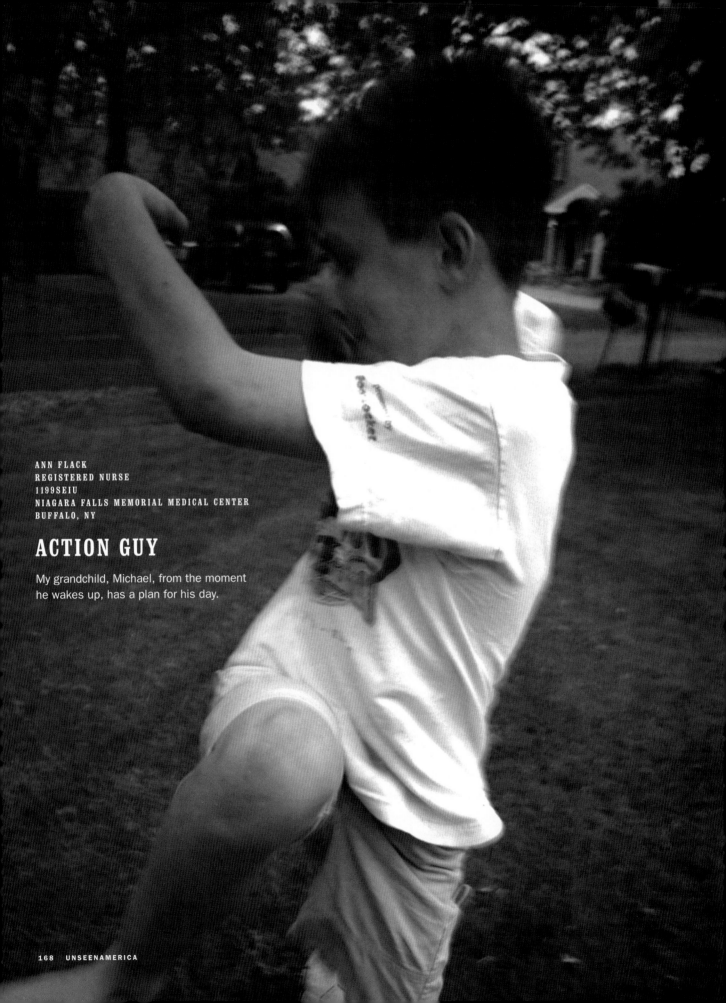

ANN FLACK
REGISTERED NURSE
1199SEIU
NIAGARA FALLS MEMORIAL MEDICAL CENTER
BUFFALO, NY

ACTION GUY

My grandchild, Michael, from the moment
he wakes up, has a plan for his day.

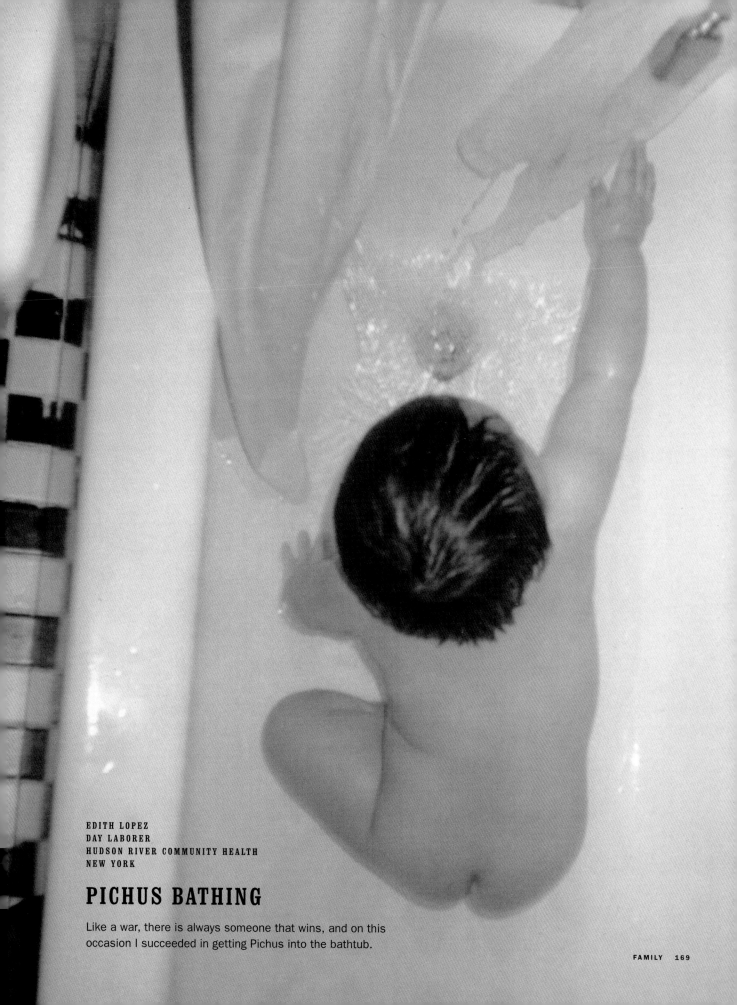

EDITH LOPEZ
DAY LABORER
HUDSON RIVER COMMUNITY HEALTH
NEW YORK

PICHUS BATHING

Like a war, there is always someone that wins, and on this
occasion I succeeded in getting Pichus into the bathtub.

PING LAM
CUTTER
LOCAL 23-25 UNITE HERE
NEW YORK CITY

UNTITLED

My son is lucky because he lives in this country and has a lot of opportunities to go to a good school and to take swimming lessons. He can have a good future.

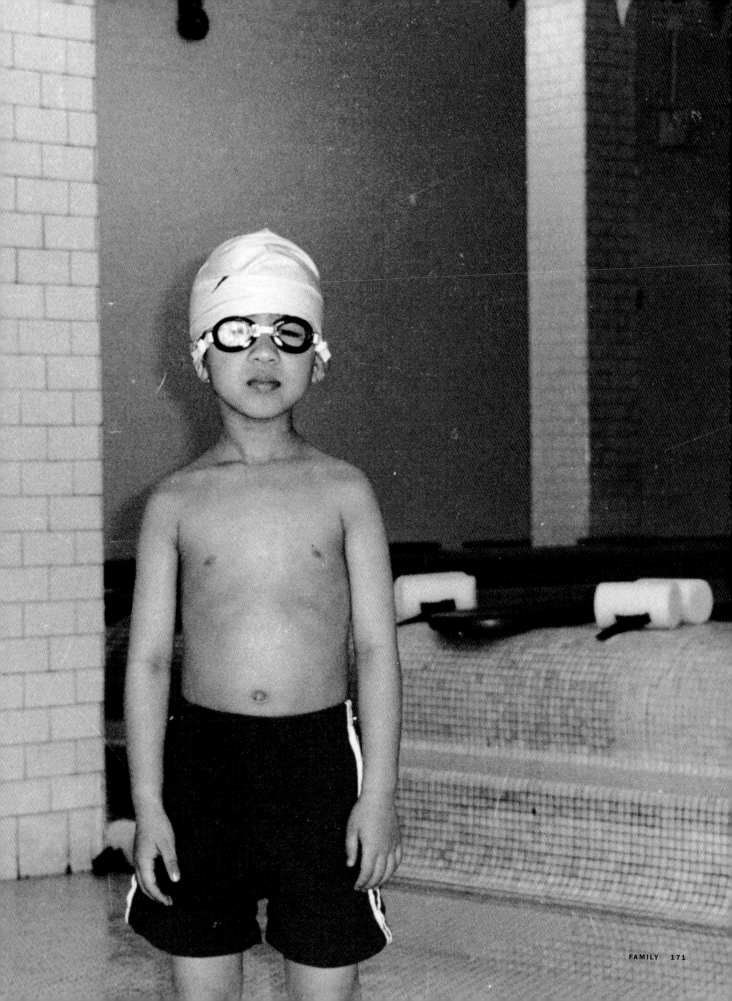

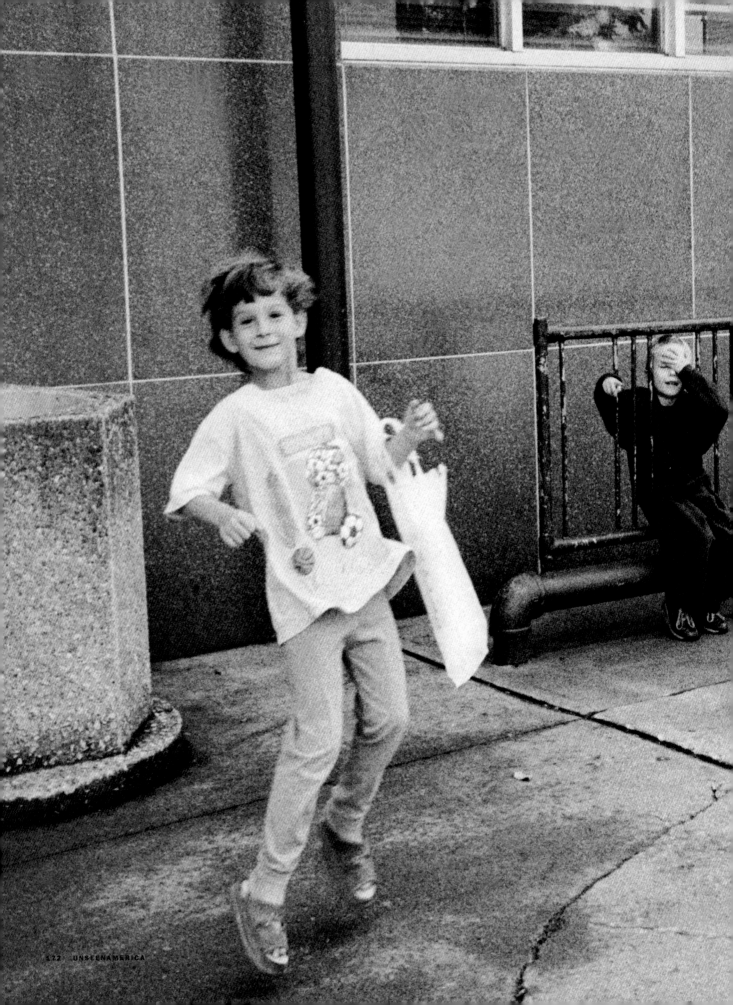

ENEDINA LOZANO
LIBRARY SPECIALIST
SEIU DISTRICT 1199 WV/KY/OH
LORAIN PUBLIC LIBRARY
CLEVELAND, OH

CHILD'S PLAY

Their weekly trip to the library is a real treat for Holly and Kevin. They walk here with their mother to get books and videos for the family's entertainment.

JOUNE MANJARES
NANNY
DAMAYAN MIGRANT WORKERS ASSOCIATION
NEW YORK CITY

MOM LOOKING OUT THE WINDOW

I never knew when I took this picture of my mom that the love in my life would come out as well. She's so dear to me; that's why I took her as my model. Just then, I came to realize that the pictures you take of loved ones will reflect yourself.

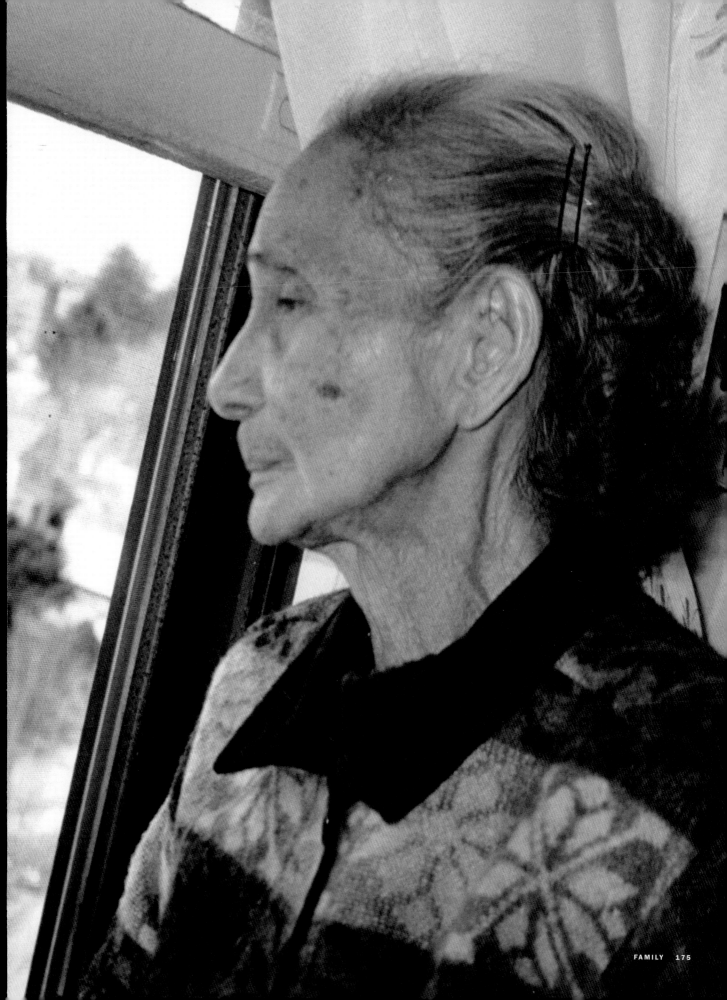

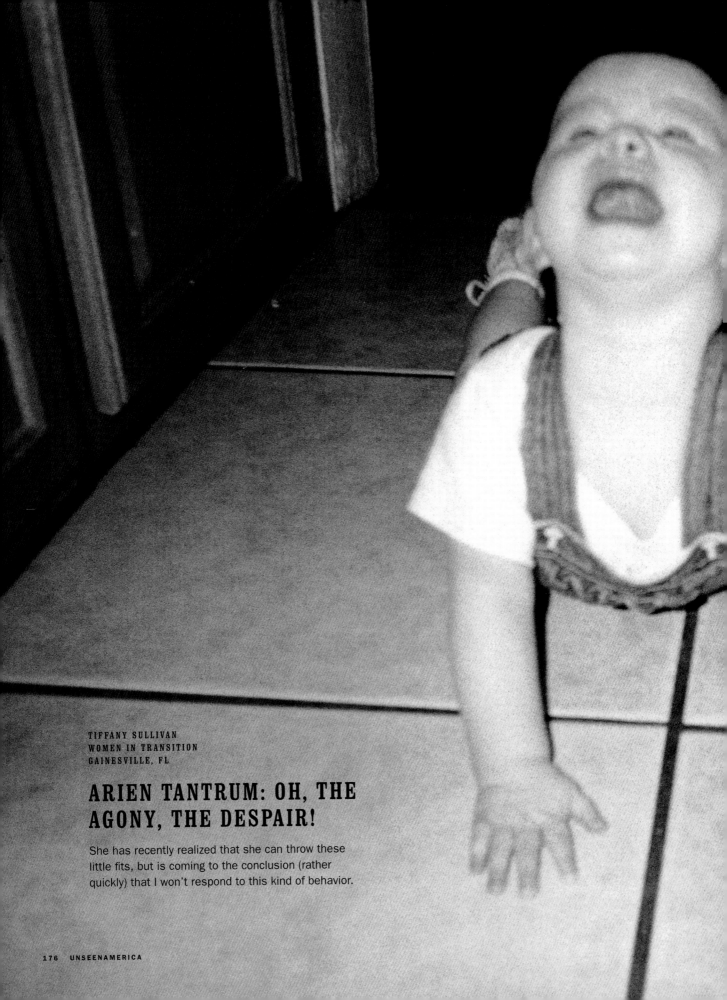

TIFFANY SULLIVAN
WOMEN IN TRANSITION
GAINESVILLE, FL

ARIEN TANTRUM: OH, THE AGONY, THE DESPAIR!

She has recently realized that she can throw these little fits, but is coming to the conclusion (rather quickly) that I won't respond to this kind of behavior.

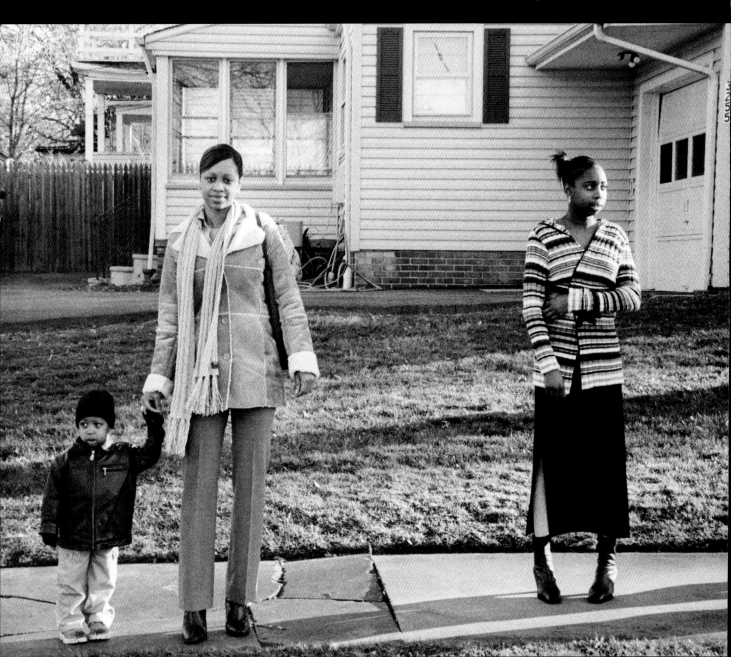

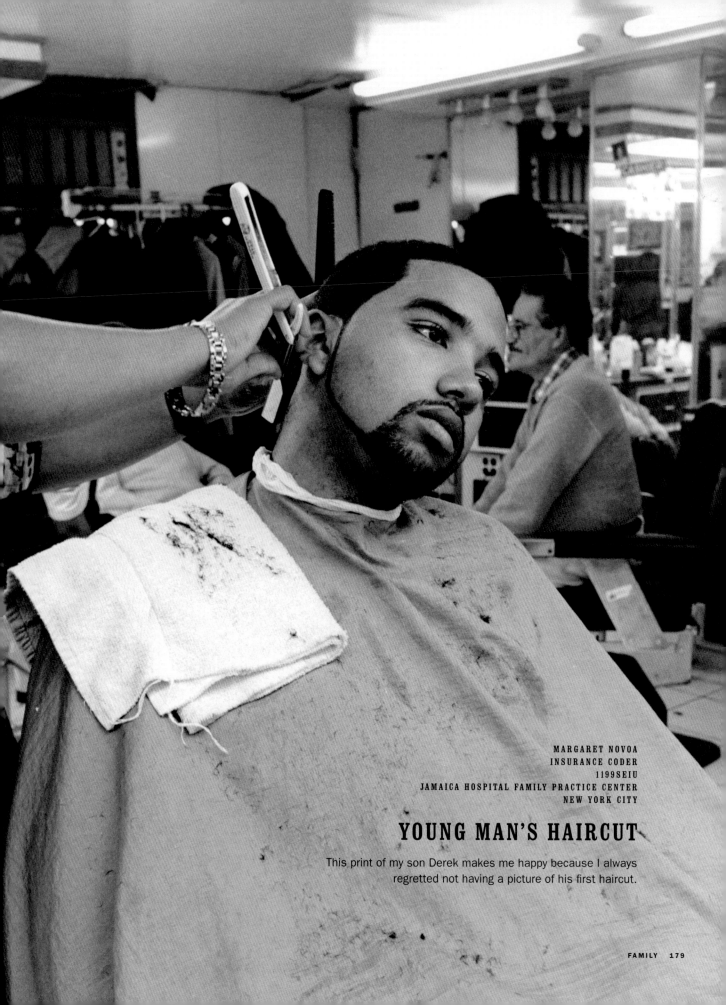

MARGARET NOVOA
INSURANCE CODER
1199SEIU
JAMAICA HOSPITAL FAMILY PRACTICE CENTER
NEW YORK CITY

YOUNG MAN'S HAIRCUT

This print of my son Derek makes me happy because I always
regretted not having a picture of his first haircut.

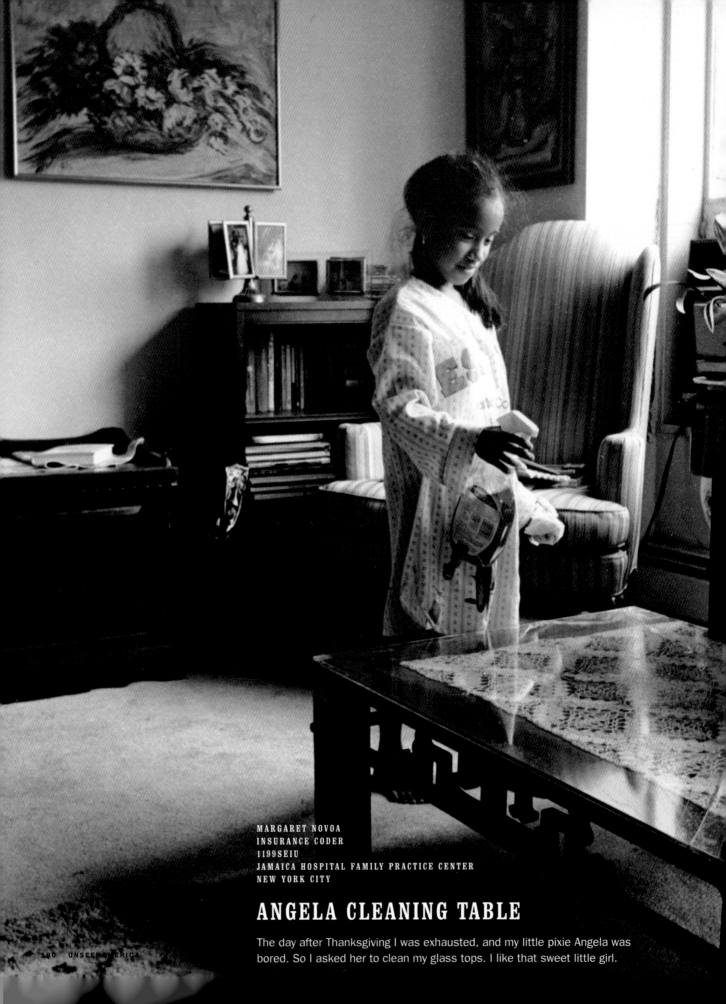

MARGARET NOVOA
INSURANCE CODER
1199SEIU
JAMAICA HOSPITAL FAMILY PRACTICE CENTER
NEW YORK CITY

ANGELA CLEANING TABLE

The day after Thanksgiving I was exhausted, and my little pixie Angela was bored. So I asked her to clean my glass tops. I like that sweet little girl.

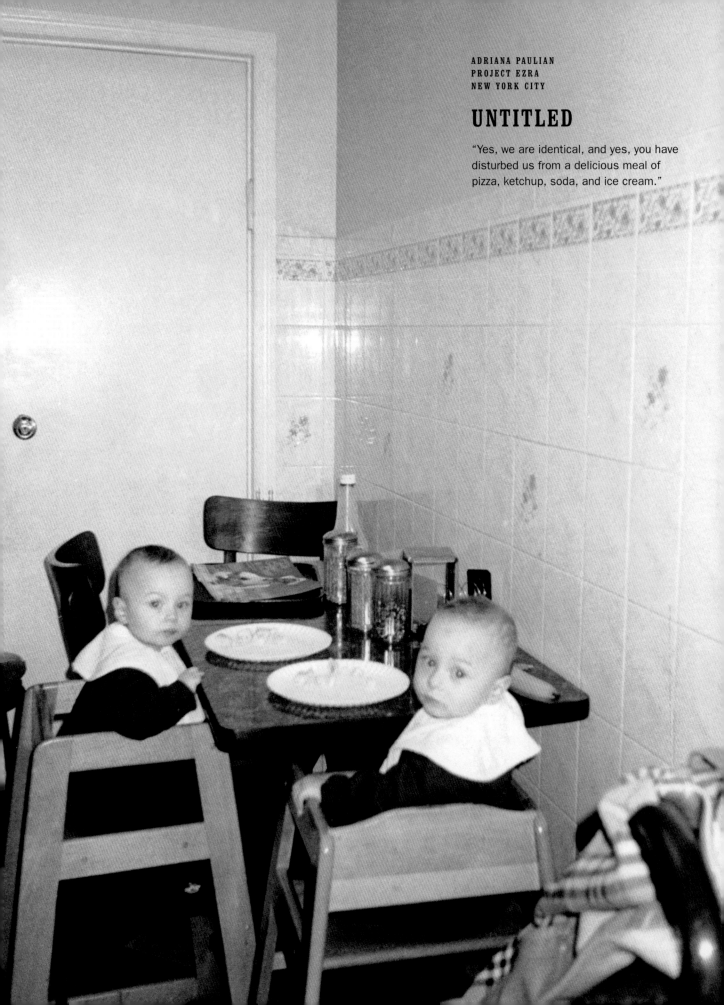

ADRIANA PAULIAN
PROJECT EZRA
NEW YORK CITY

UNTITLED

"Yes, we are identical, and yes, you have disturbed us from a delicious meal of pizza, ketchup, soda, and ice cream."

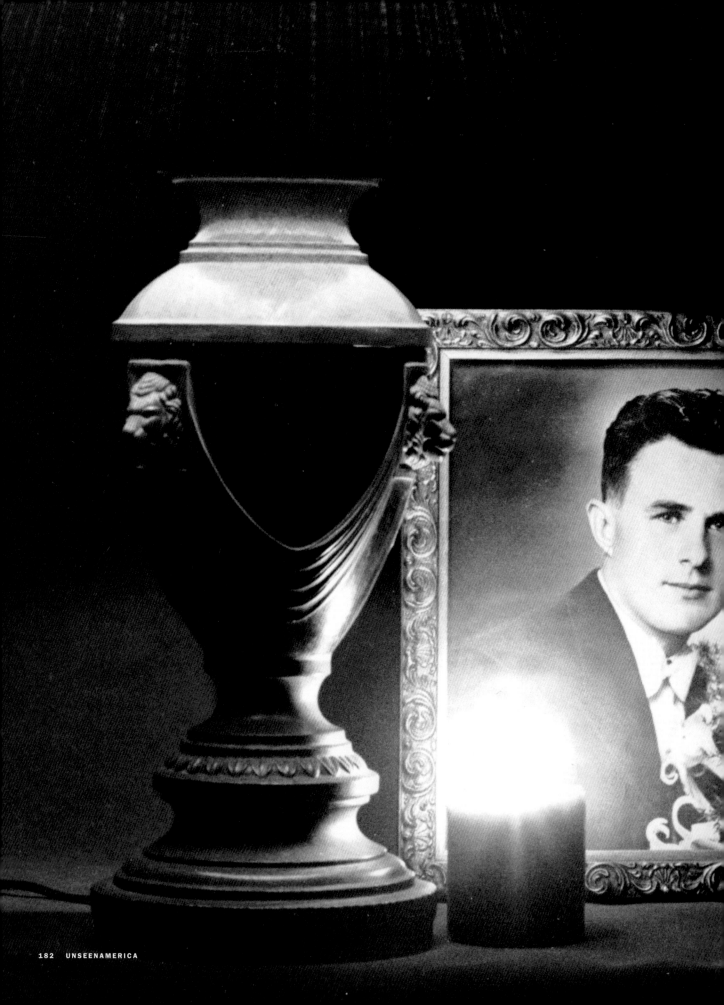

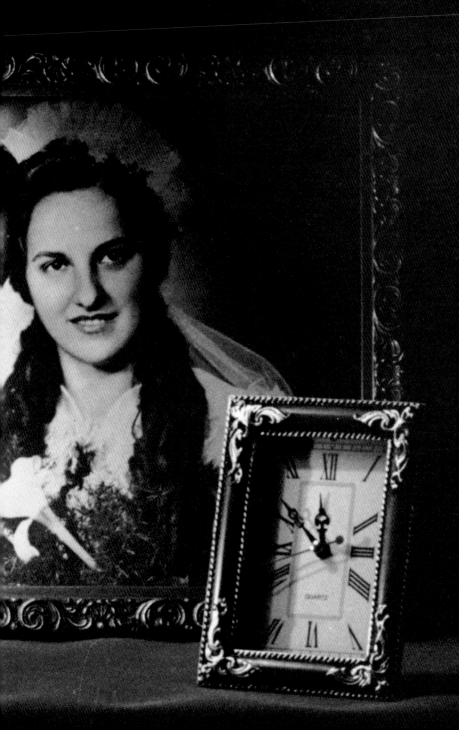

BOHUSLAV RAPOSH
BUILDING EMPLOYEE
SEIU LOCAL 32BJ
NEW YORK CITY

PORTRAIT

I take every day some pictures and I take camera with me every day—except, in the United States is problem taking pictures from group of the people because people are right away mad. "Why you take picture of me?" In Europe is no problem. Everyone smiles to camera. That's also no good for photographer.

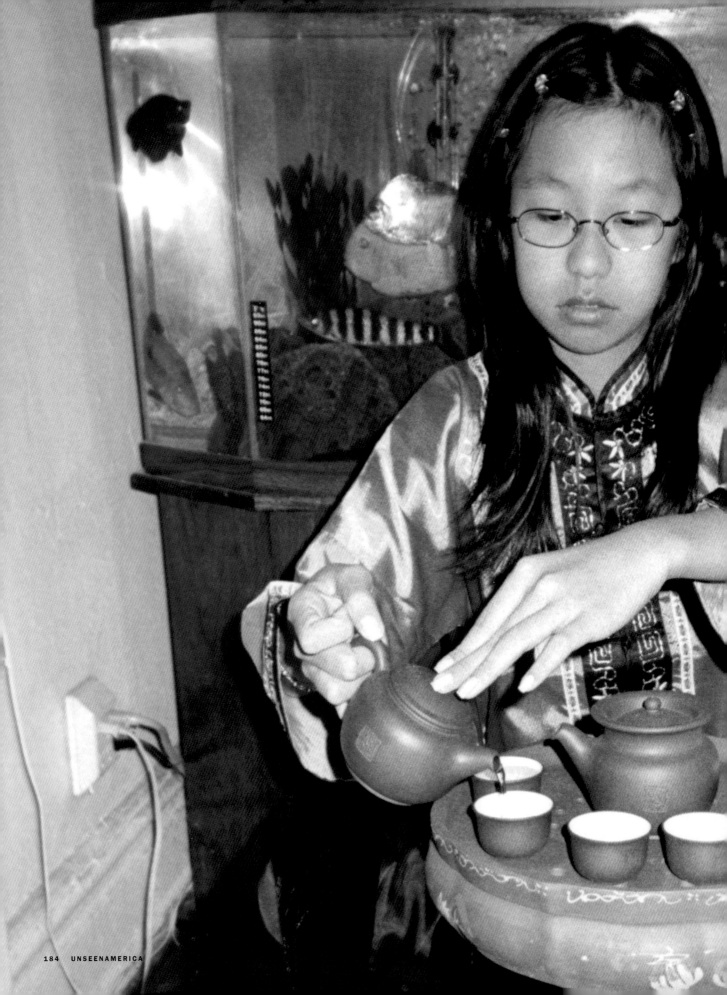

LANA CHEUNG
EDUCATION DIRECTOR
LOCAL 23-25 UNITE HERE
NEW YORK CITY

TEA CEREMONY

It was just past 9:00 p.m. and I heard the joyful cries of my daughter, "Mom, you just missed another dinner with us. Come and have some tea." Through the lens I saw not only water flowing into a cup, but also a cup of tender love and care. I believe that millions of working mothers share the same thought with me. This is the greatest reward for their hardships.

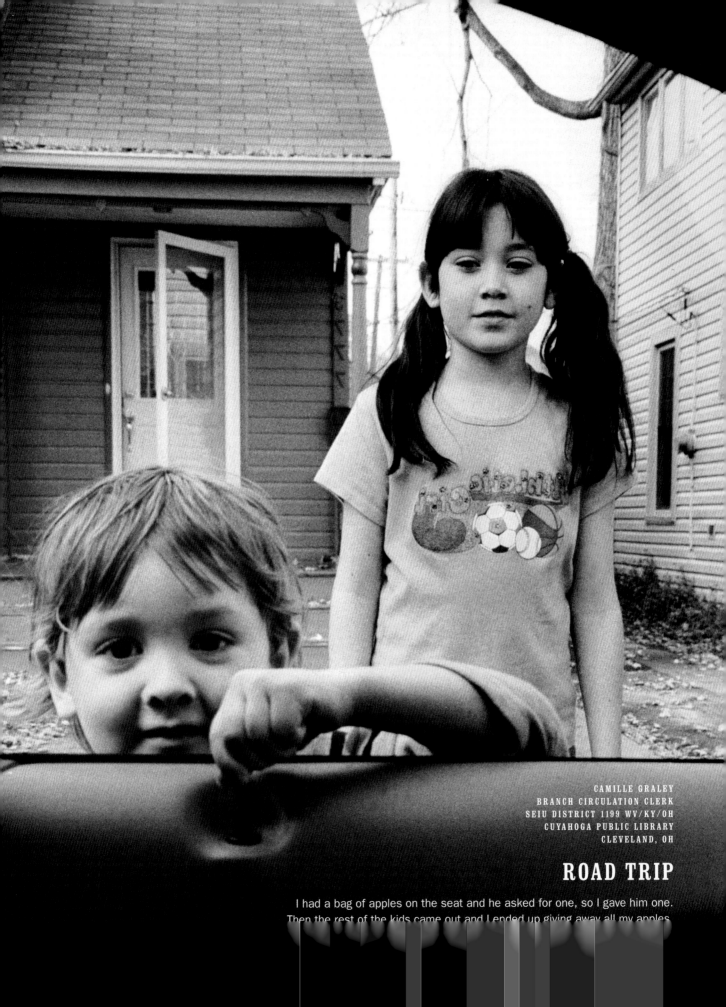

CAMILLE GRALEY
BRANCH CIRCULATION CLERK
SEIU DISTRICT 1199 WV/KY/OH
CUYAHOGA PUBLIC LIBRARY
CLEVELAND, OH

ROAD TRIP

I had a bag of apples on the seat and he asked for one, so I gave him one.
Then the rest of the kids came out and I ended up giving away all my apples.

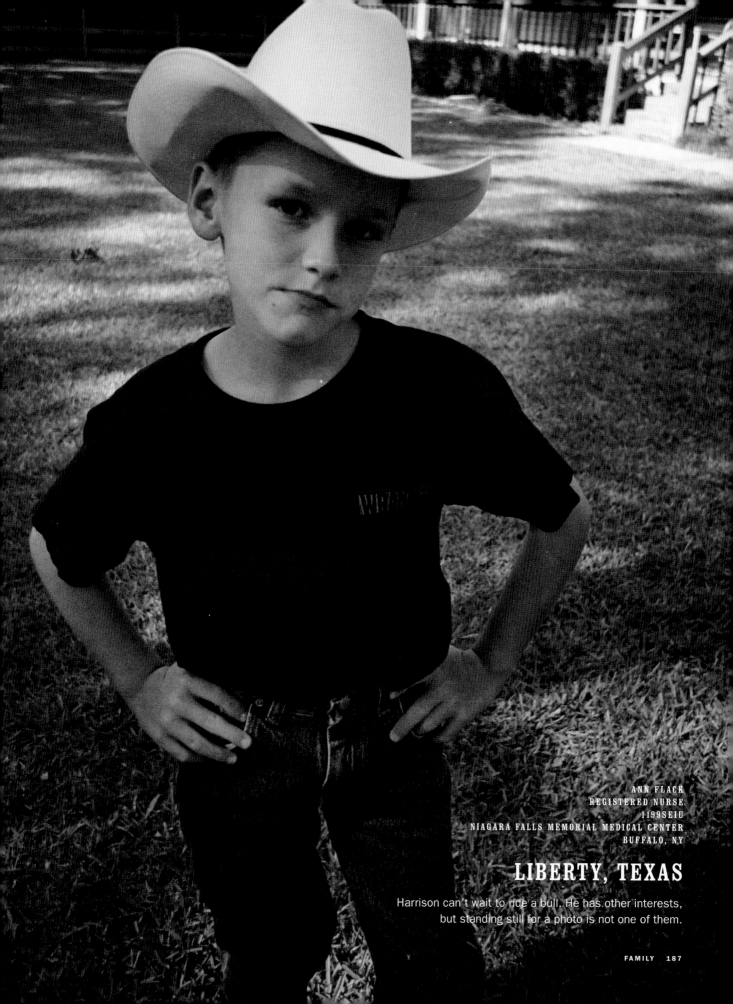

ANN FLACK
REGISTERED NURSE
1199SEIU
NIAGARA FALLS MEMORIAL MEDICAL CENTER
BUFFALO, NY

LIBERTY, TEXAS

Harrison can't wait to ride a bull. He has other interests,
but standing still for a photo is not one of them.

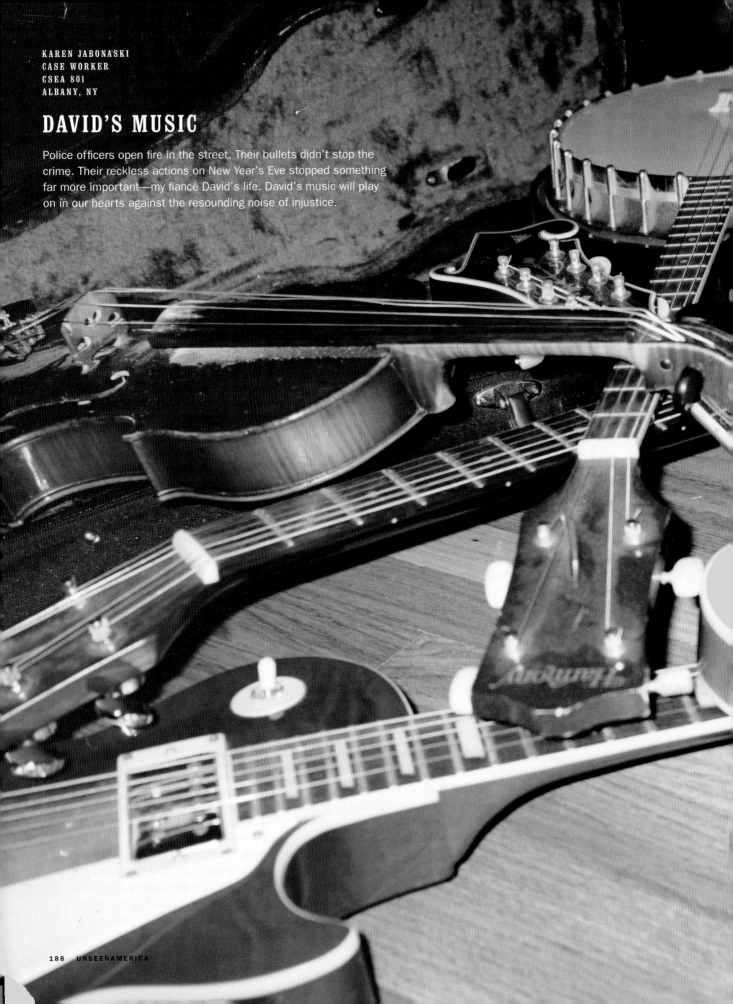

KAREN JABONASKI
CASE WORKER
CSEA 801
ALBANY, NY

DAVID'S MUSIC

Police officers open fire in the street. Their bullets didn't stop the crime. Their reckless actions on New Year's Eve stopped something far more important—my fiancé David's life. David's music will play on in our hearts against the resounding noise of injustice.

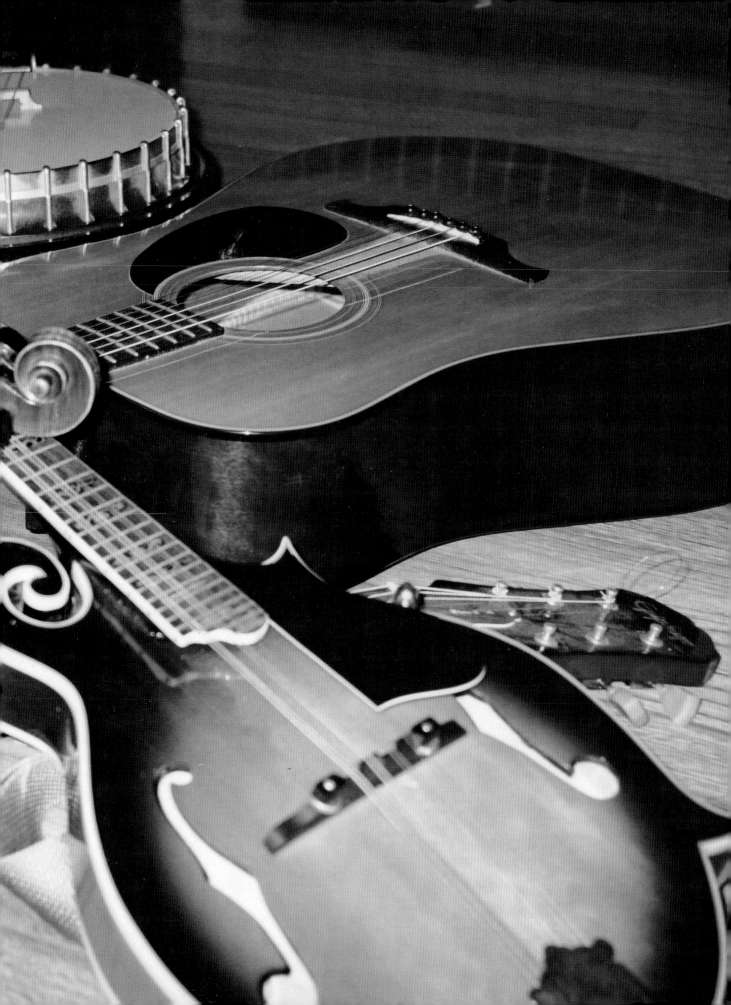

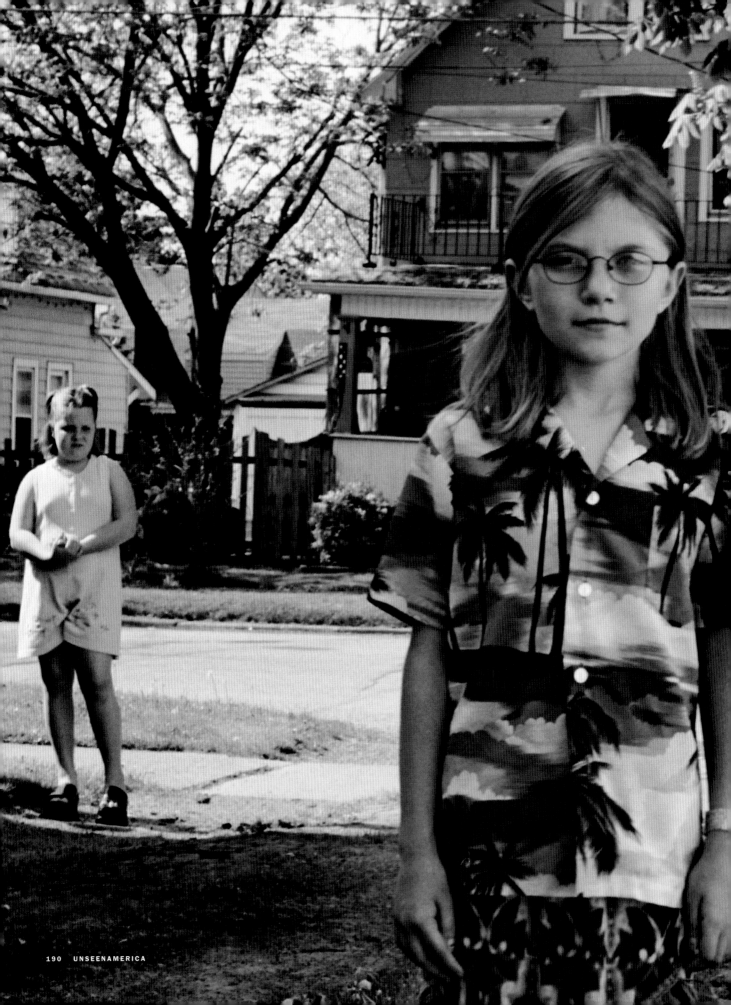

ROBERT WOLCOTT
LICENSED PRACTICAL NURSE
NORTHGATE NURSING HOME 1199SEIU
BUFFALO, NY

TWO GIRLS

It's sometimes difficult to be left to the sidelines.

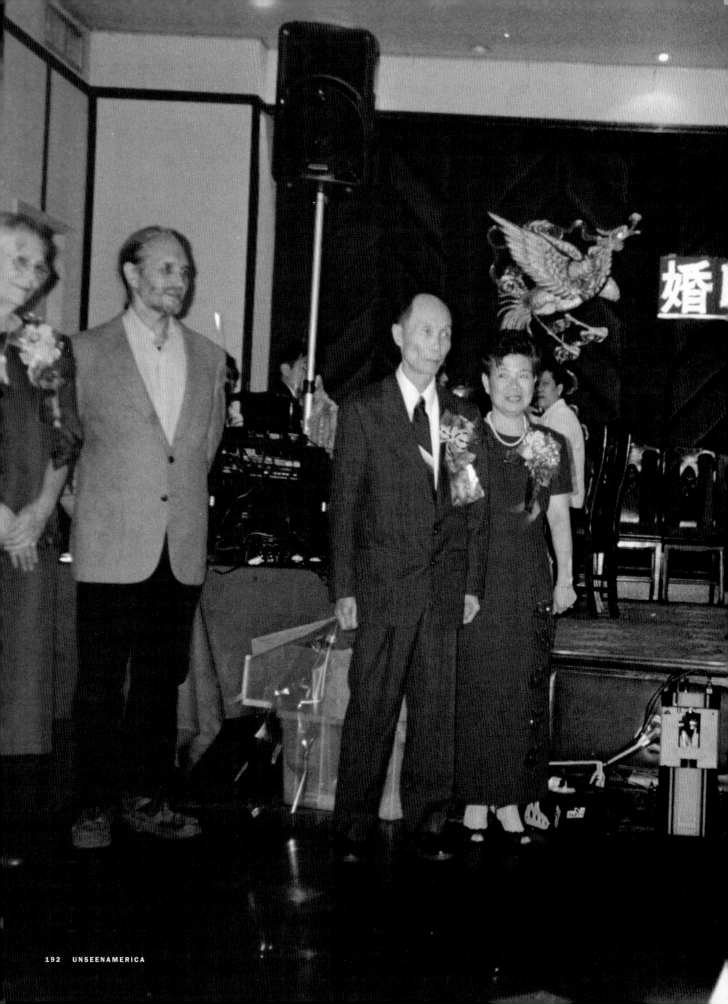

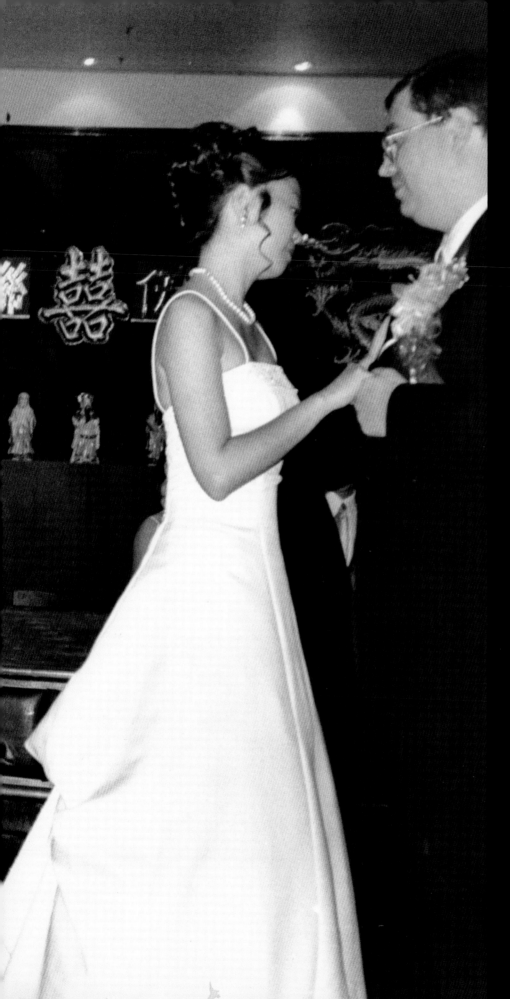

MEI YIN TSANG
ORGANIZER, FORMER SEAMSTRESS
LOCAL 23-25 UNITE HERE
NEW YORK CITY

BRIDE, GROOM, AND PARENTS

This is a cross-cultural wedding. I hope that *unseenamerica* can promote cross-cultural awareness.

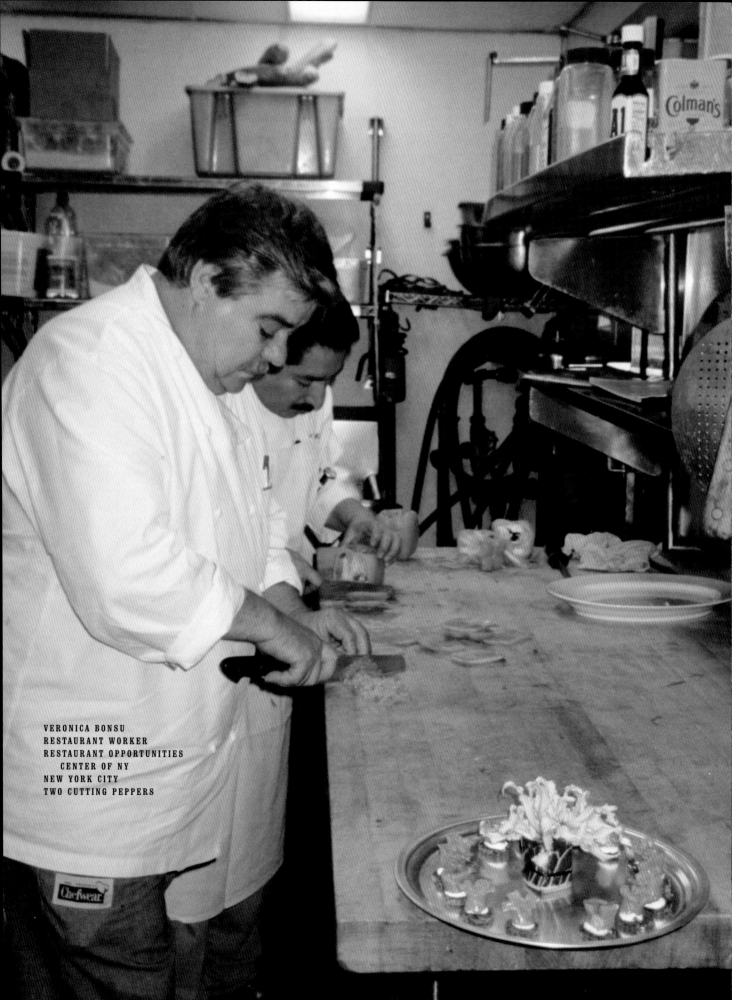

VERONICA BONSU
RESTAURANT WORKER
RESTAURANT OPPORTUNITIES
CENTER OF NY
NEW YORK CITY
TWO CUTTING PEPPERS

APPENDIX

UNIONS AND ORGANIZATIONS

At press, over three hundred unseenamerica classes have taken place around the country. The following is a list of unions and organizations that participated in this book. A more complete list of all the groups and classes is posted on our website, www.bread-and-roses.com.

1199SEIU—New York

1199SEIU is a health care union operating throughout New York State. Members work in a range of jobs in hospitals and in nursing homes and serve as home health aides. The union has always been a vigorous leader in social justice struggles, including the civil rights movement, and in local, national, and international politics. Thirty years ago, the union started an unusual program to add culture to the equation of benefits. Bread & Roses was named after a strike in Lawrence, Massachusetts, in 1912 where women and children explained that bread was not enough. Bread & Roses created the unseenamerica program, first with union members, then with several hundred groups around the country.

1199SEIU—Upstate Division, Buffalo, New York

Health care workers from hospitals in the Buffalo area produced these photographs. They include Niagara Falls Memorial Medical Center, Women's and Children's Hospital of Buffalo and Millard Filmore Suburban Hospital, and several nursing homes (Deaconess Health Center, Northgate Nursing Home, Grace Manor in Western New York). All are 1199SEIU members and leaders in their institutions.

The union represents nearly ten thousand workers in Western New York, including nurses, dietary workers, pharmacists, nursing aides and assistants, building maintenance workers, housekeepers, social workers, technicians, switchboard operators, and nearly every other title involved in health care.

Local 23-25 UNITE HERE—New York City, New York

UNITE (formerly the Union of Needle trades, Textiles and Industrial Employees) and HERE (Hotel Employees and Restaurant Employees International Union) merged in 2004 to form UNITE HERE, which represents more than 440,000 active and 400,000 retired members throughout North America. UNITE HERE members work in apparel and textile manufacturing, distribution, and retail, industrial laundries, hotels, casinos, restaurants, and food service.

Local 23-25 UNITE HERE represents workers in New York's garment industry, most of whom are immigrants from China, Latin America, and the Caribbean. They work as sewing machine operators, cutters, pressers, and sample makers.

DAMAYAN Migrant Workers Association—New York City, New York

DAMAYAN Migrant Workers Association (DAMAYAN) promotes the rights and welfare of Filipino migrant workers, particularly domestic workers. "Damayan envisions a society where families are not forced to separate in search of livelihood to meet their basic needs—a society where there is equal opportunity to live with dignity, justice, and peace." "Damayan" is a Filipino word that means helping each other. It provides workers with free low-cost legal and health services and has networking, internship, job training, and referral programs.

Social Service Employees Union Local 371, District Council 37, AFSCME, AFL-CIO— New York City, New York

District Council 37 is the single largest public sector union in New York City. District Council 37 is also New York City's largest municipal employee union with 121,000 members and 50,000 retirees. Members work in schools, hospitals, offices, museums, parks, libraries, playgrounds—indoors and outdoors, in tunnels, in treetops, on bridges—everything from accountants to zookeepers. The union also reflects the ethnic mix of the city. Local 371 represents professional employees working for agencies in New York City's Human Resource Administration.

InMotion—New York City, New York

InMotion was founded in 1993. InMotion [formerly Network for Women's Services] seeks to make a real and lasting difference in the lives of low-income, underserved, or abused women by offering them legal and related services designed to foster equal access to justice and an empowered approach to life. They provide free services, primarily in the areas of matrimonial and family law, in a way that acknowledges mutual respect, encourages personal growth, and nurtures individual and collective strength. They also work to promote policies that make our society more responsive to the legal issues confronting the women they serve.

SEIU Local 32BJ—New York City, New York

New York's building service union represents seventy thousand members who work throughout the city at residential and commercial buildings of all sizes and sorts, including the great landmarks like Lincoln

Center and Yankee Stadium. New York's cleaners, doormen, porters, maintenance workers, and security guards join together in Local 32BJ of the Service Employees International Union to form the largest building service union in the United States, with members from sixty countries, speaking twenty-five languages.

The Workplace Project—Long Island, New York

The Workplace Project was founded in 1992 to address the marginalization of low and no-wage immigrant workers on Long Island. It is the only coalition on Long Island that organizes Latina/o immigrant workers to fight for better working and living conditions. One of the organization's fundamental principles is that people most directly affected by a problem must take leadership in changing the situation, building a democratic alliance of and for immigrant workers. The Workplace Project has developed a dynamic membership of low-wage immigrant worker leaders among a constituency that—due to its transience and instability—has often been considered unorganized and unorganizable.

International Brotherhood of Electrical Workers, AFL-CIO + IBEW 236— Albany, New York

The International Brotherhood of Electrical Workers (IBEW) represents approximately 750,000 members who work in fields such as utilities, construction, telecommunications, broadcasting, manufacturing, railroads, and government. The IBEW has members in both the United States and Canada and stands out among the American unions in the AFL-CIO because it is among the largest and has members in so many skilled occupations.

The Public Employees Federation PEF, AFT/SEIU, AFL-CIO—Albany, New York

The Public Employees Federation (PEF) is a union representing 54,000 professional, scientific, and technical state employees. PEF is one of the largest local white-collar unions in the United States and is New York's second-largest state-employee union. They also represent other government and private sector workers.

Civil Service Employees Association CSEA, AFSCME Local 1000, CSEA 690, CSEA 670, CSEA 801 AFL-CIO—Albany, New York

CSEA is the Local 1000 of the American Federation of State, County and Municipal Employees (AFSCME) representing state, county, and municipal employees.

Workforce Development Institute WDI—Albany, New York

The Workforce Development Institute (WDI) provides culture, education, and training for union members through centers around the state. WDI is hosting classes in the Capital Region, Hudson Valley, Syracuse, Rochester, Buffalo, Long Island and more. WDI offers an opportunity for regional expansion and a model that other AFL-CIO state federations can reproduce across the nation. unseenamerica New York State is a collaboration of the Bread & Roses Cultural Project of 1199SEIU, the NYS AFL-CIO, and the Workforce Development Institute.

SEIU Local 82—Washington, DC

SEIU Local 82, Justice for Janitors, is the Washington DC Metro Area's Building Service Union representing over seven thousand janitors in Washington DC, Maryland, and Virginia. Local 82 is part of the Service Employees International Union. A partner of the nationwide Justice for Janitors campaign, Local 82 fights to improve the living standards of working families by winning quality jobs with full-time work, health care, and better wages for all Building Service workers.

SEIU District 1199 WV/KY/OH—Cleveland, Ohio

District 1199 represents more than twenty-six thousand public, health care, and social service workers across West Virginia, Ohio, and Kentucky. The mission of District 1199 is to provide a voice for an otherwise voiceless population, while empowering members with the tools they need to improve their lives as well as the lives of working families in general.

Pine Ridge Reservation, Lakota Nation—South Dakota

Pine Ridge Reservation was originally part of the Great Sioux Reservation, which was created by treaty with the U.S. Government in 1868. The Great Sioux Reservation included the whole of South Dakota west of the Missouri River. During the latter part of the 1800s, several treaties were entered into between the Sioux and the U.S. Government. With each new treaty the Sioux lost more land, until finally, in 1889, the Great Sioux Reservation was reduced to five separate reservations—one was the Pine Ridge Reservation.

Pine Ridge Reservation is in the southwest corner of South Dakota and encompasses about two million acres, roughly the size of Connecticut. Home to approximately forty thousand Lakota (Sioux), 35 percent of them are under sixteen years of age, according to the March 1998 Bureau of Indian Affairs populations and employment census. Pine Ridge is close to the Badlands, and Wounded Knee, the site of the infamous massacre, is within the reservation boundaries.

The reservation covers the poorest two counties in the nation with an average 86 percent unemployment versus the 5.5 percent national average. Sixty-three percent live below the federal poverty level, and that number continues to rise.

Project Renewal/Holland House—New York City, New York

Project Renewal's mission is to renew the lives of homeless men and women in New York City. They focus their efforts on the neediest and least-served of the city's indigent population—men and women who, in addition to being without a home, cope with mental illness and/or addiction to drugs.

Having helped thousands of indigent New Yorkers renew their lives, Project Renewal is proud to be regarded as one of the nation's most respected organizations working on behalf of homeless people. With a staff of nearly five hundred, of whom over 35 percent are formerly homeless clients, they reach out to more than thirteen thousand homeless men and women each year.

Hudson River Community Health—Peekskill, New York

Hudson River Community Health provides the highest quality comprehensive primary, preventive, and behavioral health services to all who seek it, regardless of insurance status and ability to pay.

It is a network of eleven community health centers located in Peekskill, Beacon, Poughkeepsie, Amenia, Dover Plains, Pine Plains, New Paltz, Goshen, and Walden. Over 36,000 patients throughout the Hudson Valley are served. Well over 150,000 health center visits are made annually in the eight counties.

All patients have a choice of his or her own primary care physician. Staff members are board certified and highly skilled in their respective fields and include physicians, dentists, nurse practitioners, midwives, social workers, and support staff. Hudson River Community Health provides a wide range of primary and preventive health services.

CUNY Center for Worker Education—New York City, New York

The City College Center for Worker Education provides working people with the opportunity to earn a Bachelor of Arts. The Center for Worker Education has approximately 850 students in attendance and offers over 150 courses a year taught by renowned scholars and professionals. Since 1981, The Center has graduated over 1,800 students, including four City College valedictorians and one salutatorian.

Women in Transition—Gainesville, Florida

This Gainesville group of photographers celebrates the lives, stories, and thoughts of six women who were recently or are currently residing in four of the area's shelters. A good portion of society thinks of shelter life with severe negativity. The truth is there are many more hidden members of society who can be labeled "homeless," but who are full-time workers and part-time students and women with children. The "homeless" photographers in this book are intelligent, hardworking, and sensitive women, who possess deeply meaningful poetry and wisdom to share.

Project Ezra—New York, New York

Project Ezra is an independent, nonprofit grassroots organization serving the frail elderly on New York's Lower East Side. They provide a variety of services to a largely homebound population.

Project Ezra's population includes over four hundred elderly individuals who are economically, physically, or psychologically marginal. In addition, throughout the year, they have contact with hundreds more in need of specific care. They offer social work services, including assessment and evaluation, as well as ongoing support and counseling.

Restaurant Opportunities Center—New York, New York

The Restaurant Opportunities Center of New York is dedicated to winning improved conditions for New York City's restaurant workers and raising public recognition of restaurant workers' contributions to the city. Founded by workers displaced from Windows on the World, the restaurant at the top of the World Trade Center, ROC-NY is a membership-based workers' center that organizes for improved conditions for New York City's restaurant workers. New York's restaurant industry is the nation's largest employer outside of government.

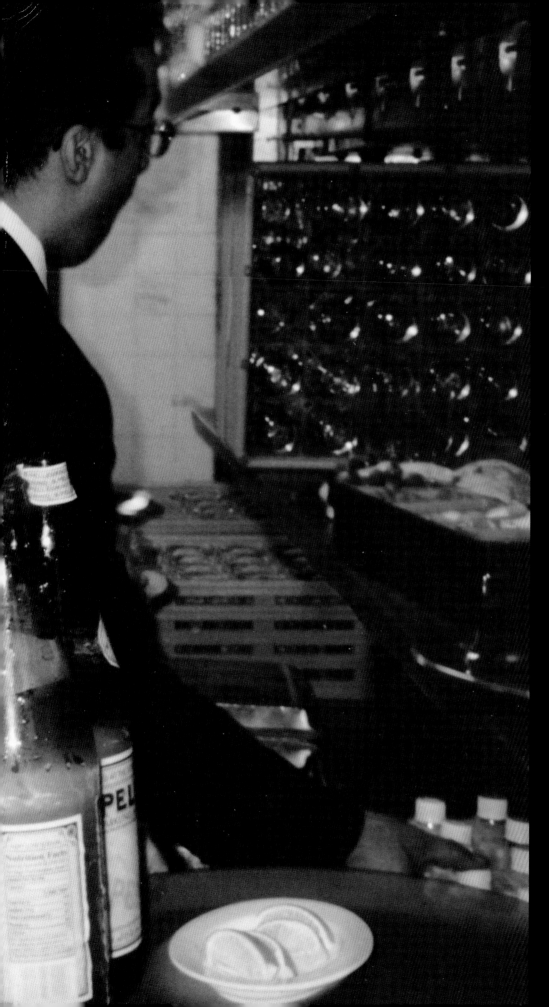

VERONICA BONSU
RESTAURANT WORKER
RESTAURANT OPPORTUNITIES
CENTER OF NEW YORK
NEW YORK CITY
UNTITLED

UNSEENAMERICA is an ongoing project of Bread & Roses, a nonprofit cultural program bringing the arts in many forms to workers and underserved audiences across the country. Bread & Roses was founded thirty years ago by 1199, New York's health care union. All proceeds from this book will be used to further our goal of adding grace and hope to the struggle for social justice. To find out more, visit us at www.bread-and-roses.com.